Mao's Golden Mangoes

and
the Cultural Revolution

Alfreda Murck (ed.)

Museum Rietberg Zürich
Scheidegger & Spiess

Preface

Albert Lutz
Director

H ow could anyone come up with the idea of preserving a half-rotten mango in formaldehyde and cherish it as a great treasure? Why would wax imitations of mangoes be carried in processions and venerated like religious relics? How is it that floats featuring giant papier-mâché mangoes figured prominently at the National Day parade and were understood as political symbols?

All these phenomena at first seem perfectly mystifying. But if you consider the political situation of China in the 1960s as well as the cultural traditions of ancient China, you will see clearly that the elevation of the mango from simple fruit to omnipresent propaganda symbol, popular for a single year, does follow an internal logic.

And let's be honest—if we scrutinize our own advertisements and political messages closely, we will discover quite a few symbols that are rather absurd in their own right, but that work perfectly well. The exhibition "Mao's Golden Mangoes and the Cultural Revolution" and the accompanying catalog not only narrate a seemingly peculiar story from 1960s China, but also aim to raise awareness about the functioning of propaganda in general.

The credit for this exhibition goes first and foremost to Alfreda Murck. Since encountering the story of the mango at the collectibles markets in Beijing, she consistently sought out mango objects and researched their origins. Talented photographer Miriam Clifford documented Ms. Murck's assorted collections and Prof. Marsha Haufler encouraged Ms. Murck to tell the story of the mango, which was first published in *Archives of Asian Art* in 2007. When Alfreda Murck told us of the mangoes in 2008, we were instantly fascinated, and when she offered to donate her collection to the Museum Rietberg, we were delighted. What's more, she agreed to act as editor of the catalog and as co-curator of the exhibition.

Alfreda Murck was also responsible for assembling this publication, which examines the mango cult in all its facets. We would like to thank all the authors of the catalog for their scholarly contributions. We are also grateful to Naomi Richards for carefully copy editing the English texts and to Li Yang and Zhuang Ying for translating from the original Chinese. The catalog was produced by Scheidegger & Spiess and well looked after by Aline Rinderer. Elektrosmog created the design. To all of them we offer our gratitude.

From the museum's team, Alexandra von Przychowski curated the exhibition. Martin Sollberger acted as exhibition designer. Jacqueline Schöb and Frederic Tischhauser designed the exhibition texts. We want to thank them and the whole team at the Museum Rietberg who have made this exhibition possible.

Introduction

Alexandra
von Przychowski

Today you can get mangoes at every well-stocked fruit stall in Beijing. The tropical fruits are used for desserts and sweets, and most children will be familiar with their taste. But until the summer of 1968, mangoes were practically unknown in northern China. If you ask the older people about their memories of the "Golden Mangoes," every one of them will be able to tell his individual story.

In Autumn 1968, China was gripped by "mango fever." The exotic fruit was omnipresent. Artificial mangoes made of wax were displayed in glass cases and venerated in a religious way. Mangoes made of papier-mâché featured prominently in the National Day parade and symbolized a political shift of power. And soon representations of mangoes appeared on quilt covers, enamel dishes, and other objects of daily use. How could a simple fruit morph into a political propaganda symbol? How could a mango become an object of highly emotional veneration?

Late July 1968 marked a political turning point in China. Two years earlier, Mao had placed the leadership of the Cultural Revolution into the hands of the students. They were called on to create a new society, to get rid of all traditions, and, at the same time, to overthrow Mao's opponents in the highest ranks of the Chinese Communist Party. The young people embraced this mission enthusiastically—and within a few months managed to plunge the country into chaos.

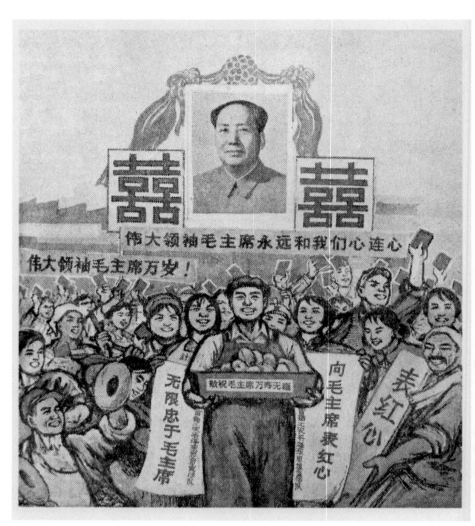

1 Celebrating the gift of mangoes,
poster of the Proletarian Revolutionary
Committee of Xinhua Printing Plant,
Beijing Daily, 12 August 1968

The Red Guards of revolutionary students and workers not only turned against all authorities, they immediately split into irreconcilable factions, fighting for power and over ideological questions. Mao Zedong adopted more and more radical measures to reunite the revolutionaries under one banner. By sending in army troops and employing "educational programs," Mao managed to subdue most of the Red Guard factions by July 1968. But at the prestigious Qinghua University in Beijing, ideological conflict erupted into open battle. To bring the students under control, Mao ordered several thousand workers from the capital to form "Worker-Peasant Mao Zedong Thought Propaganda Teams" and to occupy the university campus on 27 July. One week later, on 4 August Mao was presented with a basket of mango fruit during a visit by the Pakistani foreign minister. The next day, he ordered the mangoes to be distributed to the propaganda teams stationed at Qinghua University. The gift generated a wave of excitement among the workers. The rare and unfamiliar fruit was transformed overnight into a "precious gift," a token of their leader's benevolence, something like a religious relic of Chairman Mao, an object of veneration. The mangoes' Pakistani origin was soon glossed over. However, the political message of the gift was clearly understood and widely discussed: the students were to step down and the working class would henceforth be in charge of the Cultural Revolution and "exercise leadership in everything."

Mao's propaganda strategists quickly adopted the symbol and spread the message throughout the country. The mangoes were trucked into provincial towns and exhibited in public places. Floats with giant mangoes featured prominently at the National Day parade. Mangoes made from wax or plastic and enshrined in glass vitrines were distributed as merit awards to workers, and numerous designs depicting Mao's portrait and a bowl of mangoes were produced on badges. Images of mangoes appeared on cotton fabric and household goods. For about one year, the mango was a popular symbol. Then it vanished from the repertoire of official propaganda.

Historical background

The Great Proletarian Cultural Revolution, officially dating from 1966 to 1976, was no doubt one of the most defining experiences in the history of modern China, and it left a deep imprint on the political consciousness of all Chinese people of that time. No other period in Chinese history seems to be so complex and bizarre, so

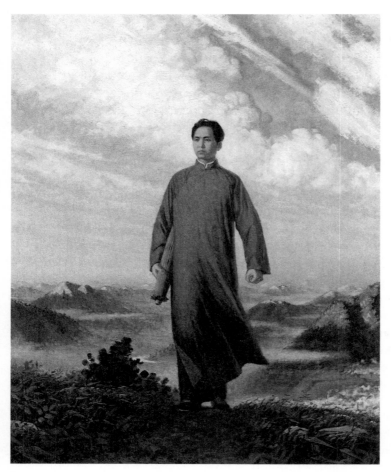

2

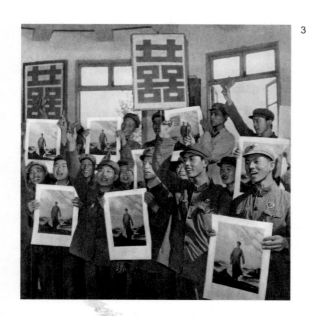

3

2 "Mao goes to Anyuan," poster
of an oil painting of 1967, circulating
widely in China after Summer 1968
and announcing the shift of political
power, *China im Bild,* September
1968, p. 12
3 Soldiers cheering the poster
of the oil painting "Mao goes to
Anyuan," *China im Bild,* September
1968, p. 13

full of contradictions and inconsistencies. Even today there is still no generally accepted interpretation or even a complete account of the events.

The Cultural Revolution developed out of a complicated political situation, brought about by a struggle for power within the highest ranks of the Party and by opposing viewpoints as to the direction the socialist revolution should take.

In 1962, China's economy was in shambles. Four years earlier, the disastrous Great Leap Forward had been launched to transform China in just a few short years into a powerful industrial nation and to speed up the arrival of the ideal socialist society. People's communes were established, and all spheres of working and living were reorganized. With the implementation of labor-intensive techniques, production levels of both grain and steel were supposed to rise dramatically. Not only was the state-organized steel industry lavishly promoted; small-scale backyard furnaces were erected in every village and commune to produce steel from scrap metal. Pots and tools belonging to the villagers were confiscated and melted down—into useless metal of low quality. Unrealistically high production targets in agriculture motivated the communes to exaggerate their production statistics, leading the central government to mandate even higher targets. This mismanagement, along with a major drought and crop failures, resulted in the most severe famine in Chinese history. More than 30 million people died of starvation between the autumn of 1958 and the end of 1961. In July 1959 Mao Zedong had to admit publicly that his campaign had yielded exceedingly negative results and he was forced to accept economic reforms by the group around People's Republic Chairman Liu Shaoqi. In an attempt to regain prestige after this disaster, Mao made plans to launch a new movement.

A second compelling reason for such a course of action might have been developments in the Soviet Union. Observing how Stalin and his cult of personality had come under severe attack, Mao must have realized that a political icon could be dismantled. The fall of Khrushchev in 1964 certainly would have alerted him that a powerful leader could even be toppled before his death.[1] The Soviet Union's new political line to achieve socialism by a peaceful transition and in coexistence with imperialism was harshly criticized by Mao. He was convinced that the ideal communist society could only be achieved by permanent revolution. The aging Mao might have considered a mass movement, a revolution from below, as the right way not only to consolidate his power, but also to fulfill his vision of a new society. The declared aim of the Cultural Revolution was nothing less than

11

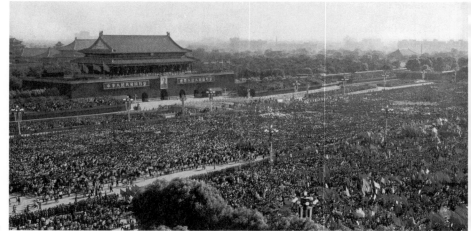

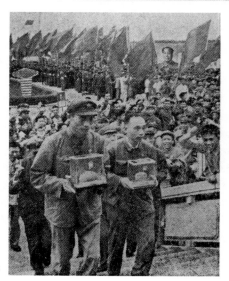

4 Mao receives Red Guards from all over the country at Tiananmen Square in August 1966, *China im Bild,* September 1966, p. 24

5 Mao on the rostrum of Tiananmen Gate greeting the Red Guards, *China im Bild,* September 1966, front cover

6 Workers at Beijing Knitting Mill cheering the mango conserved in formaldehyde, *Beijing Daily,* 8 August 1968

7 Parading the mangoes in Sichuan Province, *Sichuan Daily,* 20 September 1968

the creation of a new human being. Breaking with all traditions, he declared, would bring about a new consciousness.

In May 1966 the "Cultural Revolution Small Group" was established, composed of loyal followers of Mao, to guide the Cultural Revolution. On 8 August the Party's Central Committee passed the "Decision Concerning the Great Proletarian Cultural Revolution," calling on people to repudiate the "reactionary bourgeois line" and to overthrow "those within the Party who are in authority and taking the capitalist road," a reference to the group around Liu Shaoqi, who advocated a more moderate pace for the revolution. By late May students at middle schools and universities in Beijing had already formed the first Red Guard groups. Now they were officially tasked with scrutinizing all forms of authority for right attitude, destroying all old traditions, and creating a new society. Students throughout the country now founded their own Red Guards, and thousands flocked to Beijing to be received by their great idol, Mao Zedong. Soon the first excesses were committed: teachers and cadres were not only criticized and dismissed, but also publicly humiliated, beaten, and even killed. Their homes were ransacked, books were burned, and cultural relics were destroyed.

Soon revolution spread to the workers, who were encouraged by Mao to smash the old structures in their factories and seize power themselves. The movement became especially strong in Shanghai and led to the "January Storm" in early January 1967. Orchestrated by Mao's confidant Zhang Chunqiao, the revolutionary workers deposed the city's government and established the Shanghai Commune. But when Mao realized that in a commune the Party's influence was insignificant, he put forth a model for "revolutionary committees" as alliances between the revolutionary masses, old cadres, and the military. After less than three weeks the Shanghai Commune was restructured into a revolutionary committee, and thus came unofficially under the control of the Communist Party.

Following the example of Shanghai, workers throughout the country "seized power from below" and took over leadership in their factories. But soon they split into factions, fighting for power and authority. In the remote provinces far from Beijing the factions engaged in particularly bloody conflicts, and production in the factories ceased completely. Mao's attitude was ambiguous. On the one hand he called for constant revolution and was convinced that chaos and fighting would have a cathartic impact on society. On the other hand he was adamant, and had made clear from the beginning of the movement, that industrial and agricultural production should not be affected by

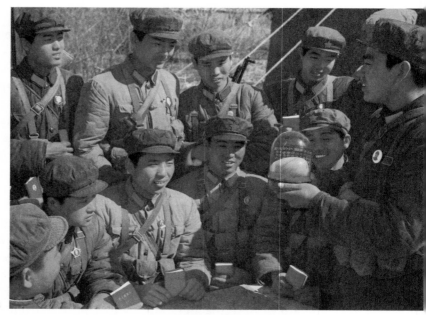

8

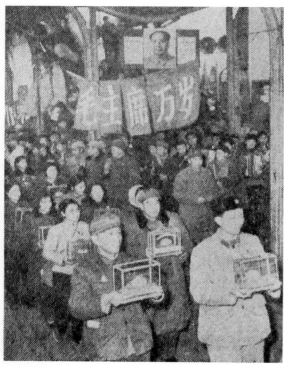

9

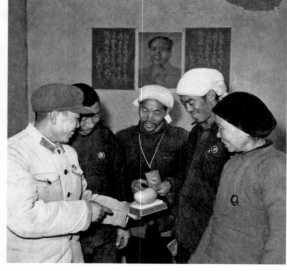

10

8 Soldiers stationed at the northern frontier regarding a facsimile mango, *China im Bild,* September 1969, p. 4

9 Parade of mangoes in Chengdu, *Sichuan Daily,* 1 February 1969

10 Peasants marvel at the mango, 1968

revolutionary activities. As early as February 1967 he ordered the army to dismantle the most radical revolutionary organizations in the provinces, occupy factories, and ensure productivity.

Nevertheless, chaos and anarchy prevailed and even intensified when revolutionaries started to turn against the Party's leadership and the Cultural Revolution Group. In the summer of 1967 a conflict between the regional army leaders of Wuhan in central China and the Cultural Revolution Group escalated, raising the specter of civil war. In Beijing, revolutionary groups took over the foreign ministry and burned down the British Chancery.

When China seemed to be sinking into anarchy, Mao acted to put an end to the revolutionary turmoil. The establishment of revolutionary committees, virtually building up a new power base of Party cadres and the army, was pressed ahead with all due haste and sometimes by force of arms. Students were directed to resume their lessons, and factories were occupied by soldiers to ensure production. Yet fighting continued until the summer of 1968. To quash the revolutionary youth, whom he had so strongly roused two years before, Mao sent them "up to the mountains and down to the countryside," purportedly to spread revolution in rural areas and to "learn from the poor farmers."

During the Ninth Congress of the Chinese Communist Party in April 1969, the Great Proletarian Cultural Revolution was proclaimed successfully accomplished. But a new phase of politics had already begun in August 1968, marked by the gift of the mangoes.

1 ── Roderick MacFarquhar and Michael Schoenhals, *Mao's Last Revolution* (Cambridge, MA: The Belknap Press of Harvard University Press, 2006), pp. 3 – 11.

① # Qinghua University and Chinese Politics during the Cultural Revolution

Xiaowei Zheng

Qinghua, China's leading university for science and technology, had occupied center stage in Beijing politics since the beginning of the Cultural Revolution. The famous name "Red Guards" *(hongweibing)* originated with a group of politically active students at Qinghua Middle School, who organized on 29 May 1966, calling themselves the "red guards who defend Mao Zedong Thought." On 1 August Mao publicly endorsed the Qinghua Middle School Red Guards, proclaiming their action against the counterrevolutionaries "righteous." This approbation inspired Chinese students across the nation to form their own Red Guard organizations. Red Guards, consisting of middle school, high school, and college students, became Mao's principal instrument in fulfilling the purpose of the Cultural Revolution: to shake up the Party as a whole in order to reinvigorate it; in other words, to "wreak havoc" with the establishment in an attempt to prevent it from going revisionist.[1]

Qinghua University's radical Red Guards, key among them the legendary Kuai Dafu, were instrumental in helping Mao to achieve the first step of the Cultural Revolution, that is, to "bombard the headquarters" and to "take out the capitalist roaders" among the leadership, Liu Shaoqi and Deng Xiaoping. The Cultural Revolution at Qinghua University started with rebel students putting up posters vilifying the university's Party committee for serious faults. Their posters took inspiration from a big-character poster by Beijing University philosophy department teacher Nie Yuanzi aggressively attacking the Party authorities at

her university, which was officially endorsed by China National Radio on 1 June 1966. An equal stimulus was the militant 2 June *People's Daily* editorial "Smashing All the Ox Devils and Snake Spirits."

On 9 June, to carry out the Cultural Revolution, Liu Shaoqi sent an outside work team to Qinghua, led by his wife, Wang Guangmei. While Mao was not in Beijing, Liu decided to follow the standard operating procedure. To stabilize the situation, he quickly sent work teams into the schools and universities, consisting of trusted cadres drawn from uninvolved units to carry out the Cultural Revolution under their guidance. On 9 June a big work team of more than 500 men and women entered Qinghua and deposed the entire Party leadership at the university. [2] This work team, though purportedly siding with the Cultural Revolution and aligning with the ideas of many of the agitated students, applied a top-down style antithetical to Cultural Revolution principles and aims.

Kuai Dafu, then a third-year chemical engineering student, emerged as the most outspoken anti-work-team student, openly challenging the work team's authority. His challenge got him attention from the very top: a summons from Mao Zedong to attend the dawn meeting of Cultural Revolution activists on 28 July 1966 and an interview with Premier Zhou Enlai on 30 July and again on 1 August 1966. [3] As Mao became increasingly vocal in his struggle against the "capitalist roaders" at the Party's center, Kuai's experience opposing the work team became more useful to him than ever. Kuai later recalled that his conversations with Zhou were mostly about his interactions with the work team led by Wang Guangmei. Linking Mao's directive of withdrawing work teams from university campuses at the end of July and Liu Shaoqi's demotion from second to eighth rank on 1 August 1966 to these conversations, Kuai realized how crucial and timely his information had been. [4]

By September 1966 the signals from the circle around Mao, mainly via the Central Cultural Revolution Small Group (hereafter Central Group), were too clear to mistake. This group was formed in May 1966 to guide the Cultural Revolution. Composed of loyal supporters of Mao and led by Jiang Qing, the Central Group escalated its accusations against Liu Shaoqi and Deng Xiaoping. On 6 September the Third Headquarters of Beijing College-Level Red Guards became a protégé of the Central Group, with Kuai Dafu as its deputy chief. On 24 September, vigorously encouraged by the Central Group, Kuai established his own Red Guard organization at Qinghua, the Jinggangshan Red Guards. [5] The latter issued a declaration clearly targeting Liu and Deng:

> The struggle between the two "lines" has been intense from the outset of the Cultural Revolution. In June and July some Central Party leaders followed the wrong class line, and to this day Chairman Mao's sixteen points could not be implemented [...] We will take it on ourselves to remove any person from his position, no matter how high, if he defies Mao Zedong Thought. [6]

Kuai was the Central Group's most stalwart point man in condemning the "bourgeois reactionary line," which was the official name for pragmatists around Liu Shaoqi and Deng Xiaoping. On 6 October all the central leaders of the Party attended a mass meeting to formally launch the campaign against the bourgeois reactionary line. At this meeting Kuai led one hundred thousand university students in an oath to blast the capitalist roaders. Overnight Kuai became a political superstar. On 9 October Kuai led four hundred Qinghua students to the center of Beijing, where they demanded that Wang Guangmei, the leader of the work team, return to Qinghua and undertake self-criticism.[7] In November and December, as Jiang Qing and other Central Group members encountered poster attacks by a group of Beijing Red Guards, largely the children of high-level Party leaders who had lost power by this point of the Cultural Revolution, Kuai Dafu was again needed to defend the Central Group by verbally bashing the attackers.[8]

In return, the Central Group was critical in helping Kuai establish himself on the Qinghua campus. On 17 December Jiang Qing particularly urged Qinghua Red Guards to unite. On 18 December Zhang Chunqiao, another member of the Central Group, went to Qinghua to urge Kuai to take the lead in uniting all of Qinghua's students, and that very day all Qinghua rebel students joined the Jinggangshan Corps, with Kuai Dafu as their leader.[9] On 25 December Jinggangshan Corps took its first action, again with the Central Group's direction and encouragement: Early in the morning, six thousand Qinghua students and teachers entered the center of Beijing via five different routes.[10] They pasted up anti-Liu and anti-Deng posters, shouted "Down with the reactionary capitalist line," and sang propaganda songs.[11] This mass public criticism of Liu Shaoqi and Deng Xiaoping had enormous impact. Apparently it realized the hopes of the Central Group, for on 30 December Jiang Qing and Central Group member Yao Wenyuan went to Qinghua to congratulate Jinggangshan for its enthusiasm and for the example it had set.[12]

Kuai's reputation soared, and his Jinggangshan Corps became the model for all other Red Guards across the nation. Meanwhile, Kuai's ego also soared, and it was this that eventually brought him to grief.

Factionalism
at Qinghua

Notwithstanding Kuai's exalted reputation outside Qinghua, maintaining student unity at Qinghua proved iffy. Antagonism toward Kuai materialized soon after the formation of the Jinggangshan Corps. Within the Corps, Kuai had quickly built up an inner circle, comprising his old comrades as well as others who had more recently gained his personal favor. His ego inflated to the point of ordering a compilation of the "Collected Works of Kuai Dafu," after the fashion of eminent Central Party leaders.[13] That was too much for Tang Wei, one of Kuai Dafu's earliest sympathizers,

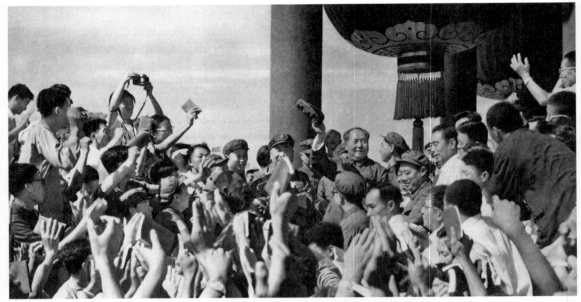

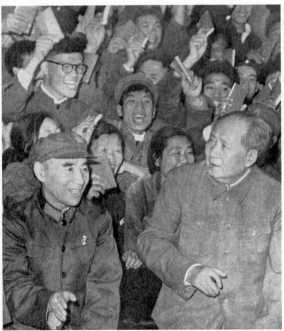

3

1　Red Guards cheering Mao, *China im Bild*, September 1966, p. 22
2　Kuai Dafu (with glasses) and other Red Guards are received by Mao Zedong and Lin Biao, *China Reconstructs*, July 1967, p. 14
3　Red Guards of Qinghua University study the newest directives, *China Reconstructs*, July 1967, p. 19
4　Ecstatic Red Guards being received by Mao, *China im Bild*, September 1966, p. 37

1
2

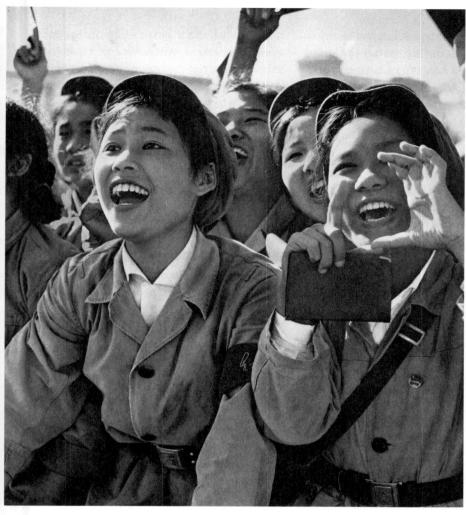

4

who publicly criticized Kuai. In his public letter of resignation, he condemned Kuai's dictatorial leadership and swelling egotism, the Jinggangshan leaders' factionalism, and their disrespect for the masses.[14] Tang Wei's criticism of Kuai's radicalism and chest-thumping resonated especially with former student cadres. Although they had supported Kuai in criticizing the capitalist reactionary line, these student cadres found the newly formed Kuai inner circle truculent and thuggish. One member of the Kuai clique had claimed that all Qinghua Party members were rotten and needed to be expelled from the Party because "they obtained their Party membership simply by flattering leaders."[15] Such belligerence and confrontational rants perturbed many of Kuai's earlier supporters, especially the former student cadres who had been drawn to Kuai by their shared revulsion over the maltreatment of the Qinghua cadres by the work team. The very first school-wide meeting after the foundation of the Jinggangshan Corps turned into an airing of complaints against Kuai. Barely two weeks after the formation of the Jinggangshan alliance on 18 December, these mounting dissatisfactions broke the alliance into five regiments (zongdui), all of which challenged Kuai's absolute control.[16]

Opposition to Kuai intensified when "his men" verbally attacked the Central Group advisor Kang Sheng. Kuai's core group claimed that Kang Sheng was a reactionary, which deeply irritated Jiang Qing and her Central Group allies. But notwithstanding his serious political mistakes and the challenges to him on campus, Kuai was still the golden boy in

the eyes of the Central Group leaders. On 26 February, when Vice Premier and Public Security Minister Xie Fuzhi received a Shanghai "power seizure committee," the prototype of a "revolutionary committee," he urged Kuai, who accompanied him, to build a stable power base at Qinghua.[17] After People's Daily propagated the Guiyang Textile Factory model of uniting each workshop to establish a "revolutionary alliance," the pressure on the regiment leaders to reunite their regiments was intense.[18] Nevertheless, they were at a standstill until the contentious issue of how to deal with cadres came to the fore.[19]

The question of how to deal with the old cadres as a bone of contention

On 31 March 1967 a Red Flag article specifically condemned the Qinghua work team's reactionary program in June 1966, when all cadres at the university were collectively put under suspicion of being "reactionary." The article asserted that most of the Qinghua cadres, that is, leaders in the university's Party committee, were good revolutionaries.[20] The faltering regiment leaders quickly took heart, since the article resonated perfectly with their views on the former Qinghua cadres and sanctioned their absorbing the cadres into a power center that would replace Kuai's dictatorship. They plunged into the debate over Qinghua's cadres. The first step in the counterattack against Kuai's group was to lash out against the rela-

tively vulnerable teachers' organization that supported Kuai. Regiment battle teams made up of former student cadres led the rhetorical assault on the teachers' organization, criticizing them for arguing that "all of Qinghua's cadres were rotten" and "professors who earned two hundred *yuan* were more revolutionary than cadres who earned forty-six *yuan*."[21] The anti-Kuai regiment leaders were strongly allied with the former Qinghua cadres. With the nation newly focused on Qinghua's cadres, they might rehabilitate the former cadres and at the same time discredit Kuai Dafu.[22]

Their chance came on 12 April, when Kuai's clique made another serious gaffe, alleging that the *Red Flag* article of 30 March, rehabilitating the Qinghua cadres, was in error.[23] Seizing the opportunity, Shen Ruhuai, who had emerged as the most adamant anti-Kuai leader, and other regiment leaders formed the April Fourteenth Liaison (hereafter the Fours) on 14 April and called themselves the "Rehabilitating Cadres Liaison."[24] The repercussions were huge. Qinghua cadres joined the Fours, greatly enhancing this fledgling faction. On 29 April 147 Qinghua cadres posted a public letter, "To All Revolutionary Cadres and Cadres Who Want to Be Revolutionaries." In this letter they claimed that the Fours followed Mao's teachings and were of all the factions the most resolute in combating the capitalist reactionary line.[25] On 1 May Kuai and his followers fired back, labeling the cadres' letter an attempt to restore the old Qinghua.[26] Their strident tone and aggressive wording drove these cadres and their student sympathizers firmly into the ranks of the Fours.

Because cadres had represented political authority at Qinghua before the Cultural Revolution, an evaluation of their role was in effect an evaluation of the old Qinghua during the first seventeen years of the People's Republic, which in turn decisively affected one's understanding and assessment of the Cultural Revolution. The Jinggangshan Corps' evaluation was, of course, negative, that of the Fours, more favorable.[27] The argument stemmed from contradictions within the pre-Cultural Revolution Qinghua hierarchy and stratification of the sociopolitical power structure at Qinghua and throughout the People's Republic during the previous seventeen years. Many interviewees recalled that such debates led them to reflect on the early People's Republic power structure and their own positions in it, and that these reflections influenced their later decisions. Students came to understand their past positions more clearly and began to switch their initial affiliations as the debates intensified and reached into the fundamentals of the power structure. The Fours expanded from about seven hundred people in mid-April when the Fours formed to about two thousand at the end of May, after six weeks of fierce argument and counterargument.[28]

The struggle between Jinggangshan and the Fours intensified after May over the formation of a campus revolutionary committee. The revolutionary committee was, according to Mao's directive, to be a legitimate, formal, long-term regime, possessing the resources to quash opposing opinions and eliminate antagonists. Kuai took this issue as an opportunity to delegitimize the Fours once and for all. The Fours were determined to fight back.

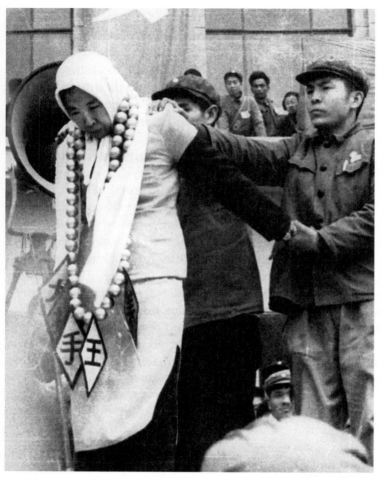

5

6

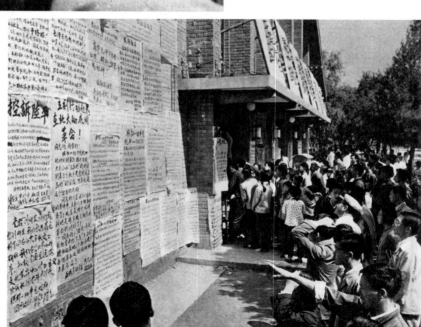

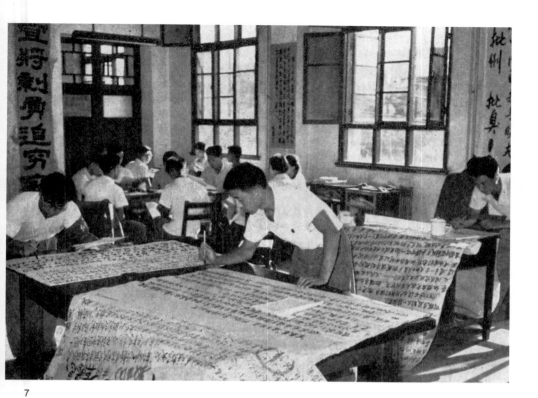

7

5 Wang Guangmei, leader of the
work team at Qinhua University,
is publicly humiliated in a struggle
session in April 1967, after Yang,
p. 215
6 Big-character posters at Beijing
University in August 1966, after
Yang, p. 138
7 Students of Beijing Normal
University writing big-character
posters attacking Liu Shaoqi, *China
Reconstructs*, January 1968, p. 29

Kuai's Jinggangshan had already established an election committee for the revolutionary committee and was preparing to celebrate the founding of the revolutionary committee on 28 May, while in Yuanmingyuan, the nearby former imperial park, the agitated Shen Ruhuai and his most dedicated followers held a secret meeting. Stating the conflict allegorically, Shen said, "Either the fish dies in the net or the net is torn to pieces. Kuai is already contracting the net. The only way for the Fours to survive is to break our way out!"[29] In the early morning of 29 May 1967 Shen and other leaders of the Fours announced the establishment of the April Fourteenth Headquarters, marking their official organizational split from Kuai. The establishment of the April Fourteenth Headquarters had a momentous effect. The planned founding meeting of Qinghua's revolutionary committee of Kuai's Jinggangshan did not take place because Zhou Enlai, informed of the factional divisions at the school, refused to attend. This humiliation deepened the Jinggangshaners' hatred of the Fours.

Zhou Enlai's no-show for Kuai Dafu's revolutionary committee crushed Kuai's attempt to become the absolute leader of Qinghua. It also made both factions understand the importance of Central Party leaders' support for their positions. Trying to act on the signals sent by Central Party leaders, both factions shifted their focus to the world outside Qinghua. Since students on both sides were intensifying their actions and rationalizations so as to win the support of Central Party leaders, they were becoming ever more open to manipulation from the center.

Although the students' actions were often inconsistent, their ideologies grew increasingly systematic. Both factions displayed great interest in the theoretical and social implications of the Cultural Revolution. Using Marxist class theory and terminology, they offered their own creative interpretations of the upheaval and of the preceding seventeen years. In August 1967, after being attacked by Jinggangshan's nationally circulated newspaper for weeks, the Fours' theorist Zhou Quanying wrote one of the most famous polemics of the Cultural Revolution, "The Fours' Spirit Shall Win!" Zhou's article influenced numerous Red Guards all over the country and was even perused by Mao.[30] The Cultural Revolution, Zhou stated, "was a revolution led by the proletariat, who were also the leading class of the preceding seventeen years." During the preceding seventeen years of the socialist regime, the overall class line "was correct and stable... those in control were from the 'good' classes and those reined in were from the landlord, capitalist, and other 'bad' classes." The article maintained that, notwithstanding problems in the central political regime, changes should be moderate and must not overhaul the entire sociopolitical structure.[31] Thus, Zhou Quanying opposed the idea of the Cultural Revolution as an all-out counterattack (da fan'ge) on the past and a wholesale redistribution of wealth and power.

Diametrically opposed were Kuai and his radical supporters, who called on their followers to "smash the old Qinghua completely" (chedi zalan jiu Qinghua). Their principle was, "Wherever oppression is worst, revolution is strongest."

To them, all Qinghua cadres were corrupt;[32] though the university leaders had already fallen, the second and third generations of cadres were also corrupt and remained a danger. Obsessed by the idea that the past must be utterly overthrown, the Corps insisted on stripping all vestiges of authority from the former cadres and vehemently denounced the policies of the preceding seventeen years.[33]

The call for order
goes unheard

By the end of 1967 Mao had back-pedaled from his support of rampage and anarchy. In October 1967 Mao again called on "all revolutionary organizations to forge great alliances." This time, Mao's directive was more concrete compared to that of seven months before. These alliances were to form "revolutionary committees" to replace the old organs of state power. After a year of struggle and the purge of many "bad people," Mao was anxious to get on with reestablishing order, via a "three-in-one" merger, comprising representatives of the PLA, the revolutionary cadres, and the revolutionary masses. In November 1967 the PLA was ordered to desist from holding public debates and pasting up big-character posters and to focus on reimposing discipline on its officers; military academies were told to form three-in-one alliances.[34] In addition, Mao Zedong Thought Study Classes were organized nationwide; 86.4 million sets of Mao's selected works and 350 million copies of the Little Red Book were published in 1967, and groups were brought to Beijing from problem provinces in the hope that local factionalism could be dissipated by Mao study. With these additional efforts, by 30 March 1968 eighteen of China's twenty-nine provinces, municipalities, and autonomous regions had formed revolutionary committees.[35]

Also in October 1967 the central CCP ordered classes to be resumed immediately (they had been suspended for almost a year and a half), and newspapers began urging students to return to school. Responding to this call, classes resumed in Qinghua on 30 October. But factional struggles there continued and even intensified. After the focus of the two factions' efforts shifted back to the campus, verbal competition between the Corps and the Fours escalated into armed skirmishes. The Corps persecuted several cadres who supported the Fours. The Fours aggressively lashed out against some teachers siding with the Corps. Both sides suffered casualties; neither would stop fighting.[36] Open war between Red Guard factions at Qinghua had its beginning in March 1968, prompted by the happenings at Beijing University, where the Red Guard leader Nie Yuanzi incited an armed fight, devastating her opposition and opening the way to the establishment of her own revolutionary committee. Soon after, in an April 1968 *People's Daily* article, Mao called on people to "never concede" when facing class enemies. Inspired by Nie's success and encouraged by Mao's new order, on 23 April 1968 Kuai Dafu started the famous Hundred Day War at Qinghua.[37]

8

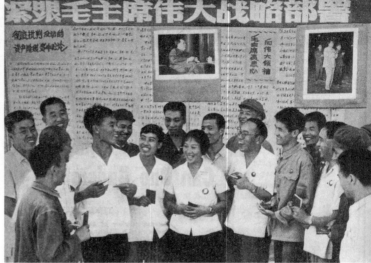

10

9

8 Students and members of the
9 Worker-Peasant Propaganda
Teams studying Mao Zedong
Thought at Qinghua University in
1968, *China im Bild*, November
1968, pp. 32, 30
10 Members of the Workers' Mao
Zedong Thought Propaganda Team
at Qinghua University, *China
Reconstructs*, January 1968, p. 5
11 Worker-Peasant Propaganda
Teams at the Beijing universities,
China im Bild, October 1968, p. 8
12 Students and workers at Qingua
University marvel at a mango, after
Yang, p. 362
13 Members of the Workers'
Propaganda Teams at Qinghua
University, dated 25 September 1968

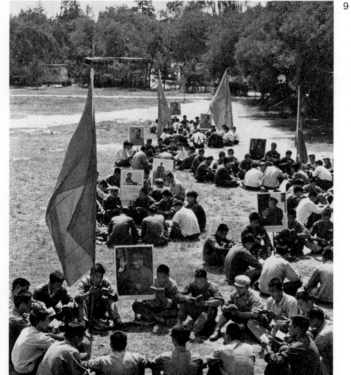

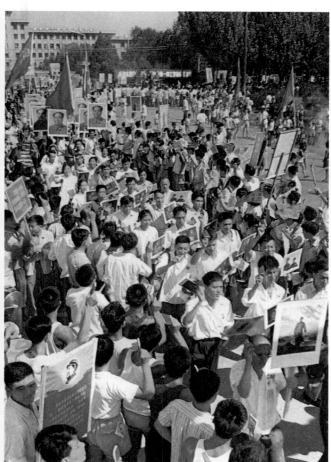

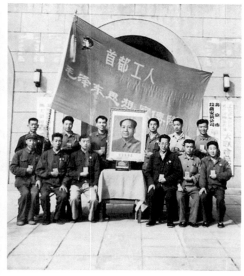

13

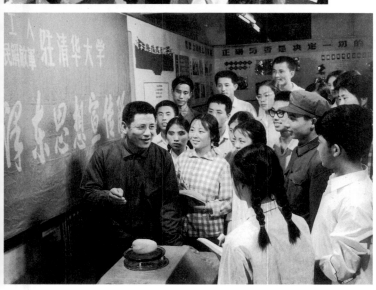

11

12

Violence erupts

The Hundred Day War began with the Corps commanders occupying the university's Meeting Hall after midnight on 23 April. At dawn the Corps loudspeakers blared forth that four hundred spears allegedly owned by the Fours had been found, and that the Corps' action had frustrated a major offensive planned by the Fours.[38] Not long after the Corps' announcement, the Fours occupied the Generator Building, just east of the Meeting Hall and across the central oval from the Science Building, which was their headquarters.[39] From 9 a.m. to 3 p.m. the Corps launched a massive attack aimed at taking the Generator Building. They succeeded. Both sides used stones, tiles, spears, and sulfuric acid as weapons. More than fifty students were wounded, many by jumping out of windows in an effort to flee the fighting.[40]

From 24 to 28 April the two sides continually vandalized buildings occupied by the other faction, destroyed the other's broadcast stations, and confiscated the homes of members of the other faction. The primary aim on both sides was to control more buildings. Both sides managed to obtain weapons from outside the campus. In addition, using skills they learned at school before the Cultural Revolution, they manufactured bombs, cannons, rockets, spears, mines, and even "tanks." By the end of April 60 percent of the Qinghua students had left campus.[41]

The final battle with cold weapons took place at the Bathhouse at dawn on 30 May. Again it was the Corps that took the offensive. First they tried to take the two-story Bathhouse with assault ladders, but the defenders easily held them off with long spears, then pushed forward with a contingent of spearmen behind a "tank" made from a tractor welded over with steel plates. The Corps fighters broke ranks and fled, leaving one of them, run through by a spear, to bleed to death. Infuriated, Kuai ordered his diehard supporters to pour gasoline on the Bathhouse and torch it. The Fours, trapped inside, were forced to surrender. The bloody battle of the Bathhouse was the last major confrontation. With one death on each side and many wounded or badly burned, factional leaders shied away from new face-offs in favor of protracted siege and countersiege.[42] To escape the bloodshed, even more students and staff fled the campus, leaving at most three hundred activists to fight it out.[43]

"The little generals have now made mistakes" (Xianzai shi xiaojiang fan cuowu de shihou le)

Finally, in early July, Mao Zedong made up his mind to end the armed fighting. On 3 July, in response to massive battles in Guangxi Province, the Central Committee, the State Council, the Military Committee, and the Central Cultural Revolution Small Group issued a joint directive ordering the immediate cessation of combat, the clean-up of defensive installations, and the immediate and unconditional surrender of all weapons to the PLA. Mao paid special attention to

the internecine war at Qinghua University. Representatives of the Beijing Garrison *(weishuqu)* were dispatched to Qinghua on 7 July, bearing copies of the 3 July Directive, to stop the armed fights. These accomplished nothing. On 9 July the Corps decided to set fire to the Fours' headquarters, the Science Building. On the same day, three hundred Fours carried the body of one of their dead fighters to Tiananmen Square, in protest against the atrocities of the Jinggangshan Corps. The Fours also sent six urgent telegrams to Mao and the Central Party, asking China's top leaders to intervene.[44] On 12 July Liu Feng of the Beijing Garrison went to Qinghua for a talk with the Fours and Kuai Dafu. Liu demanded that Kuai end his blockade of the Science Building and turn over all his weapons, again to no avail. On 15 July Kuai was received by Xie Fuzhi and other Beijing leaders. When asked to stop fighting, Kuai put forward his conditions: brand leaders of the Fours as "counterrevolutionaries," arrest the Qinghua cadres that had supported the Fours, order the Fours to publicly surrender to the Corps and to remove all their defensive installations.[45] Kuai had become obsessed with destroying the Fours.

Finally, in desperation, Mao agreed to the measures for which Liu Shaoqi and Deng Xiaoping had been excoriated two years earlier: work teams. At Mao's direct order, the 8341 Army (Mao's own headquarters unit) and the Beijing Garrison set up temporary headquarters outside the Qinghua campus, in preparation for entering the university. In addition, some thirty thousand employees of sixty Beijing factories were organized into "Capital Workers' Mao Zedong Thought Propaganda Teams" and sent onto campuses to propagate Mao's directive to stop fighting and to advance the formation of alliances. The teams assigned to Qinghua University arrived there on 27 July 1968 and were welcomed by the hard-pressed Fours. The Corps, however, greeted them with shots and stones, as ordered by Kuai Dafu. Five members of the Workers' Propaganda Teams were killed; 731 were injured.[46]

The 27 July fiasco shocked the Central Party leaders. For Mao, it was the end of his illusion that, if revisionist Party leaders could be swept aside and he could speak directly to the people, they would unfailingly follow him. The hearts and minds of his revolutionary adherents were not unfailingly at one with his own, as he had hoped. Nor could they be controlled any longer by his directives. They could only be brought back into line by force.

One day after the Qinghua debacle, the Chairman officially "summoned" the principal Red Guard leaders of the capital, Nie Yuanzi, Kuai Dafu, Tan Houlan, Han Aijing, and Wang Dabin, to a meeting in the Great Hall of the People. The Great Hall was a red-carpet venue, but the rebels had been summoned to hear the death sentence pronounced on their movement. In the meeting, which lasted from 3:30 a.m. to 8:30 a.m., Mao lambasted the Red Guard leaders for disobeying his order to "struggle, criticize, and transform" Chinese campuses, and instead forming viciously opposing factions which degenerated from diatribes even to armed combat. He revealed that he was the "black hand" behind the

order sending in work teams to quell the violence and told the Red Guards, his "little generals," that "they have now made mistakes."[47] Mao pointed out that Kuai and the other leaders could each rely on only two or three hundred hard-core supporters, whereas he could send in thirty thousand workers, not to mention the large number of troops under Lin Biao.[48] He emphasized that Red Guard violence had alienated all sections of the population, including many students, and laid out the alternatives he offered them: either military control, or "struggle-criticism-quit" and "struggle-criticism-disperse."[49] In fact Mao imposed both: PLA units moved onto many campuses, and simultaneously members of the principal Red Guard units were dispersed "up to the mountains and down to the countryside." And so the Red Guard leaders ended up in farms and factories, making revolution as true proletarians.[50]

It was time for the Red Guards to leave center stage. The term Red Guard was to live on for another decade. But the exciting days of the Red Guards were over soon after July 1968.

Mangoes, the cult of Mao, and politics during the Cultural Revolution

On 4 August Pakistan's foreign minister presented Mao Zedong with a case of mangoes. The following day, which was the second anniversary of Mao's big-character poster "Bombard the Head-quarters," Mao instructed his bodyguard, Wang Dongxing, to present the mangoes as a gift to the workers of the Propaganda Teams stationed at Qinghua University[51] Mao's gift generated great excitement immediately on arrival on the Qinghua campus. According to William Hinton's interviews, workers stayed up through the night, looking at and touching the mangoes, discussing the implications of the new policy, and contemplating Mao's act.[52] As Alfreda Murck puts it, "Chairman Mao's refusal to eat the fruit was read as a sacrifice for the benefit of the workers."[53] And the transformation of the mango from fruit to near-divine symbol was swift.[54]

The sudden emergence of the mango in mass political discourse had much to do with the cult of Mao. In the first years of the Cultural Revolution it was Mao's personal endorsement that had given the Red Guards their historical stage. It was then Mao's chastisement that changed the power dynamic of the Qinghua Red Guards. Finally, it was Mao's abandonment of the Red Guards that led to their downfall.

On 26 August the Red Guards were told to stand down, officially and in print: the *People's Daily* editorial by

Yao Wenyuan, a member of the Central Cultural Revolution Small Group, was headlined "The Working Class Must Exercise Leadership in Everything."

> In carrying out the proletarian revolution in education, it is essential to have working-class leadership; it is essential for the masses of the workers to take part and, in cooperation with Liberation Army fighters, bring about a revolutionary "three-in-one" combination, merging with the activists among the students, teachers, and workers in the schools who are determined to carry the proletarian revolution in education through to the end. The Workers' Propaganda Teams should stay permanently in the schools and take part in fulfilling all the tasks of struggle-criticism-transformation in the schools, and they will always lead the schools. [55]

As one former Qinghua student remembers, upon hearing the broadcast of the 26 August editorial he realized that "the golden age of the Red Guards is over." [56] If Mao's 28 July summons to the five Red Guard leaders had left the students with some illusion that they were still Mao's right arm, the 26 August editorial made it unequivocally clear that, for the Red Guards in particular and the students in general, the rampage was over and they must now accept the leadership of the proletariat. Qinghua students could no longer comfort themselves that Mao gave mangoes to the workers because "he did not like to eat the exotic fruit." [57]

With that, the Cultural Revolution had unmistakably entered a new phase, and the mango became both a signal and symbol of the shift to this new era of "three-in-one" revolutionary alliances.

Tragically, the dispersal of the Red Guards did not put an end to the violence, but instead proved to be the prelude to an even wider-ranging campaign of terror, during which even more people were tortured, maimed, killed, driven to madness or to suicide. Many in August 1968 had already forgotten that when the Cultural Revolution first started, its goal was to "touch people's souls" (chuji ren linghun) and to remake people's ideals. The little generals had demonstrated their failure to achieve that goal. Would the workers succeed instead? What was the purpose of the Cultural Revolution, and why did the reality differ so drastically from Mao's vision?

1-- Mao Zedong, "Just a Few Words," translation of "Zai Zhongyang gongzuo huiyi shang de jianghua" [Talk at the Central Work Conference] (25 October 1966), in Michael Schoenhals (ed.), *China's Cultural Revolution, 1966–1969: Not A Dinner Party* (Armonk, NY: M.E. Sharpe, 1996), p. 8.

2-- Xiaowei Zheng, "Passion, Reflection and Survival: Political Choices of Red Guards at Qinghua University, June 1966–July 1968," in Joseph W. Esherick, Paul G. Pickowicz, and Andrew G. Walder (eds.), *China's Cultural Revolution As History* (Stanford, CA: Stanford University Press, 2006), p. 48.

3-- Interview with Kuai Dafu by the author, 2003.

4-- Interview with Kuai Dafu by the author, 2003.

5-- Xiaowei Zheng, "Passion, Reflection and Survival," p. 48.

6-- "Jinggangshan hongweibing choubei jianli weiyuanhui di yi hao jueyi" [The first resolution of the preparatory committee of the Jinggangshan Red Guards], in Song Yongyi (ed.), *Zhongguo wenhua da geming wenku* [Chinese Cultural Revolution database], (Hong Kong: Xianggang Zhongwen daxue Zhongguo yanjiu fuwu zhongxin, 2002).

7-- Xu Aijing [Han Aijing], *Qinghua Kuai Dafu* [Kuai Dafu of Qinghua University] (Hong Kong: Zhongguo wenge Lishi chubanshe, 2011), pp. 146, 148.

8-- Ibid, p. 163. On 15 November 1966 Yilin and Dixi from Beijing Agriculture Middle School put up the accusatory big-character poster at the Qinghua University campus, targeting Mao's "close comrade" Lin Biao. On 21 November Red Guards from Number 8 Middle School attacked Kuai and those like him and claimed to "resolutely resist people like Kuai to take charge of the Three Quarters." On 30 November Li Hongshan from Chinese Forestry College put up a poster attacking the Central Cultural Revolution Small Group and urging people to "kick out the Central Group and to take over the Cultural Revolution on one's own." On 6 December Li Hongshan again attacked the Central Cultural Revolution Small Group and even urged students "to criticize Chairman Mao in the most thorough manner." Early December 1966 was plagued with the old loyalist Red Guards turning their spears against the Central Group. On 5 December Beijing's elite middle schools, such as Beida Middle School and Qinghua Middle School, formed United Action *(Liandong).* They condemned rebel Red Guard students like Kuai Dafu and targeted Jiang Qing and other Central Cultural Revolution Small Group members.

9-- Interview with Kuai Dafu by the author, 2003.

10-- Interview with Kuai Dafu by the author, 2003.

11-- "Qinghua daxue Jinggangshan lianhe zongbu yiwangxi zhandouzu" [Qinghua University Jinggangshan united headquarters 'recalling-the-past battle team'], in *Qinghua daxue Jinggangshan bingtuan wuchan jieji wenhua da geming dashiji* [The chronology of the Qinghua Jinggangshan Corps in the Great Proletarian Cultural Revolution] (Beijing: 1968), mimeographed pamphlet, 25 December 1966. Hereafter, *Dashiji.*

12-- *Dashiji,* 30 December 1966.

13-- Shen Ruhuai, *Qinghua daxue wen'ge jishi: Yige hongweibing lingxiu de zishu* [The Cultural Revolution at Qinghua University: Autobiography of a Red Guard leader] (Hong Kong: Shidai yishu chubanshe, 2004), p. 51. Special thanks to Shen Ruhuai for giving me his detailed autobiography.

14-- *Dashiji,* 20 December 1966; interview with Ji Peng by the author, 2003; Shen Ruhuai, *Qinghua daxue wen'ge jishi,* p. 51.

15-- *Dashiji,* 20 December 1966.

16-- *Dashiji,* 2–11 January 1967; interview with Shen Ruhuai by the author, February 2003; Shen Ruhuai, *Qinghua daxue wen'ge jishi,* p. 57. These five regiments were: the Mao Zedong Thought Regiment *(Mao Zedong sixiang zongdui),* the Eights' Regiment *(Baba zongdui),* the East is Red Regiment *(Dongfanghong zongdui),* Chairman Mao's Guards *(Mao zhuxi jingwei tuan),* and the Tiananmen Regiment *(Tiananmen zongdui).*

17-- *Dashiji,* 26 February 1967.

18-- Interview with Shen Ruhuai by the author, 2003. Shen explained the pressure he felt after reading about Guiyang Textile Factory's model in establishing a "revolutionary alliance" in the *People's Daily* on 1 March. This model required that small groups organize along the lines of workshops being dissolved and that all workers in a factory should join together in one revolutionary alliance.

19-- *Dashiji,* 1 and 7 March 1967; interview with Shen Ruhuai by the author, 2003.

20—— "'Daji yidapian, baohu yixiaocuo' shi zichan jieji fandong luxian de yige zucheng bufen (1966 nian 6, 7 yue Qinghua daxue gongzuozu zai ganbu wenti shang zhixing zichan jieji fandong luxian de qingkuang diaocha)" [Attacking many to protect a few is the reactionary capitalist line (Investigation of Qinghua University work team's reactionary capitalist line on the cadre problem during June and July 1966)], Hongqi, 31 March 1967, p. 5.

21—— Dashiji, 1 April 1967.

22—— Interview with Shen Ruhuai by the author, 2003; interview with Ji Peng by the author, 2003.

23—— Dashiji, 13 April 1967.

24—— Interview with Ji Peng by the author, 2003; interview with Sun Nutao by the author, 2003.

25—— Dashiji, 29 April 1967.

26—— Ibid., 3 May 1967.

27—— Ibid., 22 April 1967. The argument was expressed in a Fours' poster titled "Young Revolutionaries Should Have the Courage to Rehabilitate Cadres," written by Shen Ruhuai's battle team.

28—— Ibid., 14 April 1967, and 29 May 1967. On 14 April 1967 seven hundred people attended the founding meeting of the April Fourteenth Liaison. On 29 May 1967 two thousand people attended the founding meeting of the April Fourteenth Headquarters.

29—— Interview with Shen Ruhuai by the author, 2003.

30—— Weida lingxiu Mao zhuxi he tade qinmi zhanyou Lin fuzhuxi zhaojian shoudu dazhuanyuanxiao hongdaihui fuzeren Nie Yuanzi, Kuai Dafu, Han Aijing, Tan Houlan, Wang Dabin tongzhi shi de zhongyao jianghua [The great leader Chairman Mao and his close comrade Vice Chairman Lin in dialogue with leaders of the Beijing college Red Guards, Comrades Nie Yuanzi, Kuai Dafu, Han Aijing, Tan Houlan and Wang Dabin] (Beijing: 1968), printed pamphlet, pp. 3, 20. Hereafter, Jianghua. Special thanks to Richard Siao at UCLA for sharing his original document with me.

31—— Zhou Quanying, "414 sichao bisheng!" [The Fours' Spirit Shall Win!], in Song Yongyi and Sun Dajin (eds.), Wenhua da geming he tade yiduan sichao [Heterodox thoughts during the Cultural Revolution] (Hong Kong: Tianyuan shuwu, 1996), pp. 390, 408.

32—— Jinggangshan (24 August 1967), in Zhou Yuan (ed.), Xinbian hongweibing ziliao [A new collection of red guard publications] (Oakton, VA: Center for Chinese Research Materials, 1999), vol. 8, pp. 3890–92.

33—— Dashiji, 18 and 20 November 1967.

34—— Roderick MacFarquhar and Michael Schoenhals, Mao's Last Revolution (Cambridge, MA: The Belknap Press of Harvard University Press, 2006), p. 241.

35—— Ibid., p. 240.

36—— Interview with Sun Nutao by the author, 2003. The first large-scale armed battle took place in January 1967. Only the intervention of the Beijing Garrison under General Li Zhongqi made the two factions stop fighting. Even at the negotiating table, however, and in the presence of General Li, the two factions kept cursing each other.

37—— Interview with Kuai Dafu by the author, 2003.

38—— William Hinton, Hundred Day War: The Cultural Revolution at Tsinghua University (New York and London: Monthly Review Press, 1973), p. 154.

39—— Tang Shaojie, "Qinghua wudou yu xuanchuandui jinzhu" [Armed struggles at Qinghua and the coming of the Propaganda Teams], Bainianchao [Hundred Year Tide], no. 9 (2000), p. 64.

40—— Ibid.

41—— Ibid.

42—— Hinton, Hundred Day War, pp. 160, 161.

43—— This number is Mao's estimate, Jianghua, pp. 2, 4. The estimate according to participant Tsu was 400 at the end of July. About 300 students (200 with the Regiment and about 100 with the Fours) and an additional 100 outsiders who were "pretty bad people on the whole…. Most of them loved brawling and so both sides welcomed them…." (Hinton, Hundred Day War, p. 168). I refer to 300, the number of students engaged in the fighting.

44—— Xu Aijing, Qinghua Kuai Dafu, p. 340.

45—— Ibid.

46—— Tang Shaojie, "Qinghua wudou yu xuanchuandui jinzhu," pp. 68, 69.

47—— "Black hand" was the term used by Qinghua Red Guard leader Kuai Dafu, referring to the person who ordered to send in work teams to Qinghua University. Jianghua, p. 16.

48—— Ibid., p. 3.

49—— Ibid., p. 18.

50—— MacFarquhar and Schoenhals, Mao's Last Revolution, p. 251.

51—— Alfreda Murck, "Golden Mangoes: The Life Cycle of a Cultural Revolution Symbol," Archives of Asian Art, vol. 57 (2007), p. 2.

52—— Hinton, Hundred Day War, pp. 226, 227. Quoted in Murck, "Golden Mangoes," p. 20.

53—— Murck, "Golden Mangoes," p. 4.

54—— Ibid., p. 2.

55—— Yao Wenyuan, "The Working Class Must Exercise Leadership in Everything," in Hinton, Hundred Day War, p. 183

56—— Interview with Zheng Yisheng by the author, 2011.

57—— Interview with Huang Xi by the author, 2011.

② 1968: My Story of the Mango

Wang Xiaoping

By 16 August 1968 I was in my fourth year of working in Beijing No.1 Machine Tool Plant. Shortly after the "Campaign to Purify the Class Ranks" ended, many of the activists were transferred to the Workers' Propaganda Team, which the previous month had been sent to Qinghua University to try to end conflicts among Red Guard factions within the student body. For the time being, with the Propaganda Team gone, no one in the factory would be "exposed" as an counter-revolutionary; we were finally able to enjoy a little peace. Still, as I labored all day at my C620 tool lathe on a three-shift system, my mind remained unsettled.

In that sweltering August the workshop was equipped with standing fans about one meter in diameter. We wore long sleeves, gloves, goggles, and face masks to protect us from the hot iron filings and fragments that flew from the lathe as we worked. The breeze from the fan was welcome, but it churned up dust and filings that mixed with perspiration and clung to my skin in a disagreeably sticky layer.

That week I was on the morning shift, working from six a.m. until two p.m. But the plant usually required us to be on duty by five-thirty. By not quite ten o'clock I had already been standing for four hours and was feeling tired. I wanted to fetch a drink of water and at the same time to stretch my legs. Just as I took down my tea mug, I saw our team leader, Chen Wenlian, enter the shop. She approached the first row of tool shapers and started a conversation with my colleague Liu Songnian. Passing by, I overheard something about a factory-wide meeting to be held in the afternoon.

A meeting? It must be about the mango thing. Two days earlier I'd already gotten an earful over lunch: everyone was to receive a mango, a replica of the real fruit originally given to a member of our factory's Workers' Propaganda Team by Chairman Mao. Wax models had already been made, one for every person. What

is a "mango"? Nobody knew. Few had even heard the word, let alone seen one. Knowledgeable people said it was a fruit of extreme rarity, like Mushrooms of Immortality. It must be very delicious. Its appearance nobody could describe. To receive such a rare and exotic thing filled people with a surge of excitement. I did not participate in the discussion. A gift from Chairman Mao probably had nothing to do with me. For two years, since the start of the Cultural Revolution, I'd been used to getting out of the way when anything good happened. Since Chen Wenlian already notified us, the news seemed to be true. Still, it was none of my business. I'd better just go and fetch my water.

When I got back, Chen Wenlian was already by my lathe. She said that in the afternoon all the revolutionary workers should go to factory headquarters for a big meeting, a very important one to which we should not be late. I was told to clean up the lathe at eleven o'clock, go to lunch at eleven-thirty, and from there go immediately to headquarters. At that time our workshop was in Houchang Pingku Alley, off Nanxiao Street of Inner Xizhi Gate, in the area of today's Chegongzhuang Bridge. Headquarters, located at Xisi Shuaifu Alley, was actually our second tool plant, but since the factory director's office, the Workers Union office, and the Communist Youth League's office were all there, it was also called "headquarters." All the factory-wide meetings were held there. Usually we would walk over, which took about forty minutes. We could be there on time after lunch and a shower.

Me as well? Perplexed, I looked questioningly at Chen Wenlian. Because I was born to a family of the wrong social class, ever since the beginning of the Cultural Revolution I had doubted whether I belonged to the category of "revolutionary worker." I started working in the factory in September 1964. Due to my bourgeois family background, the Beijing Municipal Gold Medal of Excellence that I had received on graduation

from secondary girls school did not guarantee me entrance to a university. On the day I received the rejections, my physics teacher, Gao Yuanhe, hugged me and cried her eyes out. I was only a little upset. Having started my schooling fairly early, I had finished high school at seventeen. At that time I was completely unaware of the outside world. All I cared about was reading. My limited understanding of life was derived almost entirely from books. No matter where I was, I was always able to conjure up a wonderful life. I had not yet realized how not going to university would affect my life. In fact, because of my family background, I couldn't even apply for a teaching post in an elementary school. My only route was to become a factory worker. I was recruited by Beijing No.1 Machine Tool Plant.

Our factory, which was established in 1908, was big in both scale and reputation. When I started, all the rules and regulations were strictly observed. We began with a three-month training program on metallurgical technology, on how to read drawings, and so on. Both the trainers and the trainees were truly intent and dedicated. Spare-time activities were organized as well, such as playing on the basketball team, or rehearsing songs and dances. Every week we had "free time" to study technology or culture. We could also watch one or two movies per month. It felt like my high school internship in a factory. Life seemed quite interesting. After the training period I was assigned to a shop in the large-parts section, where I apprenticed at operating a vertical lathe. Because during the recruitment one of my teachers—I'm not sure which one—recommended me as a bright student, I was often assigned to organize public displays or other events. Later they simply put me in the office as a helping hand. At the same time I was also in charge of the plant's broadcasting room. Everyone said I was a good broadcaster. They said that my broadcasting sounded just like China National Radio. Encouraged, I worked even harder to please my audience. I bought many records of wonderful music.

After the noon broadcast devoted to "Good People and Exemplary Deeds," I played a selection of music for everyone. At that time there were many young people in the factory who had started working at the same time as me. Every day after work we hung out together. Sometimes we read books together. With them for company, I led a happy life.

But then came the Cultural Revolution. Those ordinary, peaceful days were over. In June 1966 the revolutionaries denounced me. How could a person with a family background like hers work in the office? She should work in the plant! A girl with whom I had had some issues in the past told me to immediately hand over the key to the broadcasting room and get out. The mouthpiece for the revolution should not be controlled by some bitch like me. I went back to the lathe. I was still young, so manual labor did not bother me.

Over time the Cultural Revolution became increasingly fierce. In the beginning "capitalist roaders" were targeted. A huge number of big-character posters were needed, and there were countless criticism and denunciation rallies. Due to my writing skills and fairly good calligraphy, I was reassigned to copy posters and to help to draft denunciation speeches. I had, however, already entered "the other register." I could write the posters and compose the denunciation speeches, but I was not allowed to speak during the rallies. Two factions of Cultural Revolutionaries declared war but then allied again, forming a unit of Red Guards and establishing a "Factory Protection Team" and a "Revolutionary Committee."

Obviously I was not included in either of them. The only thing I could do was to labor obediently at the lathe. Many a time while working in the plant, I would happen to look up over my lathe and I'd see many machines with no operators. Those revolutionaries had gone to meetings to chart the course of revolution, leaving a few "sinister heads" (literally "black heads") and me to keep working. "Sinister heads" was yet

another pejorative for those "ox-headed devils and serpent spirits" ferreted out from the plant staff. They included the former factory director, the chief of the design department, and those who had been previously labelled Rightists. Incidentally, on joining the plant, I was told that a number of talented people working there were all Rightists. In 1958 our brilliant factory director, Deng Xiao, had cannily recruited thirty-two Rightists from illustrious universities and colleges, including Beijing University of Aeronautics, the Institute of Posts and Telecommunications, and People's University. They played leading roles in the Design Department, Technical Development Department, and Training Department. In the early 1960s their contributions indeed gave Beijing No. 1 Machine Tool Plant a considerable reputation for technological innovation. But once the Cultural Revolution was launched, these thirty-two people were turned into "ox-headed devils and serpent spirits." After the "Campaign to Purify Class Ranks" started in 1968, the factory's Red Guards exposed more people, labelling them "cursed secret agents" and "bad elements." Those accused of "serious mistakes" were beaten in front of the rest of us to the point that they could not move. They were locked up in a factory room and not allowed to go home. Better off were those who were just made to work in the plant, enlarging the group of "sinister heads."

At that time I was in an ambiguous position, neither a sinister head nor a member of the revolutionary masses, but something in between, quite marginal.

Now the mangoes are to be distributed. Am I a member of the revolutionary masses? Chen Wenlian was resolute in her decision to include me in the meeting. I might as well show her some respect and get ready to go. In fact, Chen had been quite nice to me; ordinarily she was unwilling to embarrass me. Even when she treated me harshly, it was to fulfill the expectations of the revolutionaries. She was also a book lover. Personally we got along well.

41

The meeting was scheduled to start at two in the afternoon. Only when I arrived at the site did I discover that anyone who had not been exposed as a capitalist roader was allowed to attend and was counted among the revolutionaries. I noticed that other workers of my dubious type were also present. Having been excluded from so many activities, some of them were deeply grateful just to be included in this event.

That was indeed a rousing, enthusiastic meeting. Wang Qingshan, the military representative of the revolutionary committee, announced, "There are two pieces of great good news for Beijing No. 1 Machine Tool Plant. One is that Chairman Mao received representatives of workers from the capital on 15 August. Comrade Zhang Kui from our factory enjoyed the privilege of mounting the rostrum and shaking hands with the great leader Chairman Mao. This is the highest honor and a source of endless pride for all the workers of our factory. The other good news is that on 5 August Pakistan's President Ayub Khan sent a crate of mangoes to the great leader Chairman Mao, who said, 'We will not eat them. Have Comrade Wang Dongxing take them to Qinghua University for the comrades in the eight Worker-Peasant Propaganda Teams.' On 27 July, a big truckload of workers from our factory marched into Qinghua University as part of the Worker-Peasant Propaganda Teams who were putting an end to factional fighting. The vice director of the revolutionary committee of our factory, Zhang Kui, is the Vice Commander of the Machinery Bureau's Propaganda Team. Therefore a mango was bestowed on our factory. This is glorious for the entire factory. According to the decision of the revolutionary committee, the real mango has been delivered to Shanghai Machine Tool Works by Li Shuhua, the representative of senior workers, via a special plane. Because comrades there have invented China's first Numerical Controlled Machine Tool and won honor for the Chinese working class, we are sharing this glory with them. Now, in order to let everyone share

the pride evoked by the fruit, the factory authorities have commissioned wax models of the mango to be distributed to each member of the revolutionary masses as a lifelong keepsake."

That day was indeed a festive one for the factory. People were wild with joy. They shouted "Long Live Chairman Mao!" and "Long Live the Proletarian Cultural Revolution!" A few senior female workers mounted the platform, so excited that they wept and sniffled. They vowed to be loyal to Chairman Mao forever and to support the Proletarian Cultural Revolution through to the end. Attendants surged forward to shake hands with Zhang Kui, who had kept his hands unwashed for a day because they were imprinted with Mao Zedong's blessings. I was only an observer. Not having a sufficiently high rank to shake hands with Comrade Zhang, I just stood outside the crowd and watched.

The next day, wax mangoes were distributed. I got one. It lay in a rectangular glass box, gold colored and kidney shaped. Everyone held their wax model of the sacred fruit solemnly and reverently. Someone was even admonished by senior workers for not holding the fruit securely, which was a sign of disrespect to the Great Leader. Hearing this, the senior female workers' eyes again brimmed over with tears. The mangoes were said to have been placed in the most conspicuous place in everyone's home.

But I really thought it beautiful, and felt duly grateful because it allowed me to be a member of the revolutionary masses for a few days. I really wanted to know whether the real fruit was edible, what it tasted like. Unfortunately, we had only wax facsimiles.

About thirty years later, in the late 1990s, mangoes could be seen in Beijing's markets in such profusion that they were unceremoniously piled on the ground. But by then almost everyone's wax mango had disappeared.

In the spring of 2011 I vacationed with some younger colleagues in Vietnam. We all loved the drink called "mango shake." I was so enchanted by its sweetness and by the unique flavor of fresh mango that at every stop we had to find a juice shop and buy a drink.
I felt genuinely happy as I watched the golden mangoes being crushed in the blender, mixed with crushed ice cubes, and made into a delicacy for our pleasure. Suddenly it occurred to me that if we had treated mangoes like that forty years earlier, we would have been severely punished. I told my story of the mango to my younger colleagues, who were in their twenties. Incredulously they responded, "It's only a piece of fruit! People of your time! Really!"

Written on the morning
of 14 August 2011
in Jiuxianqiao (Beijing).

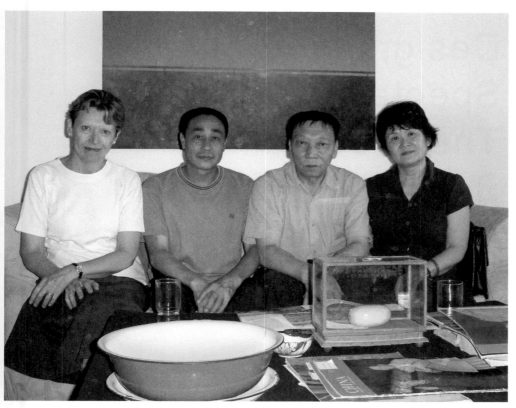

Wang Xiaoping (far right), with
Zhang Kui and Wang Qingzhu,
an old colleague from Beijing No.1
Machine Tool Plant, at Alfreda
Murck's home, Summer 2010,
photo: A. Murck.

③ Designing Spectacles: The 1968 Beijing National Day Parade

Daniel Leese

The 1968 National Day parade was unremarkable in the chain of ritualized Communist spectacles in modern Chinese history. Neither did the number of participants equal the spectacular 1.5 million two years earlier during the first Cultural Revolutionary National Day parade, nor did it introduce major symbolic innovations with the exception of mango replicas. Its content, however, revealed a significant change in the will of the central authorities: to end the anarchy that had characterized the previous months by celebrating the leadership of the working class. The parade symbolically ended the Red Guard phase of the Cultural Revolution, and thus is an excellent example of state spectacles and symbolic politics as devices of rule during the high tide of Maoist mass campaigns.

In this essay I will first describe the visible surface of the 1968 parade, then discuss the planning and organization of Communist spectacles more generally, and finally offer a reading of the 1968 parade as a political script for domestic and foreign audiences, aimed at strengthening Party leadership and establishing new social hierarchies.

毛主席啊，工人阶级无

1

2

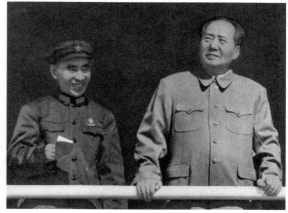

5

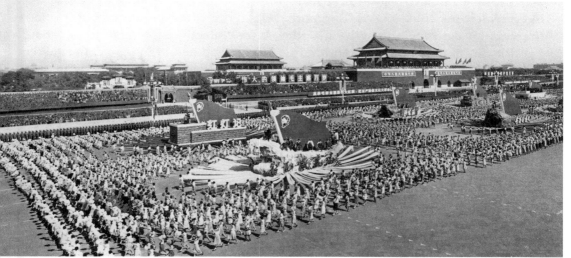

3
4

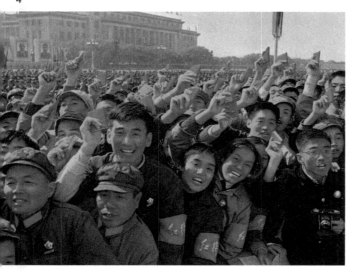

1 "Oh Mao Zedong! The working class will be loyal to you forever," *People's Daily,* 2 October 1968, p. 2
2 National Day card display, *China im Bild*, November 1968, p. 6
3 "Revolutionary literature and art fighters" at the National Day parade, *China im Bild*, November 1968, p. 5
4 Cheering public at the parade, *China im Bild*, November 1968, p. 7
5 Mao and Lin Biao review the parade on National Day, *China im Bild*, November 1968, p. 3

The visible surface of the parade

On 1 October 1968, punctually at 10 a.m., Chinese Communist Party (CCP) Chairman Mao Zedong and his "closest comrade-in-arms," Minister of Defense Lin Biao, ascended the Gate of Heavenly Peace (Tiananmen) to celebrate the 19th anniversary of the founding of the People's Republic of China. As they mounted the rostrum to the tune of "The East is Red," a majestic sight unfolded before the 74-year-old dictator, his chosen successor, and the remaining members of the decimated Party leadership. Behind a triple *cordon sanitaire* of People's Liberation Army (PLA) soldiers, the vast square below them was neatly packed with some 100,000 citizens who, upon the leaders' arrival, transformed into the first of several vast ornaments specifically created for the occasion. By lifting different-colored pieces of cloth and cardboard above their heads, the participants made the square into the image of a huge sunflower that bowed its head toward Mao Zedong, at the time commonly referred to as the "reddest red sun" of the Chinese revolution. The image was precisely choreographed to express boundless loyalty to and belief in the policies of the CCP Chairman that, during the past two years, had shaken the Chinese political system to its very foundations. High above the square, finally, nine huge red traditional paper lanterns displayed the characters "Respectfully wishing Chairman Mao eternal life!"

As Mao appeared above the crowd, the people on the square and the roughly 10,000 handpicked model workers, army representatives, and foreign dignitaries in the eight reviewing stands on both sides of Tiananmen burst into cheers and applause, together with the first units of the National Day parade that queued for kilometers along the eastern stretch of Chang'an Avenue down to Wangfujing and Dongdan Street. Xie Fuzhi, the shady minister of public security, in his capacity as head of the Beijing Revolutionary Committee, declared the parade open. After collective singing of the Chinese national anthem, Lin Biao delivered the official welcoming address. The speech, which had been drafted for him by Party scribes and corrected and approved by Mao Zedong personally,[1] emphasized the parade as a festival of the victories achieved in the past year as well as of the successful establishment of revolutionary committees in the whole country, except for Taiwan.[2] The main task ahead, Lin declared, lay in consolidating the new power structures and purifying the class ranks. From now on the working class was to exercise leadership in everything, even in former Red Guard strongholds such as schools and universities, and to effect Chairman Mao's "great strategic plan" of uniting factions nationwide by carrying the Great Proletarian Cultural Revolution through to the end.

After the short speech and the collective shouting of slogans against U.S. imperialism and Soviet revisionism, as well as praising the wisdom of the CCP Chairman, the National Day parade started along Chang'an Avenue from east to west. It comprised some 400,000 participants

organized in ten sections and lasted for about 90 minutes. The parade was clearly civilian in character, as had become customary since the Great Leap Forward in 1960. As always, the first float carried huge images of the People's Republic of China (PRC) founding date and the current year along with the state symbols. The second float consisted of a red map of the PRC adorned with the characters "Revolutionary Committees are great," accompanied by dancers dressed in the costumes of China's diverse ethnic groups. The third section comprised worker representatives from all over China who marched behind a banner reading "The working class must exercise leadership in everything," and carried huge mango replicas, reminiscent of the "precious gift" Mao had presented to the Worker-Peasant-Soldier Propaganda Teams at Qinghua University five weeks earlier. The worker's section, which behind the mangoes featured numerous other floats and banners as well as statues of Mao and his works, was followed by their "most reliable ally," the poor and lower-middle-class peasants, who behind the banner "People's Communes are great" presented models of fruits and grain as symbols of their successes in revolutionary production.

The fifth section consisted of distinguished PLA soldiers from border regions or units currently engaged in the "three supports, two militaries" *(san zhi, liang jun)* campaign to reestablish order in China's localities. They were followed by a few selected representatives of the Red Guards brandishing the Little Red Book, and, in section seven, by revolutionary representatives of government office workers and Beijing residents. The eighth part of the parade boasted some of the most elaborate and colorful floats, which presented the successes of the "revolutionary literature and art fighters" in the form of *yangbanxi,* revolutionary model operas, ballets, and music. Near the end of the parade athletes championed images of Mao's swimming the Yangzi and pantomimed the slogan "When sailing the seas, depend on the helmsman; when conducting revolution, depend on Mao Zedong Thought!" The rear was brought up by Chinese marchers heralding the heroic stand of befriended countries such as Albania, Vietnam, Laos, and Pakistan, to express Chinese support for their struggles against imperialism, colonialism, and Soviet revisionism. The parade concluded at 12 a.m. with the collective singing of the *Ode to the Motherland,* while festivities continued and climaxed later that night with a show of fireworks above Tiananmen Square.

Planning and
organization
of a Communist
spectacle

The above description, based on contemporary publications and newsreels, offers a first impression of the arrangement and scope of the parade. Yet in order to understand the enormous importance attached to spectacles of power by the CCP leadership, we need to look more closely at what was actually shown, and thus trace the function of the parades within the framework of symbolic politics in the People's Republic of China.

51

Communicating state policies via symbolism had been an important means of establishing the new revolutionary calendar when the CCP came to power in October 1949. National Day (1 October) was clearly the most significant event of the year, followed by the festivities surrounding Labor Day (1 May) and the traditional founding dates of the Party (1 July) and the army (1 August). During the first decade of the PRC, the National Day parade had strongly evoked the military victories of the past and had been divided into a review of military units followed by the civilian section. Each of the aforementioned festivities had during the early years of the PRC been awarded specific status and imagery, including meticulous orders submitted in the name of the CCP Central Committee on where and when to place which leader's portrait. [3] Whereas the international character of Labor Day demanded the prominent display of images of foreign Communist dignitaries, National Day was increasingly focused on the Chinese revolution. In the early days of the PRC images and slogans in honor of Stalin still occupied a supreme position even on Chinese National Day, but the importance of foreign Communist leaders' images had greatly decreased in the wake of de-Stalinization. By the late 1960s images of the Marxist-Leninist founding fathers, including Stalin, were commonly placed along the Eastern and Western sides of Tiananmen Square, still prominent enough to call attention to their importance as part of the Communist tradition. The chronology of the Chinese revolution, however, was visually emphasized by placing the image of Sun Yat-sen, the founder of the Chinese Republic in 1912, on the square itself, in front of the Monument to the People's Heroes and immediately opposite Mao's portrait at Tiananmen, where it had come to be placed permanently from October 1966 onward. Previously, Mao's image had only been placed atop the gate a few days ahead of the Labor Day parade in May and the Founding Day parade in October.

Organizing the National Day parade was a major logistical and ideological challenge for the Party authorities, and responsibility for the National Day parade in the Chinese capital rested with a special preparatory committee under the auspices of the Beijing municipal Party leadership. [4] Provincial capitals like Harbin or important cities such as Shanghai would model their own parades on the decisions taken in Beijing, although the regional parades commanded fewer resources and allowed for greater thematic variation. The tasks of the committee included decisions on the number and provenance of the marchers in the parade and of the crowd on Tiananmen Square, all of whom were carefully chosen from a wide network of institutions that included factories, government bodies, army units, as well as universities. The Party committee of each institution supervised the selection of trustworthy individuals, who would receive meticulous instructions and drilling in their specifically assigned duties. Cued by chalk markings on the square and quasi-military command structures within each sector, the participants would shout slogans or lift different-colored pieces of cloth or paper at certain moments of the parade—all to conjure up the happiness enjoyed by the masses

under the dictatorship of the proletariat. The emblems on the square created by choreographed mass movement[5] numbered about five in a given year, and usually included numerals of the respective year, characters lauding Mao and the CCP, and key symbolic images such as the sunflower in 1968.

The logistical aspects of organizing a great number of reliable and well-drilled participants, as well as closely coordinating the route and time frame of the parade with the command of the Beijing Garrison, which had to safeguard the event against all types of interference, by and large rested with the preparatory committee. The ideological aspects of the state parades, including the respective positioning of the sections or the choice of official slogans, regularly required decisions by the Party's top leadership, and the decision-making process was advanced by Central Committee circulars.[6] The parades were crucial instruments for communicating present policy choices to both a domestic and an international audience and therefore were treated as matters of utmost importance. The timing of the slogans, the relative length of given sections, each representing a given social group in the parade, as well as the order in which Party leaders were mentioned in the official media reports—all these supplied hints of crucial changes in leadership or policy choices that were well understood by the Chinese audience. Long sections of the Chinese-language coverage of the parades, especially during the Cultural Revolution, were thus devoted to meticulously ordering the names of dozens of central and provincial-level cadres as an indication of current Party

hierarchies and to confirm the legitimate leaders in intraparty feuds.

Foreigners did not take part in the parades, but they were specifically addressed as part of the audience. Foreign journalists and embassy staff would usually be assigned to the reviewing stands flanking the Gate of Heavenly Peace; foreign dignitaries of befriended nations would be invited onto the rostrum in token of the special friendship between their countries and China. In 1968 the honor was accorded, among others, to Beqir Balluku, head of the Albanian Labor Party's delegation to China, who during the parade enjoyed a "cordial talk" with Mao Zedong on the international situation of socialism.[7] Although the specific contents of the discussion, such as the number of Soviet troops in Bulgaria, were not made public, images of the half-hour meeting during the parade were widely covered by Chinese media to convey the special friendship between tiny Albania and China.[8] The specific reason for the coverage was Albania's staunch alliance with the Maoist leadership, which the Chinese side reciprocated by devoting great attention to the celebration of Albanian leader Enver Hoxha's 60th birthday on 15 October 1968. As for ordinary foreign participants, the preparatory committee in cooperation with the Central Propaganda Department provided guidelines of what impressions the visitors were to take away from the parade. Attendants and foreign policy staff accordingly received detailed instructions on how to evaluate recent events, what to point out during the parade, and how to specify policy changes in discussions with the foreign representatives.[9]

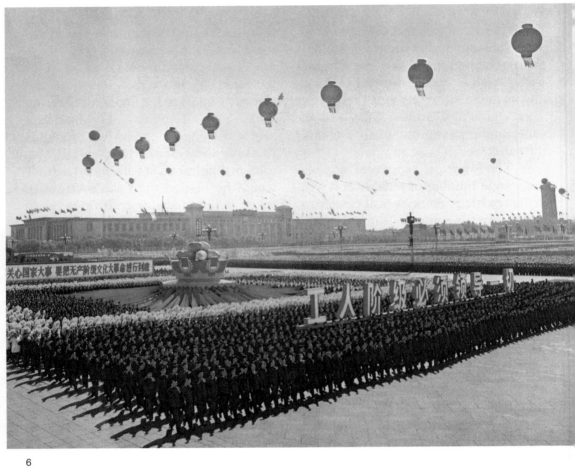

6

8

7

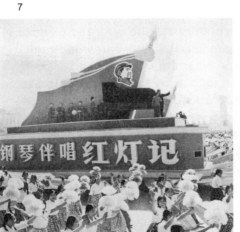

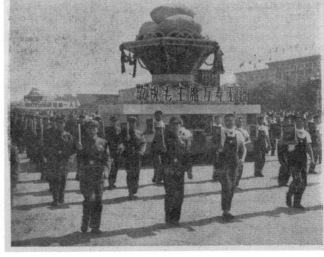

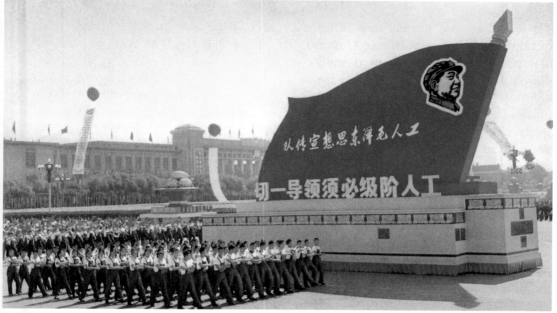

9 10

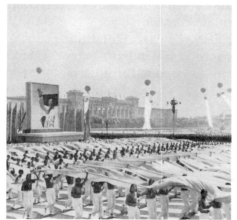

11

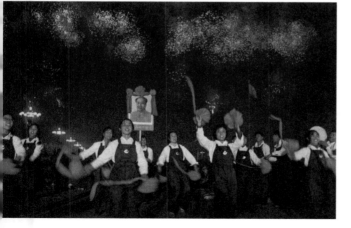

6 Float with mangoes, sunflowers, and the slogen "The working class must exercise leadership in everything," *China im Bild*, September 1968, p. 3

7 Float to celebrate the model opera "The Red Lantern," *China Reconstructs*, December 1968, p. 8

8 Mango float, *People's Liberation Army Daily*, 2 October 1968

9 Red Flag with the slogan "The working class must exercise leadership in everything," *China Reconstructs*, January 1969, p. 13

10 Athletes with streamers of blue silk reenact Mao's swimming in the Yangzi River, *China Reconstructs*, December 1968, p. 8

11 Dance praising revolutionary literature and arts, *China im Bild*, November 1968, p. 7

The National Day parade thus fulfilled multiple functions in Chinese Communist politics. First, it flaunted the regime's legitimacy and power. The organizational precision and the sheer mass of well-coached participants attested the Party leadership's ability to effectively govern the huge state. Second, the parade uniquely visualized and thus communicated policies of the moment. Each parade clearly and powerfully demonstrated the Party leadership's evaluation of past and present circumstances, which foreign countries were to be perceived as friends or foes, and which strata of the populace were presently credited with playing a major role in affairs. Third, this visualization of politics was not merely a gigantic show to impress or indoctrinate domestic and foreign audiences, but also served as an important occasion of self-reassurance for the Party leadership itself.[10] By reproducing the perceived social hierarchies, the Party leadership renewed its claim to power. Each parade therefore should be perceived as a microcosm of centrally coordinated political performance, aimed at visualizing and communicating Party rule, which itself in the process received renewal and affirmation.

The 1968 parade as a political script

Which messages and policy choices were visually embodied and thus communicated through the 1968 National Day parade? Most significant, specific policies were less important in 1968 than immediate questions of power and legitimacy after two years of violence and factional warfare. Mao Zedong's personal predominance was demonstrated through various textual and visual means. Both domestic and foreign newspapers showed Mao alone atop Tiananmen and referred to the parade as Mao's personal reception of worker representatives and the masses. Chinese-language editions made it a point to vividly describe Mao's physical condition ("glowing with health and radiating vigor") before praising the second in line of command, Lin Biao, who in the following two years would be added to the headlines as a host. His delivery of the main speech at the parade confirmed Lin's status as Mao's closest comrade-in-arms. The other members of the central leadership were listed, again in Chinese-language publications only, in descending order of their official rank, starting with Premier Zhou Enlai and the nominal head of the Central Cultural Revolution Small Group, Chen Boda, and on down to Kang Sheng and the more prominent members of the later-named "Gang of Four," as well as several high-ranking PLA generals and Lin Biao's wife, Ye Qun, thus demonstrating the rapidly grown importance of Leftist circles and the army within the top leadership.

Before commenting on the parade itself, the Chinese-language reports continued with a detailed list of the official representatives from each provincial revolutionary committee who had been invited by Mao to enjoy the parade from the Gate of Heavenly Peace with him. Their highly unusual presence served to clarify who, after the violent factional struggles all over China during the Cultural Revolution, was now enjoying Mao's personal endorsement, the crucial source of legitimacy. Finally, the names and ranks of foreign delegates invited onto the rostrum were specified, most prominently the representatives of Albania, Pakistan, Myanmar, Vietnam, and Laos.

The media coverage of the parade thus made patent relative status and power, by listing in detail the hierarchy of the members within the hierarchically listed subgroups on Tiananmen rostrum—those who represented the core of China's leadership as well as those who represented valued foreign friends. The Tiananmen rostrum held the apex of a four-layered spatial hierarchy that continued with representatives from famous work teams, army units, and foreign delegations in the eight reviewing stands; with the carefully chosen marchers in the parade; and with the selected members of the crowd on the square. By mirroring the spatial hierarchies the newspaper reports communicated the legitimacy of the new leadership bodies and the trustworthiness of their allies to their respective audiences.

If the vertical hierarchies by and large served to express power distribution among the top leadership, the parade itself was a horizontal depiction of social hierarchies. Unlike the previous two years of mass revolutionary turmoil, when praise of Mao Zedong overshadowed all social demarcations, the 1968 parade was noteworthy for its clear differentiation of social classes. Most of its ten sections comprised a sharply defined social group and demonstrated its relative importance in the current political situation. Whereas in the 1967 parade many sections had promoted a particular theme and comprised representatives of the "revolutionary masses" drawn from different social classes, in the 1968 parade the symbolic return to leadership of the classic constituency of CCP power, the working class along with poor peasants and the army, signalled the demise of the Red Guard organizations as challengers to the established order. The slogan "The working class must exercise leadership in everything" (gongren jieji bixu lingdao yiqie) had been coined by Mao personally [11] on the occasion of sending Mao Zedong Thought Propaganda Teams, the first one to Qinghua University in late July 1968 and later other teams to other universities, to quell the violence among Red Guard student factions. Mao's backing of the Thought Propaganda Teams was symbolized by his gift to them of mangoes, which he had received as a gift from Pakistan. [12] Accordingly, the mango as a token of Mao's trust featured prominently in the working-class section of the National Day parade in the form of giant fruits made of papier mâché.

The slogan that the working class must exercise leadership in everything had been further popularized by an article drafted by Yao Wenyuan and published nationwide on 26 August 1968. [13] Its message of a return to working-class

leadership, however, merely served to propagate, in scarcely veiled terms, a return to Party leadership, the Party being the supposed avant-garde of the proletariat. During the following month the working class was publicly celebrated, although it never came even close to leadership in the Cultural Revolution, and concomitantly the role of the Red Guards dwindled. By the end of the year most of them had been "sent down" to the countryside to perform manual labor. Their marginalization in the parade was mirrored in the brevity—one or two sentences—of their mention in media accounts. The demise of the Red Guards marked the end of a utopian attempt to realize a novel form of communist governance that was to emerge from the struggle against revisionist and bureaucratic tendencies within the Chinese Communist Party itself. The 1968 parade therefore symbolized a conservative turn away from the notion of spontaneous mass movements and back to "moving the masses."[14]

Successes of the revolutionary "art fighters" were blazoned in the media's reportage of the eighth section of the parade, attesting the influence of the Central Cultural Revolution Small Group centered around Mao's wife, Jiang Qing, who had come to dominate all spheres of artistic production. Description of this section therefore was of considerable length and drew public attention to the model operas and their political patrons.[15] Still, Mao tried to balance the influence of the Leftists against that of the PLA faction and the moderates within the government's leadership group, for example, by deleting a slogan in praise of the Central Cultural Revolution Small Group from the official list during the preparations for the 1968 parade.[16] By allowing overweening preeminence to no group, Mao made clear that everybody within the leadership ultimately depended on his political backing, although this was only perceivable within the core leadership, who would get to see changes in successive drafts of the program for the parade.

Nationalism enjoyed little focus in the program. Although members of all of China's distinct ethnic groups marched under the national flag, commendations of ethnic unity were fairly scarce in the media. The same went for China's athletes; previously a symbol of national pride and strength, they were mentioned only in passing. After all, the national sports administration and its former chairman, He Long, had come under heavy criticism for championing competition and "medal-seeking" at the expense of proletarian internationalism.[17] Therefore the parade emphasized mass sports, especially pantomime swimming in remembrance of Mao's famous swim in the Yangzi in mid-1966, rather than competitive sports and national honor.

The last section of the parade linked Chinese-foreign conflicts to an overview of global resistance to imperialism and colonialism. Besides Albania as an ally against Soviet revisionism and Pakistan as an ally against India, therefore, the parade highlighted the most prominent Cold War conflicts in China's vicinity, including those in Vietnam, Laos, and Cambodia. International student protests got no official mention at all, even though many of the foreign students and intellectuals,

unaware of or willfully blind to the dire realities of Maoist rule, glorified Cultural Revolutionary China as a kind of ideal society that they hoped to achieve. [18]

After providing the slogan for each of the above conflict scenarios, the Chinese-language reports concluded by listing some two hundred names of Central Committee members, army delegates, representatives of government organs, and so-called democratic personalities such as Sun Yat-sen's widow, Song Qingling, as part of the CCP's united front approach. The epilogue of names was by no means irrelevant. Mention in the official parade reports served as proof that the individual was still considered one of the masses and not an enemy of the people. Every slogan in the parade and every character in the corresponding reports was thus endowed with enormous symbolic weight and read accordingly.

Read as a political script, the 1968 National Day parade heralded the end of Red Guard turmoil and a return to Communist Party dictatorship in the name of the working class. It revealed the continuing importance of the radical Leftists and the army's considerable role in political affairs, and foreshadowed the increase in that role throughout 1969 and 1970. The period was characterized by the return of local Party authorities, backed by military power, who would systematically set about destroying former opponents, thus ushering in the bloodiest phase of the Cultural Revolution. [19] None of this could be immediately perceived from the parade's symbolism, but many contemporary Chinese Red Guards and rebels gradually became aware that they had been used by

Mao, who now consigned them not only to the dustbin of history, but to hard labor in the countryside or worse.

National Day parades continued for two more years and ended abruptly after Lin Biao's flight and death on 13 September 1971. Mao's betrayal by his chosen successor, and the difficulties of explaining that unexpected turn of events, along with a perceived war threat from the Soviet Union, led to a cancellation of the parade on short notice. Replacing the parade were publicized "get-togethers" *(lianhuan)* between Party leaders and "the masses" in parks, or public assemblies. On 13 September 1972 the CCP Center announced its plans to continue with this "simplified" *(jianhua qingzhu)* form of National Day celebrations, thus interdicting parades even in smaller cities. [20] It would be over a decade before the Party on special occasions returned to the parade-style celebrations. The huge parades in 1984, 1999, and 2009, each an important anniversary of PRC history, no longer resembled the Cultural Revolutionary style but returned to the heritage of the early 1950s, with a strong military component and powerful emphasis on national and ethnic unity. The fundamental function of the parades, however, as symbols of Party leadership and legitimacy, has remained unchanged.

1-- Zhonggong zhongyang wenxian yanjiushi (ed.), *Jianguo yilai Mao Zedong wengao* [Manuscripts of Mao Zedong's post-1949 writings], vol. 12 (Beijing: Zhongyang wenxian chubanshe, 1998), pp. 576f.

2-- For a translated version of the speech, see *China Pictorial,* November 1968, inside cover.

3-- On the specific imagery, see Daniel Leese, *Mao Cult: Rhetoric and Ritual in China's Cultural Revolution* (Cambridge: Cambridge University Press, 2011), pp. 38–42.

4-- On the origins of the committee, see Chang-tai Hung, *Mao's New World: Political Culture in the Early People's Republic* (Ithaca, NY, and London: Cornell University Press, 2011), pp. 95f.

5-- On the "ornamental" function of the masses in a capitalist context, see the classic description by Siegfried Kracauer, *Das Ornament der Masse: Essays* (Frankfurt am Main: Suhrkamp, 1963), pp. 50–64.

6-- The Cultural Revolutionary circulars on the state spectacles are still unavailable, but the respective documents from the 1950s offer fairly comprehensive frameworks of comparison. See for example "Zhonggong zhongyang guanyu 1957 nian guoqingjie jinian banfa de tongzhi" [CCP Center notice regarding the 1957 National Day commemoration arrangements], 15 September 1957, Hebei Provincial Archives 855-4-1045.

7-- For a transcript of the talk, see "Mao Zedong yu Baluku de tanhua zhi yi" [Mao Zedong's talk with Balluku, Part One], in Song Yongyi (ed.), *Chinese Cultural Revolution Database* (Hong Kong: Chinese University Press, 2006) (CD-ROM).

8-- *China Pictorial* 11 (1968), p. 4.

9-- Since the post-1966 documents are unavailable for research, the explanations regarding the turning away from the Great Leap Forward in the early 1960s provide the best comparisons currently available; see for example Zhongyang tongyi Zhongyang waishi xiaozu, "Guanyu 1962 nian guoqingjie qijian waibin jiedai gongzuo de qingshi baogao" [Agreement of the CCP Center concerning the Central Foreign Affairs Small Group's 'Report Regarding Foreign Guests Reception Work during 1962 National Day'], *Zhongfa* [62] 485, 19 September 1962.

10-- On this point and for an excellent discussion of parades in Soviet Russia, see Malte Rolf, *Das sowjetische Massenfest* (Hamburg: Hamburger Edition, 2006), pp. 22f.

11-- Zhonggong zhongyang wenxian yanjiushi (ed.), *Jianguo yilai Mao Zedong wengao,* p. 533.

12-- On the historical context of the event and Pakistan's astonishment over what was perceived as an outstanding foreign policy success, see Leese, *Mao Cult,* pp. 219–223.

13-- For the context and history of the slogan, see Jennifer May, *Sources of Authority: Quotational Practice in Chinese Communist Propaganda* (Ph.D. diss. Heidelberg University, 2008), pp. 125–143.

14—— See Tang Shaojie, *Yi ye zhi qiu: Qinghua daxue 1968 nian "bairi da wudou* [One Leaf Knows the Autumn: The "One Hundred-Day Great Armed Struggle" in 1968] (Hong Kong: Zhongwen daxue chubanshe, 2003), p. 260.

15—— On the model works, see Paul Clark, *The Chinese Cultural Revolution: A History* (Cambridge: Cambridge University Press, 2008).

16—— See "Zhonggong zhongyang bangongting yinfa Mao Zedong guanyu dui wai xuanchuan gongzuo de pishi" [Mao Zedong's instructions on foreign propaganda work printed and distributed by the CCP General Office], 12 July 1971, in Song Yongyi, *China's Cultural Revolution Database*.

17—— Several of China's most prominent athletes committed suicide during 1968 owing to intense political persecution; see Daniel Leese, "Zitatgymnastik und Ping-pong-Diplomatie: Zur Instrumentalisierung des Sports während der Kulturrevolution," in Volker Klöpsch, Manfred Lämmer, and Walter Tokarski (eds.), *Sport in China: Beiträge aus interdisziplinärer Sicht* (Cologne: Sportverlag Strauß, 2008), pp. 65–88.

18—— For an introduction to the role of China and the Cultural Revolution in French debates during the late 1960s and early 1970s, see Richard Wolin, *The Wind from the East: French Intellectuals, the Cultural Revolution and the Legacy of the 1960s* (Princeton, NJ: Princeton University Press, 2010).

19—— For several case studies of this period, see Yang Su, *Collective Killings in Rural China during the Cultural Revolution* (Cambridge: Cambridge University Press, 2011).

20—— See "Zhongyang guanyu guoqingjie qingzhu huodong de tongzhi" [CCP Center notice regarding celebratory activities on National Day], *Zhongfa* [1972] 36, 13 September 1972.

④ Food as Metaphor

Alfreda
Murck

W hy should we not be surprised that the mango became a sacred emblem for Mao Zedong? That the mango was used symbolically is completely natural within the practices of the culture. Chinese texts reveal a tradition of looking at edibles and seeing something more, and that tradition continues to the present day. During the chaotic times of the Cultural Revolution, nimble minds found coded messages in even more unlikely objects than the mango. Meat dumplings that were being delivered to an incarcerated person under investigation were said to contain a secret signal. Why? Because two of the dumpling wrappers had broken open, which was said to indicate that two people still on the outside had been exposed (presumably as counterrevolutionaries or capitalist roaders, depending on the time).[1] This interpretation was extreme, but it is understandable given China's fascination with food and its history of creating metaphors.

The practice of reading metaphors in food began in early antiquity. It was closely aligned with selecting food offerings that would content the ancestors, who in turn ensured good crops and general prosperity. Over the centuries authors assembled a rich repertoire of metaphors, symbols, and allegories of edibles. This essay will outline a few of them that are drawn from fruits and vegetables.

The creation of metaphors was facilitated by the ease of punning in the languages of China, which have a plethora of homonyms. For example, "vegetable" *(cai)* sounds like "talent" *(cai)*, and the term for the light-green color *(qingbai)* of many vegetables employs the same characters as "pure and incorruptible." Many metaphors and allegories are auspicious. Some address matters of the heart, but because literate men were seriously interested in the most prestigious occupation open to the educated elite—government service—many more address power relations between sovereign and minister.

Harmonizing the soup

An early metaphor for the relationship between sovereign and official comes from the fifth-century BCE Warring States classic the *Zuo zhuan,* in a passage that makes an important distinction between harmony and assent:

> When the Marquis of Qi returned from his hunt, Yanzi attended him on the Quan Terrace. Ziyou [also known as Ju] drove up to it at full speed. The marquis said, "It is only Ju who is in harmony with me!" Yanzi replied, "Ju is an assenter; how can he be in harmony with you?" "Are they different," asked the marquis, "—harmony and assent?" Yanzi said, "They are different. Harmony is like making a soup. [One uses] water and fire, vinegar, pickles, salt, and plums to cook the fish and meat. These [ingredients] are brought to the boil over firewood, then the cook harmonizes them, leveling out their flavors so as to supply whatever is deficient and carry off whatever is in excess. Then the master eats it, and his mind is made tranquil." [2]

Yanzi analogizes the relations between minister and ruler to harmonizing flavors. The minister tactfully points out improprieties for the ruler to avoid. And conversely, if the ruler resists doing what is proper, the minister emphasizes why it is good to act accordingly and refutes the ruler's reasons for resisting. Yanzi concludes,

> "Now it is not so with Ju. What you approve of, he approves of. What you disapprove of, he disapproves of. This is like flavoring water with water. And who would care to eat that?"

Yanzi likens a sovereign's encouraging a diversity of opinion to a chef's perfecting a soup by judiciously mingling flavors. To listen only to a "yes man" is to lose the benefits of good advice. In the inequitable relationship between all-powerful ruler and humble advisor, this culinary analogy circumspectly but pointedly maintains the view of the vulnerable official. It is metaphor in the service of statecraft.[3]

The millet of Zhou

A foodstuff that vividly evokes loyalty to a fallen regime is millet grain. The brothers Boyi and Shuqi lived at a time of dynastic change in the eleventh century BCE when the Shang dynasty fell to the Zhou. They preferred starvation in the mountains to eating the millet *(su)* that would have come as salary for serving the Zhou usurpers. On Shouyang Mountain the brothers ate ferns, discussed politics, and died paragons of loyalty to the Shang. Their story was kept alive because the second-century BCE historian Sima Qian told it in his *Records of the Grand Historian.* [4]

A similar crisis of loyalty developed when the Manchu overthrew the Ming dynasty (1368 – 1644) and established the Qing dynasty (1644–1911). Talented men had to ask themselves, "Should I serve the foreign Manchu occupiers or resist until Chinese rule is restored?" For Ming-dynasty loyalists, the colorful eighteenth-century handscroll that opens with a stalk of millet may have evoked a reference to the brothers Boyi and Shuqi rather than to the abundant harvests of the Qing Fig.1.

After 1949 the People's Republic of China followed the example of the Soviet Union in using grain imagery to express confidence in the agricultural sector. Bundled stalks of wheat formed into roundels are an important part of the national insignia and convey the idea of abundant harvest.

Stem lettuce

The Tang-dynasty (618–906) poet Du Fu (712–770) cast the distinctive green vegetable "stem lettuce" *(woju,* today known as *wosun)* as a metaphor for the educated gentleman in his poem *Plating Stem Lettuce.* [5] Following the outbreak of the An Lushan rebellion in 755, he and his family fled the warfare. Now, some eleven years later (the rebellion having been suppressed in 763), they were living as refugees in the Three Gorges area of Sichuan and Du Fu was trying to get back to court to serve the emperor.

Looking forward to eating the light-flavored woody stems, Du Fu planted stem lettuce in his garden. A drought broke, with torrential downpours. When next he looked, his garden was overrun by weeds while his prized stem lettuce had not yet sprouted. Du Fu, a scrupulous official as well as a poet, saw in his ruined garden a metaphor of the court: principled officials unable to lift their heads or speak their thoughts while knaves thrived as advisors to the emperor.[6]

To make the meaning of his new metaphor abundantly clear, Du Fu compared the lettuce to established metaphors of probity and purity, such as the orchid. Stem lettuce, the refined hero of his poem, is likened to the cymbidium orchid. Throughout garden metaphors, weeds are cast as nuisances or worse, as despicable, dishonorable, self-enriching pettifogging bureaucrats. Of the weeds, Du Fu wrote, "And so we know how the corrupt harm the upright."

As mentioned above, the use of homonyms—*cai* to suggest both "vegetable" and "talent," *qingbai* to suggest both the color of green vegetables and "pure and incorruptible"—was carried further by Song-dynasty scholars, who used green vegetables' color, scent, and taste as powerful metaphors.

The pallor of people near starvation was likened to the pale green color of vegetables. Conversely, officials indulging in extravagant cuisine (i.e., were not eating simple vegetables) were forgetting the needs of their people. If an official daily ate vegetables, he was more likely to understand how people in his jurisdiction felt. In an aphorism on the art of good governance, the compassionate, responsible official was juxtaposed with the underfed populace: "Scholar-officials should not for a day be without this flavor; the people must not for a day have this color." The Song-dynasty scholar Luo Dajing (died after 1248) recorded this passage and appended a commentary: "I say, if the people have this color, then the reason is that scholar-officials do not know this flavor."[7] Luo added that if those who serve in high office chewed on vegetable stems, then they would truly understand their official duties, and the common people would therefore have adequate food.

Bamboo shoots

Spring bamboo shoots were plentiful in the countryside. Officials, when stationed in remote posts or banished to remote places, discovered these simple pleasures. Bai Juyi (772–846), a Tang-dynasty official and man-of-the-people, wrote enthusiastically about consuming bamboo shoots:

> This county is a veritable hometown of bamboo—
> Spring sprouts cover every hill and valley.
> A man from the hills cuts himself an armful,
> To carry to morning market.
> Things are cheap for being plentiful:
> Two cents will buy a whole bunch.
> I pop them into the cooking pot,
> And they're ready by the time the rice is done.
> Purple sheaths shredded like ancient brocade,
> Pale flesh splits open like newfound jade.
> And so every day I make a meal of them,
> Through their whole season I yearn not for meat. [8]

Bai Juyi concludes his poem with a recollection of his service in the Tang-dynasty capitals Chang'an and Luoyang where, working at the court, he could not buy many fresh bamboo shoots. He plans to indulge in this succulent country fare before the shoots grow into bamboo. The simplicity and wholesomeness of country life is thus contrasted favorably with life at court.

Continuing the celebration of bamboo shoots is a prose-poem by the famous calligrapher Huang Tingjian (1045 – 1105). Huang had a tumultuous career in the Northern Song (960 – 1127) imperial bureaucracy. His most satisfying appointment was as drafter of the history of the previous reign. Later that became a source of misfortune: at a time when the imperial court was sensitive to criticism and banished many prominent officials to remote places, he was accused of sarcasm and exiled to southern Sichuan. While in Rongzhou in mountainous southern Sichuan, Huang wrote a prose-poem averring that bitter bamboo shoots are good for people, just as "bitter" advice is good for the government:

1

2

1 *Flowers, Vegetables, and
Fruit* (detail), anonymous (spurious
signature of Xu Chongsi [11th cen-
tury]), Qing dynasty, 18th century,
handscroll, ink and color on silk, The
Art Institute of Chicago, Lucy Maud
Buckingham Collection
2 Teapot with red chili pepper,
around 1966–1970, porcelain,
Collection Alfreda Murck, Beijing
3 *Excellent Vegetable*, anony-
mous, late Yuan or early Ming
dynasty, 14th–15th century, ink on
paper, The Freer Gallery of Art,
Washington D.C., Gift of Charles
Lang Freer

3

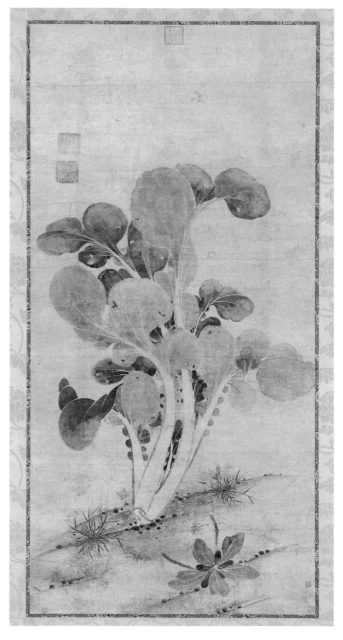

Excessively fond of [opinions like] bitter bamboo shoots
such that ten people criticize me, I playfully write "Bitter
Bamboo Shoots." The words are:
The bitter bamboo shoots of Bodao [another name for
Rongzhou] are the best in Liangchuan. Piquant and crisp,
they are incredibly satisfying. They are a little bitter but
still delicious. Mild, fine, and dense, one can eat many at
a sitting without getting sick.

Huang Tingjian then uses an ancient premise of herbal
medicine: if the concoction is not bitter, it will not do the
patient any good:

The bamboo shoots are bitter but flavorful, like loyal
remonstrance that enlivens a country; much [criticism] need
do no harm, just as scholars thereby all become wise.
Because the shoots absorb the essence of rivers and
mountains, they can grow strong in the rain and dew and
not be hurt by strong winds. At banquets they are used
as an appetizer; for wine drinkers they are a mouth-water-
ing snack. [Milder tasting] Cassia-rose and Menggong
bamboo shoots also can be had here, yet they can never
compete [with the bitter kind].

The people of Shu say that bitter bamboo shoots are not
fit for eating. If eaten, they will revive old diseases and
make people thin and weak. I, however, have never [refused]
them. By the same token, superior officials don't talk,
but [intuitively] know. Average officials when in court appear
to agree, but on leaving court fall into confusion [and
disagreement]. Pedestrian officials believe everything they
hear, but not the evidence before them; their thickhead-
edness cannot be penetrated. Li Taibo once said, "Enjoy
being drunk; never offer the sober an explanation."

Huang likens the frank opinions that got him into po-
litical trouble to the wholesome bitterness of "medici-
nal" bamboo shoots. The ability to enjoy and derive
health from bitter bamboo shoots is analogized with
the government's ability to accept and benefit from un-
pleasant criticism in Huang's droll prose-poem. Huang
Tingjian's holograph of this prose-poem is extant. It is
undated but stylistically consistent with other works
written during his exile in Sichuan.[9]

Lichees

In the eighth century, during the Tang dynasty, the gorgeous concubine Yang Guifei so loved the succulent lichee that the doting emperor Minghuang (r. 713–755), to please her, had them couriered from southern China to the capital at Chang'an (present-day Xi'an). The lichee thus became a symbol of indulgence and conspicuous consumption at court.

For those living in the distant south, however, lichees were a commonly available tropical treat. When the Song scholar-official Su Shi (1037–1101) was exiled to Huizhou in Guangdong Province, he enjoyed ripe tangerines, plums, and lichees daily. Su Shi wrote a long poem mentioning the Han court requisitioning lichees from Jiaozhou (in present-day Guangxi Province), and the Tang emperor Minghuang supplying concubine Yang Guifei with lichees from Fuzhou (in present-day Sichuan Province). [10] At about the same time, reflecting on these delicacies, Su Shi wrote the following quatrain:

> Beneath Luofu Mountain are four seasons of spring,
> Here my tangerines and plums are fresh one after another.
> Every day I can eat three hundred lichees,
> I won't mind a long stay as a man of Lingnan. [11]

To those detractors who wanted to see Su Shi suffer in his southern exile, his description of the mild seasons and delicious fruit of southern China may have felt like a taunt. Not only was Su removed from the hazards of court infighting, he could routinely enjoy fruits that were a rare luxury in the capital.

In another poem, also written in exile in Huizhou, Su Shi pondered his future. Su did not want to end like the Tang-dynasty official and poet Liu Zongyuan (773–819), who died while in distant southern exile in Liuzhou, Guangxi Province. Red lichees were left on altars to him. Su Shi wrote, "I do not aspire to be like the sagely Liu of Liuzhou,/At whose shrine people leave dishes of red lichee." [12]

Su did not want to become the center of a cult, but that is exactly what happened. Over six hundred years later, in the eighteenth century, Su Shi became

the focus of a cult, which was quietly patronized by Weng Fanggang (1733–1818) and other Chinese scholars who were at a serious disadvantage competing in the Manchu-controlled bureaucracy. Weng composed a poem for a small painting by Luo Ping (1733–1799) that depicted Su Shi's home on "White Crane Peak." [13] Weng wrote, "The meaning of this cannot be transmitted; the lichees were not for eating." Notwithstanding the gusto of Su's "Every day I can eat three hundred lichees," to Weng Fanggang the lichee belonged on an altar, an object of worship. This concept anticipates the treatment of the mango in 1968. The mangoes that were gifted by Mao became objects to be revered by those who worshipped him.

Lichees, combined with other plants and objects, lent themselves to multiple puns and combinations of puns. In Chinese the name of the fruit is pronounced *li zhi,* which can denote "cleverness," "benefit," and "to establish," as in "to establish sons." *Lizhi* paired with water caltrop *(ling)* and sacred fungus *(lingzhi)* can be read as "It is better to be foolish than clever" *(lingli bu ru chi).* That reading is based on a sarcastic poem by Su Shi in which he remarked that most parents want bright sons, and yet his intelligence had brought him only catastrophes. A stupid son had a better chance of career advancement, since stupidity serves well in high office. [14] This outspokenly sarcastic view of the imperial bureaucracy was exactly what got Su Shi into trouble.

The colorful parade of fruits, grains, and vegetables in the handscroll in The Art Institute of Chicago Fig. 1 is probably datable to the late eighteenth or early nineteenth century. What was the artist thinking when he assembled these images? The title sheet dated 1802 places the assemblage in the tradition of verisimilitude *(xie sheng),* which was traditionally held in contrast to metaphorical scholar paintings *(xie yi).* Is it an accident that bamboo shoots, which call to mind cultural heroes such as Bai Juyi and Huang Tingjian, are juxtaposed with red lichees that evoke Liu Zongyuan and Su Shi? It is a delightful visual feast and might be a series of visual puzzles as well.

Melons, peapods, and beans

The melon season *(guashi)* suggested a brief term of service, usually less than a year. It comes from the story of two men who were assured that they would be relieved of duty by the next time melons ripened. But at the next melon season they were not relieved of their guard duties and were left facing an indefinite time far from the cosmopolitan center. They then plotted to rebel. [15] In most occurrences of the term *guashi* in poetry, however, the theme of rebellion was weaker by far than that of frustration born of being trapped in a situation that seems endless. Du Fu uses *guashi* in lamenting that he still had to seek patronage as he had the year before: "But at this melon season, I am again sojourning/Floating like duckweed, bitter at having to creep and climb." [16]

Peas in fuzzy, inedible pods figure prominently in a famous quatrain composed by Cao Zhi (192–232) literally to save his life. The earliest record of the poem is in the circa fourteenth-century novel *Romance of the Three Kingdoms*. Cao Zhi and Cao Pi were both sons of Cao Cao and Lady Bian. After their father died, Cao Pi took the throne and schemed to eliminate his talented younger brother Cao Zhi. In an evocative scene in the novel, Cao Pi, jealous of Cao Zhi's literary talents, challenges Cao Zhi to compose a poem in the time it takes him to walk seven steps. If he fails, he faces execution. Cao Zhi brilliantly rose to the taunt and recited the following:

> They were boiling beans on a beanstalk fire;
> Came a plaintive voice from the pot,
> "O why, since we sprang from the selfsame root,
> Should you kill me with anger hot?" [17]

The "Seven Step Poem" became a reference to unseemly conflict between siblings. Brothers growing from the same stalk ought not to feud. Although they may have different talents and be in competition, ultimately they must recognize their common heritage.

Mangoes, peaches, and peppers

Since antiquity peaches were associated with the Queen Mother of the West. In her garden grew magical peach trees that fruited only once a millennium. Called "longevity fruit" *(shou guo,* or "longevity peach," *shou tao)*, the peach came to symbolize the wish for a prolonged healthy life. To be wealthy or fortunate enough to consume a peach ensured this outcome.

During the Cultural Revolution the attributes of the auspicious peach were appropriated for the mango. Because mangoes did not grow in central China, where literary metaphors were crafted, they were free of "feudal" cultural associations. After Mao presented mangoes to the workers, they became an emblem of Mao Zedong's love and concern. The exoticism of the mango allowed it to be molded to fit the circumstances.

The absence of established literary meanings encouraged mythologizing. A rumor circulated that mango trees—like the peach trees in the garden of the Queen Mother of the West—fruited only once every century, some said once every thousand years. Thus mangoes were called Thousand-year Fruit. Precious beyond imagining, they could ensure a long life, and yet Mao Zedong had not eaten them but had given them to the workers. Giving them away confirmed Mao's selflessness; giving them to workers attested the importance he placed on the political mission of the working class. Other than entrusting them with his Highest Directives, Mao had never before given a gift to the workers. Because Mao had not eaten them, the recipients did not eat them but strove to preserve them as a tangible emblem of his high regard for the working class. Like the longevity peach, the mango also became a wish for long life, specifically for Mao's long life.

Mango was not the only addition to food symbolism in the second half of the twentieth century. Red chili pepper as an indicator of revolutionary spirit was another Fig. 2. Mao Zedong, who grew up loving the spicy food of his home province, Hunan, famously declared that only those who could eat chili peppers could make great revolutionaries. More than one enthusiast

choked trying to demonstrate his revolutionary credentials. In 1958 Mao issued his chili pepper challenge to Soviet guests:

> "Since red represents revolution," Mao said, "let's form a Red Pepper Party to show our loyalty to Communism. Anyone who can consume a red pepper will be our comrade." His Russian guests did not realize the pepper was burning hot and were shocked when they chewed a whole red pepper, finding it nearly unbearable. Nikolai A. Bulganin (1895–1975), who first responded to Mao's call to chew a red pepper, "almost passed out, coughing and choking, [engulfed in] tears and with a running nose, he couldn't speak a word." Khrushchev called Mao's trick as barbaric as that of a Tartar. Fedorenko, who served as interpreter for the delegation, was prudent enough not to translate the unfriendly comment. [18]

If the chili pepper was burning hot, the mango was ineffably sweet. Arriving at a turning point in the Cultural Revolution when the students were replaced by the working class, the mango brought excitement to a dry propaganda campaign. It added golden hues to the reds of the revolutionary pepper, the rising sun, and the People's Republic of China flag. Promoted by the propaganda department as a symbol of Mao's support for the working class, the mango campaign would not have succeeded had there not been a groundswell of enthusiasm from the workers who received them, or cultural precedents stretching back almost three millennia. Even intellectuals who scorned "the precious gift of the mango" readily acknowledged that it fulfilled an important role in providing a focus for ideas much larger than itself.

1–– Yan Jiaqi and Gao Gao, *Turbulent Decade: A History of the Cultural Revolution,* trans. and ed. by D. W. Y. Kwok (Honolulu: University of Hawai'i Press, 1996), p. 264.

2–– James Legge, *The Chinese Classics, Tso chuan,* Chao 20 (521 BC) (reprint, Taipei: Southern Materials Center, 1985), vol. 5: pp. 679, 684.

3–– Ibid. p. 684.

4–– Sima Qian, *Records of the Historian: Chapters from the Shih chi of Ssu-ma Ch'ien,* trans. Burton Watson (New York: Columbia University Press, 1969), "Shih chi 61: Biography of Po Yi and Shu Ch'i," pp. 11–15.

5–– "Planting Stem Lettuce *(Zhong woju),*" in Qiu Zhaoao (ed.), *Du shi xiangzhu* [Annotated Poetry of Du Fu], 5 vols. (Beijing: Zhonghua shuju, 1985), 15:1347.

6–– The "center of his garden" *(zhong yuan)* is a homonym for "Central Plain," which was another way of referring to the imperial court; Alfreda Murck, "Paintings of Stem Lettuce, Cabbage and Weeds: Allusions to Tu Fu's Garden," *Archives of Asian Art,* vol. 48 (1995), pp. 32–47.

7–– Luo Dajing, *Helin yulu* [Conversations at Helin], in *Congshu jicheng xinbian* (reprint, Taipei: Hsin Wen-feng, 1985), vol. 87, p. 139; *juan* 9:100.

8–– Bai Juyi, "Eating Bamboo Shoots," trans. Alice W. Cheang, in "Poetry, Politics, Philosophy: Su Shih as the Man of the Eastern Slope," *Harvard Journal of Asiatic Studies,* vol. 53, no. 2 (December 1993), pp. 325–387, with a couple of lines from Stephen Owen's translation in *Anthology of Chinese Literature* (New York: Norton, 1996), pp. 499–500.

9–– Huang Tingjian's "Bitter Bamboo Shoots," National Palace Museum Taipei, is undated; contemporary authority Fu Shen dates it to the spring of 1099, the year after Huang was sent to Rongzhou. Shen C. Y. Fu, "Huang T'ing-chien's Calligraphy and His Scroll for Chang Ta-t'ung: A Masterpiece Written in Exile" (Ph.D. diss., Princeton University, 1976), pp. 52–53. See *Gugong fashu* (Taipei: National Palace Museum, 1962), vol. 10–1, p. 35, eleven lines of small running script.

10–– Su Shi, "In Praise of Lichees *(Lizhi tan),*" in *Su Shi shiji,* vol. 7, *juan* 39, pp. 2126–28. Qian Xuan (ca. 1235–after 1302), *Lizhi,* handscroll, ink and color on silk, followed by a boldly written colophon by Wen Zhengming (1470–1559) transcribing Su Shi's "In Praise of Lichees," in *Gugong shuhua tulu* (Taipei: National Palace Museum, 1997), vol. 16, pp. 417–42.

11–– Trans. Kathleen M. Tomlonovic, "Poetry of Exile and Return: A Study of Su Shi (1037–1101)," (Ph.D. diss., University of Washington, 1989), p. 167. "On Eating Lichee *(Shi lichi),*" poem #2, in *Su Shi shiji,* vol. 7, *juan* 40, pp. 2192–93. Luofu Mountain is in Huizhou, Guangdong Province.

12–– Su Shi, "Moving House *(Qian qu),*" in *Su Shi shiji,* vol. 7, pp. 2194–2196.

13–– The album containing Luo Ping's painting is discussed in Kim Karlsson, Alfreda Murck, and Michele Matteini (eds.), *Eccentric Visions: The Worlds of Luo Ping (1733–1799)* (Zurich: Museum Rietberg, 2009), cat. no. 32, pp. 232–237 and p. 83.

14–– Terese Tse Bartholomew, *Hidden Meanings in Chinese Art* (San Francisco: Asian Art Museum of San Francisco, 2006), p. 73, 3.19.4. See also entries 6.27 and 8.19. Su Shi, "Bathing My Son, Playfully Written *(Xi er xizuo),*" in *Su Shi shiji, juan* 47, p. 2535.

15–– *Zuo zhuan* (Duke Zhuang, eighth year), in Legge, *The Chinese Classics*, vol. 5, pp. 81–82.

16–– Du Fu, "Autumn Day in Kui Prefecture, a Song Submitted to Supervisor Zheng and Adviser Li in One Hundred Rhymes *(Qiuri Kuifu yonghuai fengji Zheng Jian, Li Binke, yibai yun),*" lines 35–36; see Alfreda Murck, *Poetry and Painting in Song China: The Subtle Art of Dissent* (Cambridge, MA: Harvard University Asia Center, 2000), p. 89.

17–– Luo Guanzhong, *Romance of the Three Kingdoms,* trans. C. H. Brewitt-Taylor (reprint, Taipei: Wen-hsing shu-tian, 1966), vol. 2, chapter 79, p. 198.

18–– Hanchao Lu, "Mao and Food Culture: The Quotidian as Statecraft in Chinese Politics," paper presented at AAS Annual Meeting, Honolulu, 2 April 2011, citing the memoire of Nikolai Trofimovich Fedorenko (1912–2000). A Russian Sinologist and diplomat, Fedorenko served as an interpreter for Stalin and Khrushchev and was the Soviet ambassador to the United Nations from 1963 to 1968. In China his memoire was published under his Chinese name: Fei Delin, *Fei Delin huiyi lu: wo suo jiechu de Zhong Su lingdao ren* [Memoirs of Fedorenko: The Chinese and Soviet leaders with whom I had contact] (Beijing: Xinhua chubanshe, 1995), pp. 146–148.

⑤ Political Awakening through the Magical Fruit: The Film *Song of the Mango*

Adam
Yuet
Chau

S ong of the Mango (Mangguo zhi ge) was made in 1976 by the Chang-chun Film Studio, and adapted from a short story entitled *The First Lesson (Diyi ke)* by Gu Yu.[1] Though fictional, this feature film portrays events during the mango-fever period in a socialist-realist style that highlights the relic qualities and iconic uses of Mao's mangoes.[2] The characters and the plot might be allegorical, but enough of the details of the events are realistic for the film to serve as an ethnographic portrayal of that particular time.[3] Below I provide a summary of the film, situate the film in its political context, and then analyze some of the pertinent themes (illustrated by screen shots).

The story is set in the late summer of 1968, not long after Mao gave the mangoes to the Workers' Propaganda Team that had just occupied the Qinghua University campus. In the fictional southern city of Linxi ("Between the Streams") various factories were also organizing workers' Mao Zedong Thought Propaganda Teams to be sent into schools and other institutions. Their task was to occupy the "superstructures," i.e., the institutions charged with forming people's minds, such as schools, publishing houses, film studios, radio stations, theater and other performing troupes, so as to carry out Mao's political program of "struggle, criticize, and reform" *(dou, pi, gai).*[4] Xia Caiyun, a middle-aged female worker and senior Party member at the Linxi City Sixth Textile Factory, was the leader of her factory's propaganda team, serving as its "political commissar." The team marched into the Oriental Textile Industry University, its aim to end the

1 The Workers' Mao Zedong Thought Propaganda Team marches along the city streets on their way to the Oriental Textile Industry University campus.

2 The Workers' Propaganda Team organizes a mass rally on campus to criticize the bourgeois revisionist "line" in education.

virulent conflicts among the various Red Guard factions (the Red Rebels Headquarters [*Hongweisi*], the Learn from Workers and Peasants Rebel Army [*Xuegongnong zaofan bingtuan*], the Storm and Thunder Rebel Army [*Fenglei zaofan bingtuan*]), etc., and to consolidate class struggle Fig. 1.

It just so happened that Xia Caiyun's twin daughters, Zhou "Little Twin" and Zhou "Big Twin," were prominent leaders of two of the factions. Big Twin and her comrades-in-arms in the Storm and Thunder Rebel Army, as well as other factions, were willing to accept the Workers' Propaganda Team's leadership, but Little Twin and her comrades-in-arms in the Red Rebels Headquarters, who were being manipulated by a certain Nie Jialiang, resisted the worker representatives.[5] A middle-aged male revisionist educator and cadre at the university, Nie feared that the workers would take control of the university. In the earlier phase of the Cultural Revolution Nie had been labelled a "capitalist roader" by the Red Guards and was "struggled" against, but he had shrewdly submitted a self-criticism letter to the Red Rebels Headquarters faction, then the dominant faction, and as a result was rehabilitated and regained power. He became the advisor to the Red Rebels Headquarters and a behind-the-scenes manipulator. After many twists and turns of the plot, including violent confrontations (though the violence is not explicit in the film), the taking and releasing of hostages, and teary testimonies and confessions, Xia Caiyun called for a mass struggle rally Fig. 2 of all the students and staff of the university, and there she exposed the conspiracies of the capitalist-class revisionists. All members of the rival factions finally came together to form a "great union" after the students and others recalled that their true mission was to reassert the necessity of proletarian class dominance and to fight against revisionists and capitalist roaders. The film ends with the whole city celebrating the arrival of Mao's mangoes into Linxi City. A procession of thousands of students, workers, and other residents welcomes the mangoes and parades them around the city.

The political context

In essence *Song of the Mango* is a celebration of the working class and Mao's visionary politics, but its being filmed in 1976 about an event in 1968 warrants careful consideration of the political context. The 1970s, up to the arrest of the so-called Gang of Four in October 1976, were marked by intense struggle between the radical Leftists, headed by the Gang of Four (led by Jiang Qing, known in the West as Madame Mao) and supported by Mao, and those Communist Party leaders who wished to follow a much milder path of revolution, emphasizing economic development and people's welfare. The leader of the moderate faction was Deng Xiaoping, who was purged during the early years of the Cultural Revolution but rehabilitated and groomed as his successor by the ailing Premier Zhou Enlai in 1974. But Mao and the radical Leftists, unhappy with Deng's economism and fearing that the legacy of the Cultural Revolution would be lost or even subverted, launched a new wave of political campaigns to reassert the importance of class struggle and "following the right line."

This struggle was fiercest in the realm of the arts and the inevitable ideological criticisms of the arts. From the beginning of the Cultural Revolution in 1966, Jiang Qing had been hailed as the "standard-bearer of the arts" and the Gang of Four had almost completely controlled such ideological apparatuses as newspapers and publishing. Any artistic production that did not fully meet their ideological requirements was immediately and widely attacked in editorials, reviews, and other "theoretical writings." One such film is directly relevant to our discussion of *Song of the Mango.*

In 1974 a film entitled *Song of the Gardener (Yuanding zhi ge)* was released. [6] Its format was that of Hunanese opera. Its story was that of a female teacher who patiently and successfully transformed a rebellious pupil into someone who understood the importance of knowledge in the task of realizing socialism. The teacher was likened to a gardener, "growing" the next generation of revolutionaries. The film was intended to highlight the importance, and the challenge, of "revolutionizing education." But on viewing *Song of the Gardener* in her private screening room, Jiang Qing became infuriated. She sensed a conspiracy behind likening the teacher to a gardener. How could the gardener be anything other than the Communist Party? How could a "stinking number nine" *(choulaojiu)*—the abusive term for intellectuals and teachers during the Cultural Revolution—be a heroine? How could the film celebrate book-learning when the correct ideological stance was to despise bourgeois knowledge? Jiang Qing began to orchestrate attacks on the film, accusing it of attempting to impugn the legacy of the Great Proletarian Cultural Revolution and to glorify counter-revolutionary, revisionist education. Her campaign, however, hit a most unexpected stumbling block. Finding it attacked by Jiang Qing and her associates, Mao decided to see this film himself while on a convalescence trip back to his home province, Hunan, at the end of 1974, and apparently thoroughly enjoyed it (perhaps not only because it was in his own Hunanese

dialect). In any event, he pronounced it a good film. For the moment Jiang Qing had to call off her smear campaign.

At the end of 1975 Mao, alerted to the recently rehabilitated Deng Xiaoping's "economicist" policies, again stripped Deng of authority. Taking advantage of this new campaign against the right-leaning revisionist elements in the top echelons of the Party, Jiang Qing launched a fresh attack on *Song of the Gardener.* At the same time she commissioned a number of films as a counteroffensive, among them *Song of the Mango.* The choice of a title to parody *Song of the Gardener* was deliberate, especially since the ideological messages of the two films are diametrically opposed. The title was also meant to evoke a song of the same name, composed in 1969 and briefly wildly popular, about Mao's gift of mangoes.[7]

The film *Song of the Mango* is a heavily dramatized adaptation of a short story by Gu Yu entitled *The First Lesson.* It was first published in 1973 in the Gang of Four–controlled literary monthly *Dawn Radiance (Zhaoxia)*—published in Shanghai but with nationwide submissions and distribution—in response to the journal's call for literary works that depicted class struggles during the Cultural Revolution.[8] In 1975 *The First Lesson,* together with many other "politically correct" works previously published in *Dawn Radiance,* including poems, essays, and plays as well as short fiction, was anthologized in a 500-page volume entitled *Prelude (Xuqu).* All of *Prelude's* contents were supposed to focus on the Cultural Revolution and the central themes of class struggle and struggle over the correct "line." The anthology enjoyed a large printing, wide distribution, and substantial sales.

Gu Yu's story took up a mere twenty-six pages in the anthology. Even though the plot outline was more or less faithfully reproduced in the film, the original story was much simpler, with no named villain, no violent confrontation, and fewer narrative twists. But most relevant for our discussion is that, even though the story concerns the Workers' Propaganda Team's entry into the university campus, it makes no mention whatsoever of Mao's gift of mangoes. The script writers grafted Mao's mangoes onto the original story to enhance the legitimacy of the Workers' Propaganda Team and to add emotional and uplifting opening and closing sequences.

3 Xia Caiyun, textile-factory worker and political commissar, addressing a crowd of coworkers just after returning from a political studies class organized by the municipal government and on the eve of the factory workers' Mao Zedong Thought Propaganda Team's march into the university. It is here, at the opening of the film, that Xia Caiyun reveals Mao's gift of the mangoes to the Workers' Propaganda Team occupying the Qinghua University campus in Beijing (the first of such occupations).

4 Xia Caiyun addresses the students and the masses at the big rally on the lawn of the university campus to "thoroughly condemn the bourgeois revisionist educational line." Note the low camera angle.

The good versus the bad

The plot of *Song of the Mango* is strung on the series of struggles between the good, epitomized by Xia Caiyun, and the bad, personified by Nie Jialiang. The cinematic portrayal of these two central characters helps to establish the opposition not just between these two individuals, but between what they represented: the revolutionary path as directed by Chairman Mao versus bourgeois reaction and conspiracy for a revisionist comeback.

As was standard in all genres of art and literature during the Cultural Revolution (including theater, films, and propaganda posters), the directors adhered to the "three prominents" principle— "red, shiny, and bright" *(hong, guang, liang)* and "tall, large, and complete" *(gao, da, quan)*—in presenting the proletarian paragons. According to the "three prominents" principle, as promulgated in 1968 based on Jiang Qing's directives, among all the characters in any work of art the positive characters must be made prominent, among all the positive figures, the heroic figures must be made more prominent, and among all the heroic figures, the central figure must be made most prominent.[9] In other words, the leading hero or heroine must have an overwhelming share of the scenes and lines in a film or play. According to "red, shiny, and bright," the heroes and heroines must always be presented in warm colors, especially red and gold (as in the sun's rays); they must always be facing the light, with no shadows cast on their faces, and they must radiate light and brightness. According to "tall, large, and complete," they must always appear tall and imposing, exuding both righteousness and power (hence the frequent use of low camera angles so as to make them tower over the rest of the cast, and full closeups so that they fill the screen) Figs. 3, 4; and their characters must always be impeccable, without flaws or weaknesses.

The opposite principles were applied to the villains. Villains must be portrayed in cold colors (especially black) and in shadows or dark corners. Their faces must be dark and somber, suggesting that they are evil and scheming; their stature must appear small, suggesting that they are petty, weak, not to be feared, and easily subjugated by proletarian dictatorship. Nie Jialiang, the villain in *Song of the Mango,* is portrayed in this way. He is usually found in his room, which looks like a work-unit dormitory or office, pacing and plotting his next move. The room is darkened by light-occluding dark curtains, the telephone is black, and there are shadows everywhere Fig. 5.

Nie Jialiang also appears isolated, an important aspect of villainy always to be highlighted, since according to Cultural Revolution theory, the villains are always few *(yixiaocuo,* literally a "pinchful"), though they might be in positions of power *(dangquanpai),* requiring denunciation and "struggle against" *(pidou).* When Nie Jialiang is with other people, he is invariably corrupting youth and fanning the flames of factionalism and chaos, his ultimate aim being to drive out the Workers' Propaganda Team Figs. 6–8.

5 Nie Jialiang pacing his room, plotting his next move. Note the dark tones, the many shadows, and the dark corners.

7 Nie Jialiang persuading a young teaching assistant (Yang Yangming, literally, Yang "Become Famous") that only academics should run the university and that workers should go back to the factories instead of disrupting proper education. He feigns sympathy that the Cultural Revolution has blocked Yang's promotion to lecturer.

6 Nie Jialiang inveigling Huang He, a naively trusting and thoughtlessly brave Red Guard, into stirring up trouble at crucial moments.

8 Nie Jialiang at the big criticism rally toward the end of the film. The image suggests that he is trying to hide among the revolutionary masses, but at the same time he stands out because of his dark-colored clothes.

Mao as the source of revolutionary legitimacy

In *Song of the Mango,* the people representing the good and the right drew their strength to fight the bourgeois revisionists from Chairman Mao himself. Chairman Mao was evoked either visually or orally dozens of times in the film. Indeed, the Workers' Propaganda Team members derived their revolutionary legitimacy from Chairman Mao's decision to occupy university campuses and other similar "superstructures." When the Chairman is mentioned, faces glow with a look of transport, and everyone present appears ready to follow the Great Helmsman in whatever battle he dictates and against whomever he is declaring a class enemy Figs. 9–13.

Reconciliation between factions and the Great Unification

As discussed above, the contrast between the good and the bad in the film had to be utterly clear cut: the workers are incorruptibly good, the revisionists and bourgeois-minded, capitalist-roader intellectuals are unrepentantly bad. But to add drama and plot twists, persons of a certain ambiguity are introduced: people who are essentially good but have been manipulated by the villains into mistaken thought and actions (these mistakes all prove to be grave, since all mistakes have ideological implications). So the ultimate triumph of the good people over the bad, which occurs toward the end of the film, is to win back these good but unwittingly corrupted people to the "correct" way of thinking Figs. 13–20.

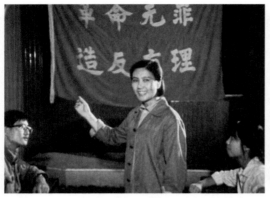

9　Xia Caiyun reminds the Red Guard "little generals" how they were all of one mind when they began the Cultural Revolution—to challenge and depose the reactionaries from their positions of power—and how they have deviated from the true path by factional fighting and allowing themselves to be manipulated by bad elements. The red flag in the background is the battle flag of the Red Guards, embroidered with the famous Cultural Revolution battle cry bestowed by Mao: "To make revolution is no crime. To rebel is justified." Xia Caiyun reminds the Red Guards that it was the factory workers who embroidered the characters onto that flag before the Red Guards marched to Beijing to see Chairman Mao, demonstrating the hope that the working class put in the younger generation.

11　Xia Caiyun reads aloud passages from Mao's collected works as the leader of the Workers' Propaganda Team, Master Tang, looks on. She later reveals in the film that she began working in textile factories when she was only twelve years old, a child laborer, and only became literate after Liberation (i.e., the founding of the People's Republic of China in 1949).

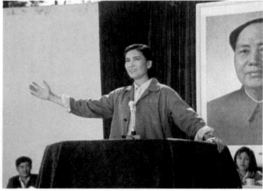

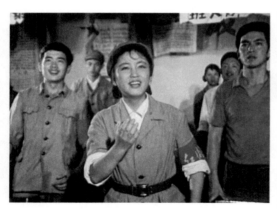

10　Zhou "Little Twin," nicknamed "Little Cannon" because of her hot temper and fighting spirit, recalls the moment when Chairman Mao met with the Red Guards on Tiananmen Square. Note the rapt expressions on the faces of the Red Guards.

12　Xia Caiyun addresses the crowd at the big rally toward the end of the film, just before the mango procession. Note, at the back of the stage, the giant portrait of Mao, from whom Xia Caiyin draws her energy and legitimacy. None too subtly, the portrayal of Xia Caiyun hints at the possibility of female leadership in a post-Mao world. This is achieved cinematically by first showing Xia Caiyun in front of the giant Mao portrait and then having the camera pan and zoom toward her until the image of Mao is no longer in the frame and Caiyun fills the screen with her dramatic "I lead, you follow" gesture (see also Fig. 4).

13 Liu Xiaozhou, a Red Guard in the Red Rebels Headquarters faction, hurt a member of the Workers' Propaganda Team with a brick, and was fearfully anticipating punishment by the Propaganda Team. Instead, Xia Caiyun invokes his bravery against "bad people" at the beginning of the Cultural Revolution and proposes to educate rather than punish him, since punishing him would be falling into the trap of the enemy, who wishes to stir up conflicts among the revolutionary masses. Duly moved, Liu Xiaozhou rushes out of his hideout, greets Caiyun, and in tears admits his misdeed. This scene is followed by Caiyun speaking in front of the Red Guards' battle flag (see Fig. 9).

14 When challenged at the big rally by trouble-making Red Guards about the workers' right to direct university affairs and education, Xia Caiyun tells a story of the poisoning of working-class minds by bourgeois education. Twenty-some years earlier, in the pre-Liberation era, Caiyun (standing, in pink) and Ah Xiu (on the right with headband) both worked in a textile factory. Ah Xiu's husband, also a worker, was crushed to death by a machine. Ah Xiu gave birth to a posthumous baby boy but had to give him up in order to keep her job. Fortunately Chunhua, a peasant woman (center with blue headscarf), agreed to adopt the baby. The boy was named Daxing, literally "Great Fortune" (but connoting "narrow escape," since he could have been a victim of infanticide). Chunhua raised Yang Daxing in the liberated areas (i.e., areas under Communist control) where he could go to school, a luxury inaccessible to a peasant boy in the unliberated areas. Eventually Chunhua sent Daxing off to secondary school in the city. It turned out to be the last time she saw him.

 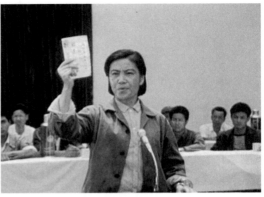

15 Chunhua writes to Daxing that she has become very ill, but Daxing writes back saying he can't possibly come back to visit his mother, since he has just finished university and been assigned a teaching job, and moreover, he has never mentioned to anyone that he has a peasant mother. His great aspirations preclude letting people know about his humble background. In this scene Chunhua, on her sickbed and holding Daxing's letter, laments to Ah Xiu (Daxing's birth mother) and begs her to "bring him back" (to the good boy that he used to be). Chunhua dies grieving.

16 Back to the big rally after the flashback, Xia Caiyun holds up the letter Daxing wrote to his adoptive mother and asks: Is the story of Daxing merely the misfortune of one family? How many children of working-class and poor peasant background have been poisoned by bourgeois educational ideology? Can we afford to let bourgeois revisionist education continue?

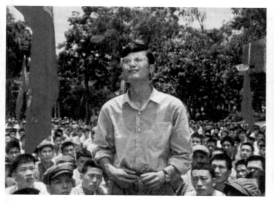

17 In the audience teaching assistant Yang Yangming ("Become Famous"), the one who has been influenced by Nie Jialiang, begins to weep and cries out "mother" (mama). He confesses before the masses that he is Yang Daxing, the young man who had been poisoned by the bourgeois revisionist education "line" and had forgotten his class roots.

19 After a round of excited slogan shouting, the twin sisters reconcile. Wayward "Little Twin" is in tears, showing that she has recognized her past mistakes and repented her opposition to the Workers' Propaganda Team and allowing herself to be manipulated by bad people.

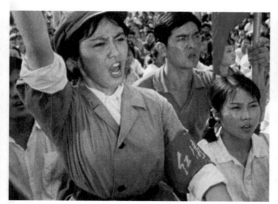

18 A sure sign of reconciliation and the reaching of some kind of shared understanding and collective will is the mass shouting of revolutionary slogans. Here, at the conclusion of the mass rally, Zhou "Little Twin" leads the slogan-shouting in enthusastic response to Xia Caiyun's call to follow Mao's "strategic planning" (zhanlue bushu).

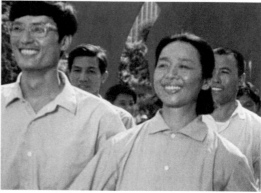

20 Yang Daxing joins arms with his birth mother, Ah Xiu, in the mango parade at the end of the film, symbolizing his return to the fold of the working class.

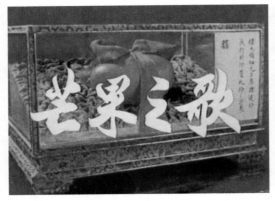

21　The opening of the film features a mango in a glass vitrine along with the title in big characters.

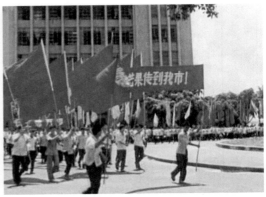

23　Revolutionary masses in procession in the city center. The banner reads: "Enthusiastically welcome the mangoes, Chairman Mao's precious gift, that have passed to our city."

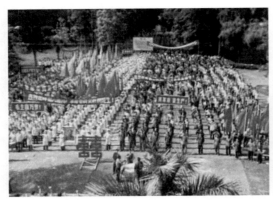

22　The film opens with the large rally in front of the city government building, celebrating the establishment of revolutionary committees at all the work units in Linxi City. The Sixth Textile Factory workers, mostly women, form the columns in white uniforms.

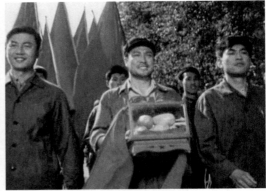

24　Master Tang, the leader of the Workers' Propaganda Team, heads the procession holding the mangoes in a reliquary-like glass case.

Mangoes as symbol in *Song of the Mango*

Ultimately it was Mao's mangoes that gave the Workers' Propaganda Team members the strength and inspiration to prevail. Therefore the mango features right at the beginning of the movie. The film opens with its title, *Song of the Mango,* in four big characters superimposed on a close-up shot of a plump golden mango displayed in an ornate, rather traditional-looking glass container Fig. 21. A wide red silk ribbon encircles the mango, and it rests on an inclined base covered with ruffled violet silk. To one side on the front of the glass cover is an inscription on white paper: "The precious gift given to us by the great leader Chairman Mao—mango." Next to this inscription is the character for "double happiness," a character traditionally used to signify happy, festive occasions such as weddings or the birth of a son. This still image of the mango remains for a few seconds before the film credits appear, [10] thus establishing the mango as the central symbol of the film. Just a few minutes into the film, the mango is mentioned again. The Linxi Sixth Textile Factory is celebrating the establishment of its revolutionary committee Fig. 22, and the assembled workers welcome a group of worker representatives who have just returned from a trip on which they studied the latest Mao thoughts; they will constitute the Workers' Propaganda Team. Xia Caiyun, the designated political commissar of the Propaganda Team (i.e., the real head of the team, even though Master Tang, a male worker, is "team leader"), tells the crowd surrounding her: "Not long ago the great leader Chairman Mao gave the Workers' Propaganda Team at Qinghua University a precious gift of mangoes, [a gesture of] greatest support for all members of Workers' Propaganda Teams. With the support of Chairman Mao, comrades, we will definitely learn earnestly and work earnestly so that we will not fail to live up to the Party's and Chairman Mao's expectations."

Just as the film opens with the mango image, it also closes with the mango image (the mangoes do not figure in the plot of the film), though this time in the form of an image and a song. As Xia Caiyun successfully concludes the mass struggle rally, all participants in the rally are roused to an even higher level of excitement by the loud announcement from the public address system: "The mangoes, the precious gift given to the Workers' Propaganda Team by the great leader Chairman Mao, have arrived in our city!" All join in a great procession—thousands of people in various formations—to welcome the mangoes and to parade the mangoes along the main boulevards of the city Fig. 23. Red flags are flying high, fists are raised high, people shout slogans, and the main characters of the film (except the villain) all come together in a grand alliance led by Xia Caiyun and the workers. Master Tang leads the procession, holding the mangoes in a glass display case Fig. 24. Curiously, in this container are at least five or six mangoes piled up on a plate, rather than the sole mango that opens the film. Perhaps the filmmakers are hinting at the mangoes' magical ability to multiply?

The procession sequence is overlaid with a rousing song accompanied by drums and cymbals, whose lyrics are translated below:

Red flags covering the sky,
flying and dancing, facing the sun;
The members of the Workers' Propaganda Teams
are full of fighting spirit,
Determined to utterly bury the bourgeois class.

Their fragrance spreads ten thousand miles,
Chairman Mao gave us mangoes
to express his profound love and care;
Each mango symbolizes the hope He has put in us.

Raising high the iron hammer,
Sounding the death toll for the old world.
It is our honor to reveal a new chapter of history.[11]

For the members of the Workers' Propaganda Team and members of the working class in particular and the Chinese revolutionary masses in general, Mao's mango gift had become a "key symbol" of Mao's loving concern for them and of his putting them in the driver's seat of the Cultural Revolution.[12] It galvanized their attention, regard (as an object of intense viewing), energy, and devotion, as previously only Mao's portrait had been able to do.

1-- Gu Yu was the pen name of Huang Zhanpeng, see http://baike.baidu.com/view/928936.htm. The directors of the film were Chang Yan and Zhang Puren. The female protagonist, Xia Caiyun, was played by Yu Ping, and her Red Guard twin daughters were played by Zhou Lina. The entire film can be watched on *youku,* a Chinese internet video broadcast site, or purchased on DVD. There is even a version with English subtitles. I have not been able to ascertain how widely and for how long *Song of the Mango* was shown in cinemas. According to one source, it was released on 1 October 1976 as one of ten new films celebrating National Day, though it was withdrawn soon after the arrest of the Gang of Four on 6 October; see Liu Yangdong, *Hongdi jinzi: liuqishi niandai de Beijing haizi* [Golden characters on red background: Beijing kids during the 1960s and 1970s] (Beijing: China Youth Publishers, 2005), section 84.

2-- For some recent studies on Mao's gifting of mangoes in August 1968 and the subsequent mango fever, see Michael Dutton, "Mango Mao: Infections of the Sacred," *Public Culture,* vol. 16 (2004), pp. 161–187; Xu Ben, "Maozhuxi zeng mangguo de yizhong jiedu: Zhongjian zhongguo shehui de liwu guanxi" [One way of interpreting Chairman Mao's gift of mangoes: Rebuilding the gift relationship in Chinese society], online article posted on 3 August 2007 at http://xubenbk.blog.163.com/blog/static/13194315420091061035382 58/ (last downloaded on 30 July 2012); Afreda Murck, "Golden Mangoes: The Life Cycle of a Cultural Revolution Symbol," *Archives of Asian Art,* vol. 57 (2007), pp. 1–21; Adam Yuet Chau, "Mao's Travelling Mangoes: Food as Relic in Revolutionary China," *Past and Present,* Supp. 5 (Relics and Remains) (2010), pp. 256–275.

3-- For a discussion on how allegorical narratives can nevertheless provide ethnographic insights, see Rey Chow, *Primitive Passions: Visuality, Sexuality, Ethnography and Contemporary Chinese Cinema* (New York: Columbia University Press, 1995).

4-- The "struggle, criticize, and reform" slogan refers to Mao's political program for the Great Proletarian Cultural Revolution: to "struggle" against those in power who follow a capitalist road; to "criticize" bourgeois reactionary intellectual authorities and the ideologies of the bourgeoisie and all other exploiting classes; and to reform education, the arts, and all "superstructures" that do not match the socialist economic "base" so as to facilitate consolidating and further developing the socialist system.

5-- In these allegorical films the names of some of the protagonists are intended to convey certain definite meanings. This is particularly telling in the case of Nie Jialiang. Jialiang literally means "family excellence," which suggests "feudal" values. Even his family name, Nie, is a homophone of another character that means sinful.

6-- This section is based on materials gleaned from Liu Shu, *Zhongguo dianying muhou gushi* [Behind-the-scenes stories in Chinese cinema] (Beijing: Xinhua Publishers, 2005).

7-- The lyrics of this song can be found in the appendix.

8-- This paragraph is based on materials gleaned from Wang Yao, "Wenge wenxue jishi" [A chronicle of 'Cultural Revolution literature'], *Dangdai zuojia pinglun* [Contemporary Writers' Criticism], April 2000, available at http://www.literature.org.cn/article.aspx?id=30889.

9-- These principles were first pronounced by Yu Huiyong, "Rang wenyi wutai yongyuan chengwei xuanzhuan Mao Zedong sixiang de zhendi" [Let the stage of literature and arts always be the battlefield for propagandizing Mao Zedong Thought], *Wenhuibao,* 23 May 1968. See Wang Yao, "Wenge wenxue jishi." See also Pan Gang, "Hong, guang, liang, gao, da, quan: geming (wenge shidai) xuangzhuanhua de chuangzuo biaozun [The creative criteria of propaganda posters during the revolutionary (Cultural Revolutionary) period: red, shiny, and bright; tall, large, and complete]," online article posted on 4 April 2009 at http://blog.sina.com.cn/s/blog_4be0ddf00100d2pf.html (last downloaded on 30 July 2012).

10-- In Chinese films of that era credits appear before the film proper begins.

11-- The lyrics in Chinese, transcribed from the film by the author, can be found in the appendix.

12-- On key symbols, see Sherry B. Ortner, "On Key Symbols," *American Anthropologist,* vol. 75, no. 5 (October 1973): pp. 1338–1346.

⑥ The Reverse Apotheosis of the Peasant-Worker

Alonzo
Emery

V isual and literary depictions of peasants [1] and workers transformed radically during the past four decades of Chinese history. Recalibrated by an often turbulent interplay of social and cultural forces, the image of Chinese peasants shifted from that of national heroes in the 1960s and '70s to that of beleaguered victims of lopsided development during the past two decades, from citizens most worthy of Mao Zedong's gifts during the Cultural Revolution to the ill-protected young laborers in China's factory towns today. In examining the depiction of contemporary rural migrant factory workers, I rely on my year-long investigation of high-tech factories in Dongguan, Guangdong Province. One enduring theme emerges from my research into China's past and present: the weight of political, legal, and technological forces continues to readjust and redefine class hierarchy in China's popular imagination and mass media. Deeper understanding of the seismic shifts in popular imagery related to China's peasants and workers gives context to the rise and fall of the mango as a cult image during that heady summer and fall of 1968. [2]

1 "Chairman Mao's Literature
Is Like the Sun," Fan Pu and Tang
Dequan, 1964, printed poster,
53 × 77 cm, courtesy of Dong
Zhongchao

THE TRANSFORMATION
OF THE PEASANT

Beginnings in high gloss

In the 1960s and '70s few Chinese civilians enjoyed more acclaim than the worker and the peasant-farmer. They rose quickly to be the pop-idols of their time Fig. 2. But propaganda images of hearty, muscular peasants masked the cruel reality on the ground: during the so-called "difficult period" *(kunan shiqi)* of 1958 to 1962, the poorly conceived agricultural policies of the Great Leap Forward contributed to widespread famine, which left millions of peasants dead.[3] Yet even as peasants languished in the countryside, the image of the happy farmer endured. As we see in Fig. 1, the aged farmer beams with vitality, and even his wrinkles seem perfectly set in an upward tilt: the farmer is airbrushed to a fare-thee-well. His recitation of teachings from one of Mao's books suggests literacy despite his humble origins. He fully embodies idealized old-age in Communist China.

A new, not necessarily fresh face

During a watershed moment in the People's Republic of China's visual history, the Second National Youth Arts Exhibition of 1980 helped reverse the deification of high-Communism's happy, ageless peasants. During the exhibition, held in the China Art Gallery[4] in Beijing, Sichuanese artist Luo Zhongli exhibited his painting *Father,* which offers a close-up rendering of a weatherbeaten, hollow-cheeked, thoroughly wrinkled farmer poised to drink murky tea Fig. 3. At 227 × 154 cm, the overwhelming scale of the painting commanded attention and its high realism stood in stark contrast to the propaganda machine's comic-book renderings of peasant heroes and heroines. *Father* must have forced even the most ardent believers in government-engineered imagery to reconsider the mythology surrounding China's peasants.

99

2 An old farmer, *China im Bild*,
May 1967, p. 12

3 *Fuqin (Father)*, Luo Zhongli
(b. 1948), 1979, oil on canvas,
227 × 154 cm, collected by National
Art Museum of China, Beijing

By the time Luo Zhongli exhibited *Father* in 1980, China's proletarian revolution, and the isolationist policies it inspired, had begun to wane: Mao and Nixon embarked on diplomatic rapprochement in 1972; Mao's death followed four years later; Deng Xiaoping inaugurated his Reform and Opening policies in 1978; and the Gang of Four awaited sentencing for crimes against the state and its people. This newly hewn political landscape created the perfect launching pad for visual departures from the status quo. Radical as Luo's painting seemed at the time, *Father,* however, bore some of the last vestiges of a bygone era's myth-making: before granting approval to exhibit the painting, the vice minister of Sichuan's propaganda committee apparently advised Luo to add a ballpoint pen behind the farmer's left ear to suggest that, despite the farmer's enfeebled physical condition, this was a literate peasant, educated thanks to the State's equalizing social policies. [5]

A new medium
for a new age

Although *Father* won first prize at the exhibition
and shook the few that viewed it in Beijing, Luo's image
did not enjoy the same pervasiveness as the state's pro-
paganda. Almost twenty-five years after the Second
National Youth Arts Exhibition of 1980, however, the
advent of the internet would provide a conduit for
spreading images and information rivaling the state's
own iconography. In 2004 sociologists Chen Guidi and
Wu Chuntao created a sensation with their book *Survey
of the Chinese Peasant,* which details the often tumultu-
ous life of rural families living in Anhui Province.
Their book points an accusatory finger at the gaping
urban-rural divide and thus questions the vaunted sta-
tus of peasants:

> During the national exams for college entrance, [Ding
> Zuoming] scored just a few marks below the entrance mar-
> gin. If he had not been a native of Lixin County—if he
> had been born in Beijing or Shanghai—he would have been
> a college student right away, for his grades exceeded the
> entrance requirements there. Actually, if he had been born
> anywhere but Luying Village, he would have had a different
> fate. But being only a graduate of the local high school,
> he had no choice but to go back to his native village, and
> thus he ended up as a dirt-poor peasant like any other,
> going down to the fields every day to tend to the crops.[6]

With 150,000 printed copies selling within months, the
Survey quickly topped the bestseller list on the main-
land. Likely due to its popularity and its candor in re-
counting violent crimes, the government banned the
Survey in March 2004, shortly after its publication. But
the book was such a hot item that millions more sold
on the black market and copies continue to spread on
the internet.[7] Like *Father, Survey of the Chinese Peasant*
allowed China's urban masses an aperture into some
of the cruel realities of life in China's countryside. By
spreading its content over the internet, Chinese neti-
zens presaged the important role that social network-
ing websites and microblogs would later play in reshap-
ing the images of peasants and workers.

THE TRANSFORMATION
OF THE WORKER

Today, journalists, artists, documentarians, blog-
gers, and musicians work to alter, and perhaps lend
greater realism to, the image of the Chinese worker. A
landmark year in this development was 2010, when a
series of worker-led protests and a rash of suicides com-
plicated the myth of the happy, or at least complacent,
factory worker. By focusing on the center of China's
industrial production in the Pearl River Delta, we can
better understand how this transformation emerged
and also the historical context upon which it rests.

A new economy

When China's Communist Party Leader Deng
Xiaoping embarked on his Southern Tour to the Pearl
River Delta in 1992, he ushered in radical change for
the region, not to mention the national economy, by
opening the door to the rapid growth of cities such as
Shenzhen and Dongguan with a simple catch-phrase
that launched a thousand—or perhaps more aptly one
hundred thousand—entrepreneurs: "To get rich is glori-
ous."[8] By this time, the global public already knew
Deng as the reformer who ended China's years of isola-
tion with his Reform and Opening policies begun in
1978, policies allowing for significant foreign invest-
ment in some coastal areas. Deng was the leading ar-
chitect of the new China we see today.

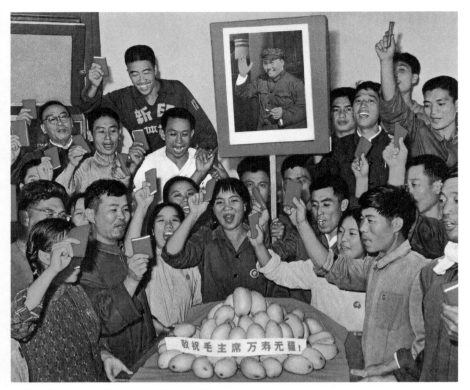

4 Members of the Worker-Peasant Propaganda Teams
at Qinghua University cheering the gift of mangoes,
calender sheet, July 1970, Collection Claudia Lux, Berlin

5 Employees work on the assembly
line at Shenzhen Foxconn plant in
May 2010, Bloomberg, by Getty Images

A new reality

Two decades after Deng's Southern Tour, shifts in global production, and the threats to employment they create, place new pressures on Chinese factory workers and diminish their power in society. These new pressures also teach the owners of Chinese factories that they must remain quick and nimble or watch their profits perish. In her book *The China Price*, Alexandra Harney chronicles the peril and promise of China's manufacturing sector, revealing how the factories operating out of China's coastal regions teeter at the precipice of dramatic change: "Now, as costs on the coasts rise, factories are looking for new locations where the cost savings outweigh the expense of moving."[9] During my year-long investigation of high-tech factories in Dongguan, begun in September 2009, several factory managers confirmed plans to cut costs by moving their factories inland to the provinces of Hunan, Henan, and Sichuan to be closer to the pools of laborers from which they normally draw. The specter of shifting production away from the coasts into the interior and even overseas, matched with recent economic downturns, may foreshadow a possible end to financial sustainability for manufacturers in China's Pearl River Delta and the young workers they employ.

A new generation

Shifts in the demographic make-up and life philosophy of China's factory laborers add to the complexity of the situation faced by factory owners and their workforce. Manufacturers based in China and, by extension, the globally recognized clients they serve, are scrambling to develop corporate social responsibility systems that reflect the dynamism and mercurial nature of China's new workforce. In the past, the industrial laborers untethered by Deng's Reform and Opening would "go out" [10] from their rural hometowns to work in the coastal manufacturing zones at almost any price. These workers often came from large peasant families and would accept substandard working conditions as long as such jobs secured paychecks to send to their many kin back on the family farm. Visions of countless, nameless, faceless migrant workers streaming into factories defined China's manufacturing sector in the 1980s and '90s. Their anonymous, low profile stands in stark contrast to the ubiquity of the worker image in the heyday of high Communism, when the individual characters of workers were brought to the fore as a means of advancing a social narrative about their importance in society. Today's fraught images of less-than-exuberant workers depart even further from the old visual narrative.

The traction already gained by China's population control polices in rural areas means that many of the workers "going out" now, those children born in the 1980s and even the 1990s, [11] often come from single-child or two-child households. Unlike the parents of factory workers a generation before, the parents of workers born after 1980 are less keen to have their children live so far from home. They remain frightened by the prospect of losing to the city what, for many farm-bound Chinese parents, is their main insurance policy against destitution in old age. Moreover, children of the post-1980 generation have grown up in a novel set of circumstances, living as the sole focus of sets of parents and grandparents ever ready to spoil them with the added wealth, albeit meager, acquired in China's increasingly

106

capitalistic economy. The elevated status of these only children also makes them less likely to accept substandard working conditions. Factories seeking to maintain a happy workforce are rolling out policies attempting, but often failing, to address the shift in priorities of their workers: lifestyle and the search for adventure have replaced the make-money-at-any-cost ethos that seemed to define the Chinese workforce in the 1990s. Thus, the combination of new standards of living, increased protection under labor laws, external pressures from civil society, as well as an increasingly consumer-based public creates a complex quagmire of seemingly irresolvable tensions often giving rise to disputes both in and outside of the factory.

A new image

Today, the scene of workers surrounding Mao's mangoes Fig. 4 finds itself replaced by less optimistic images spewing from the Foxconn factories in the Pearl River Delta Fig. 5. Employing over one million workers in the Peoples Republic of China, Taiwanese-owned Foxconn is the world's largest electronics manufacturer. On 17 March 2010 Foxconn factory worker Tian Yu attempted suicide by jumping from one of the buildings near her production line, an act that left her paralyzed from the waist down. In the first five months of 2010 at least eleven of her co-workers took their own lives. 12 Due in large part to the company's high-profile in China, stories of the Foxconn suicides spread around the internet like wildfire, forcing its recalcitrant billionaire chairman and president, Terry Gou, to face an angry public that accused the company of operating a sweatshop. 13

Perhaps in response to the attention surrounding the well-being of China's factory workforce, Chinese artists recently returned to the worker as subject. The lyrics of Beijing-based songwriter Jiang Guoliang's "Yongbao shengming" (Embrace Life) captures the melancholy attending the new image of China's workforce:

107

6 *Welcome to the Desert of the
Real*, Wang Jianwei (b. 1958), 2010,
video installation and performance,
courtesy of the artist

We walk along the outskirts of the city,
Leaving footprints of world change.
Many wishes have become like wisps of smoke,
Too much sweat has fallen,
Our lives are in a gray space.
Sleepless nights have nothing but stars to see.
Although life is always withering away,
Instead we have made the city's sky blue.
Walking alone in the city street,
Wanting to cry without the melancholy of tears,
But hope those vanished dreams can become memories,
after we succeed. [14]

In the visual arts, Sichuan-born artist Wang Jianwei's video installation *Welcome to the Desert of the Real* [15] seems to reveal his understanding of the modern worker's plight Fig. 6. The video depicts a Chinese urban street-scene with a migrant worker standing at the end of a long line of customers waiting to purchase meat from a corpulent butcher. However, two figures emerge to delay the worker from claiming his share: one seems to be a member of the security forces and the other, a newly middle-class bureaucrat. As the other figures in line fall away, the worker is left to face off against his more powerful adversaries. In Wang's depiction of the new China, workers no longer stand as the first, and worthiest, beneficiaries of society's gifts, be they mangoes, meat, or other such bounty. That the worker in Wang's video eventually expresses his rage with violence reflects contemporaneous accounts of the dispossessed taking justice into their own hands. [16]

A new storyteller

In 1968, factory workers were made leaders of education and of society as a whole. Four decades later, death and despair seem more common associations in art and the media. Still, one must not cast the image of the modern factory worker in too dismal a light. As Leslie T. Chang reveals in her book *Factory Girls: From Village to City in a Changing China*,[17] life in China's factory towns—despite myriad occupational and social hazards—often proves preferable to life toiling on the farm. In director Fan Lixin's documentary *The Last Train Home*, we also discover that factory town life provides at least a modicum of freedom and happiness for the documentary's young factory-worker protagonist.[18]

Emboldened by newly found freedom from family ties and by growing rights consciousness, some workers even find success in advocating for their rights: in the summer of 2010 thousands of workers in Foshan, Guangdong Province, staged a walkout of a Honda factory. Eventually, their act of protest achieved a 24 to 33 percent wage increase.[19] What is most striking about this and other related events in the Pearl River Delta is that they garnered considerable popular attention, thanks to China's legions of "barefoot" journalists and microbloggers. With more video-camera-equipped citizen journalists and video-bloggers instantly spreading unedited images from around the country, the depiction of the worker—or anyone in China, for that matter—might finally come to enjoy what for decades it has not: a measure of nuance and objectivity.

1-- The term "peasant" is often used interchangeably with "farmer" for the Chinese *nongmin,* and I use it in this article without the derogatory connotation it may carry elsewhere.

2-- See Alfreda Murck, "Golden Mangoes: The Life Cycle of a Cultural Revolution Symbol," *Archives of Asian Art,* vol. 57 (2007), pp. 1–21.

3-- For two chilling accounts of the famine, see Jasper Becker, *Hungry Ghosts: Mao's Secret Famine* (New York: Holt Paperbacks, 1998) and Frank Dikötter, *Mao's Great Famine: The History of China's Most Devastating Catastrophe, 1958– 1962* (London: Bloomsbury Publishing, 2011).

4-- The China Art Gallery is now called the National Art Museum of China.

5-- See Martina Köppel-Yang, *Semiotic Warfare: the Chinese Avant-Garde, 1979–1989. A Semiotic Analysis,* (Beijing: Timezone 8 Books, 2004), p. 93.

6-- Zhu Hong (trans.), *Will the Boat Sink the Water* (New York: PublicAffairs, 2007), p. 4.; for the Chinese original, see Chen Guidi and Wu Chuntao, *Zhongguo Nongmin Diaocha* [Survey of the Chinese peasant] (Beijing: Renmin wenxue chubanshe, 2004).

7-- See Alonzo Emery, "Is this as good as it gets?" *South China Morning Post,* 20 September 2004.

8-- Whether or not this was Deng's actual saying, this quote is attributed to him by many scholars and laymen both in and outside of China.

9-- Alexandra Harney, *The China Price: The True Cost of Chinese Competitive Advantage* (New York: Penguin Books, 2008), p. 282.

10-- See Leslie T. Chang, *Factory Girls: From Village to City in a Changing China* (New York: Spiegel & Grau, 2008), pp. 3–16, where the author explains the concept of "going out," which means essentially to leave one's hometown to work in more developed areas of China.

11-- In China, children born in or after 1980 are referred to as *balinghou* and those born in or after 1990 as *jiulinghou* (literally "after-eight-zero" and "after-nine-zero," respectively). Whether from wealthy or rural backgrounds, the *balinghou* generation is often characterized as being spoiled, selfish, and materialistic. For a description of the generation born between 1981 and 1995, see Michael Stanat, *China's Generation Y: Understanding the Future Leaders of the World's Next Superpower* (Paramus, NJ: Homa & Sekey Books, 2005).

12-- Like Tian Yu, an estimated 17 others attempted (but failed) to commit suicide during that period. See Mimi Lau, "Struggle for Foxconn girl who wanted to die," *South China Morning Post,* 15 December 2010.

13-- For more on Foxconn and the scandal, see David Barboza, "After Suicides, Scrutiny of China's Grim Factories," *The New York Times,* 7 June 2010, A1. The total number of suicides and suicide attempts remains in dispute.

14-- Jiang Guoliang, *Embrace Life* (2010). The song can be found at http://music.10086.cn/newweb/qk/guoso/1DFE47E0DA350DB5/t/6.html.

15-- Wang Jianwei (b. 1958), *Welcome to the Desert of the Real,* video performance installation (2010), http://www.wangjianwei.com/hyldzssm.html (last downloaded on 15 December 2012).

16-- For one such account, and more broadly the economic and social conditions that contributed to it, see Charles Duhigg and David Barboza, "In China, the Human Costs That Are Built Into an iPad," *The New York Times,* 26 Januar 2012, A1.

17-- See n. 9.

18-- Fan Lixin, *The Last Train Home,* Zeitgeist Films (2009).

19-- See Richard Swift, "Whose miracle?" *New Internationalist Magazine,* no. 441 (1 April 2011).

Catalog of the Alfreda Murck Collection at the Museum Rietberg Zürich

Alfreda
Murck

I Mangoes as a Gift to the Workers

The summer of 1968 marked a turning point in the Cultural Revolution: the student Red Guards, who had been the leaders of the movement, were asked to step down while workers were put in charge.

The Cultural Revolution had been launched in 1966 as a mass movement. On 25 May of that year the philosophy teacher Nie Yuanzi of Beijing University transcribed a big-character poster, said to be authored by a member of the Cultural Revolution Small Committee, aggressively attacking the Party authorities of her university and calling young intellectuals and students to revolution. When the text was officially approved by being broadcast on national radio on 1 June, the students rose up. After the first formation of a student's group at Qinghua Middle School, calling itself "Red Guards Who Defend Mao Zedong Thought," and its endorsement by Mao, students across the nation established their own Red Guard organizations.

From the beginning of the Red Guard movement, the students split into irreconcilable factions, fighting over questions of ideology and power. As early as Spring 1967 they were urged by the Party Center to reunite, yet the fighting continued and even grew more severe. The following autumn Mao became more resolute in his demand for an end to the anarchy. Students at the universities were ordered to resume classes, devote themselves to the study of Mao Zedong Thought, and build "Great Alliances." Nevertheless, the turmoil at the major universities in Beijing intensified. At the prestigious Qinghua University it erupted in open battle in April 1968. Thousands of students fled the chaos. The remaining followers of the various factions—an estimated four hundred—started using improvised weapons, bombs, and tanks against each other. This period is known as "The Hundred Day War at Qinghua."

Finally, on 27 July, Mao ordered some thirty thousand workers from Beijing factories to organize in "Worker-Peasant Mao Zedong Thought Propaganda Teams." They were to occupy the campuses and pacify the students using Mao Zedong Thought as "an inexhaustible source of strength and a spiritual atom bomb of infinite power".[1] The teams sent to Qinghua University unexpectedly encountered violent resistance. Five workers were killed and 731 seriously wounded. Early the next morning, having summoned the leaders of the Red Guard factions, Mao declared that the usefulness of the Red Guards had passed and that workers would now take over leadership of the movement.

Just days later, on 4 August, Mao received the Pakistani foreign minister on an official visit and was presented with a case of several dozen mangoes. He instructed his bodyguard Wang Dongxing the next day to distribute the fruit to the workers occupying the Qinghua University campus. Not even Mao could anticipate the excitement that the gift of mangoes would generate.

1 Poster of mango on
 porcelain plate
 1968, color printing on paper
 53.0 × 68.3 cm

On 5 August 1968 Mao Zedong sent
Pakistani mangoes to the Worker-Peasant
Propaganda Teams who had brought
warring factions of Red Guards under
control at Qinghua University. The text
of this medium-size poster links the
gift of mangoes to the anniversary of
Mao's famous text "Bombard the
headquarters—my big-character poster,"
officially sanctioning the Red Guards'
attacks on Party leadership, and to the
Central Committee's decision on the
Cultural Revolution, taken at the 11th
Plenum of the Central Committee and
actually published on 8 August 1966,
also known as the Sixteen Points. The
text reads: "Our Great leader Chair-
man Mao forever joins his heart with
the hearts of the people.

To commemorate the happy day of the
second anniversary of Chairman
Mao's big-character poster "Bombard the
headquarters" and the publishing of
"Decision of the Chinese Communist
Party's Central Committee on the
Great Proletarian Cultural Revolution,"
Great Leader Chairman Mao present-
ed the precious gift that he had person-
ally received from foreign friends—
mangoes—to the Capital Worker-Peas-
ant Mao Zedong Thought Propagan-
da Teams. Chairman Mao said: 'We do
not want to eat them; have comrade
Wang Dongxing take them to Qinghua
University for the comrades in the eight
Worker-Peasant Propaganda Teams'."

Coming from the Great Leader himself,
the exotic fruit inspired something
close to religious awe. Mangoes were
rarely shown resting directly on a table
or against an indeterminate ground.
They typically were displayed reveren-
tially on a porcelain plate or dish, or
in a bowl or basket. Here a single mango
is further set off with festive confetti,
an embroidered doily under the plate,
a draped stand, and a deep red curtain
as background.

我們偉大領袖毛主席永远和羣众心連心

在紀念毛主席《炮打司令部》大字报和《中国共产党中央委员会关于无产阶級文化大革命的决定》发表两周年的大喜日子里，偉大領袖毛主席亲自把外国朋友赠送的珍貴礼物——芒果，轉送給首都工农毛澤东思想宣傳队。毛主席說："我們不要吃，要汪东兴同志送到清华大学給八个团的工农宣傳队的同志們"。

伟大領袖毛主席亲自赠送給首都工农毛澤东思想宣傳队的珍貴礼物——芒果

117

2 Small poster of mango
 on porcelain plate
 Datable to 1968 or 1969,
 color printing on paper
 18.5 × 25.7 cm

"Our country has a population of
700 million, and the working class is the
leadership class. Bring into full play
the leading role of the working class
in the great Cultural Revolution and in
all fields of work. The working class
also must continuously raise its poli-
tical consciousness through struggle."
Below the picture the text reads:
"The precious gift personally presented
by Great Leader Chairman Mao to
Capital Workers' Mao Zedong Thought
Propaganda Teams—mango."

The *People's Liberation Army Daily* and
the *People's Daily,* mouthpiece of the
Party, carried daily changing quotes of
Mao in their mastheads from the
beginning of the Cultural Revolution.[2]

The gift of the mangoes accompanied an
important political directive that was
a turning point in the Great Proletarian
Cultural Revolution. The mangoes
signified that the working class would
henceforth be in charge of forwarding
the Cultural Revolution. The unspoken
message was that the Cultural Revolu-
tion no longer needed students and that
the students must cease their violence
and general agitation.

The picture in this economical poster, in-
tended for schools and factories, is
identical to Fig. I–1 but it carries a differ-
ent proclamation. This text first appeared
in the headline of *People's Daily* on
15 August, making the new directive clear
to everybody.

Mao did not oppose this cult of the per-
sonality. In a private speech of March
1958 he said, "The question at issue is not
whether or not there should be a cult
of the individual, but rather whether or
not the individual concerned represents
the truth. If he does, then he should
be revered."[3]

Masthead of the
People's Liberation Army Daily,
26 August 1968

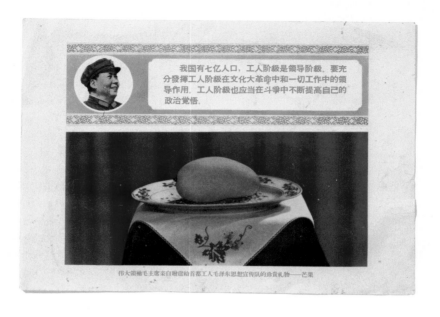

伟大领袖毛主席亲自赠送给首都工人毛泽东思想宣传队的珍贵礼物——芒果

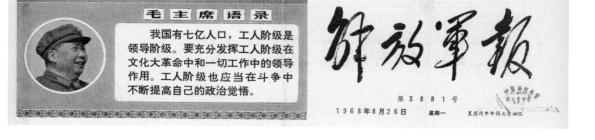

3 Members of the Worker-
 Peasant Propaganda Teams
 at Qinghua University
 cheering the gift of mangoes
 August 1968, black-and-
 white glossy photograph
 25.3 × 22.8 cm

The mangoes originally were presented to Mao by Pakistan's foreign minister, Mian Arshad Hussain, on his official visit to Beijing. But when Mao regifted the mangoes to the workers occupying Qinghua University campus, they swiftly transformed from fruit to a near-divine symbol. The message accompanying the mangoes said that Mao was making the Worker-Peasant Propaganda Teams the permanent managers of education.

According to William Hinton's account, workers stayed up through the night looking at and touching the mangoes, discussing the implications of the new policy, and contemplating Mao's generosity.[4] Some students, who had been the object of repression, were also caught up in the excitement, perhaps relieved that the Chairman himself had intervened to end the Red Guard violence.

The inscription on the ribbon placed across the pile of mangoes reads: "Respectfully wishing Chairman Mao eternal life." The photograph graced the front pages of *Beijing Daily* and *Sichuan Daily* on 7 and 8 August 1968, respectively.

The same photograph, printed in color, adorned the month of July in a 1970 calendar.[5]

Calendar sheet, July 1970,
Collection Claudia Lux, Berlin

120

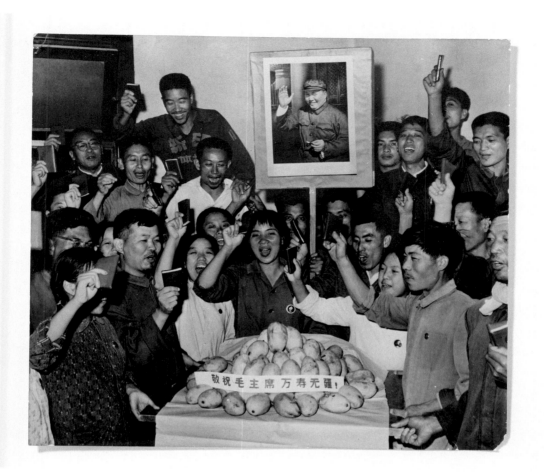

4 Factory Workers at Beijing
 Knitting Mill applauding
 the mango
 From *China Revista
 Illustrada,* October 1968,
 back cover
 Color printing on paper
 36.5 × 26.0 cm

Most of the workers who had been in-
volved in the 27 July action had re-
turned to their factories to which a fresh
mango was delivered. It was greeted
with the same awe and excitement. But
soon the fruit started to rot. To pre-
serve the precious gift from Mao the
mango was sometimes soaked in form-
aldehyde as was done at Beijing Knit-
ting Mill.

Mao Zedong's doctor Li Zhisui writes
about another factory, the Beijing
Textile Factory, holding a ceremony com-
plete with quotations from Mao's pub-
lished works. They covered the mango
with wax in the hopes of preserving it.
When that failed to arrest the spoilage,
they boiled it in a large pot of water and
held another ceremony, replete with
religious symbolism. After recitation of
Mao's words, they each sipped a spoon-
ful of the mango broth. When Dr. Li
related these events to him, Mao only
chuckled.[6]

This photograph was doctored before
being published in different language
versions of *China Pictorial*. The same
photograph was earlier published in
People's Daily, 8 August 1968, without
the poster of Mao Zedong on the wall.
Photographs were commonly manipu-
lated to add politically correct details,
to erase those who had fallen from grace,
even to whiten teeth.

Workers cheering the mango,
People's Daily, 8 August 1968

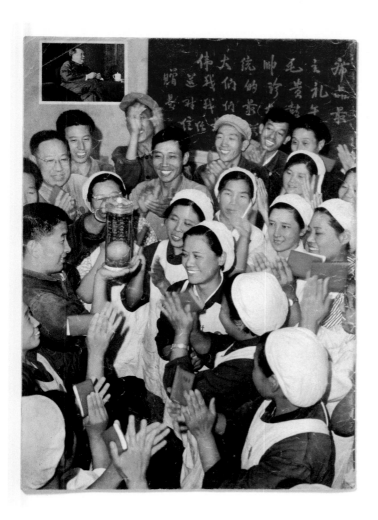

123

5 Bust of Mao Zedong in
 Zhongshan suit
 August 1968, tan rubber
 21.0 × 18.5 × 11.0 cm

On the front of the base of this rubber image of Chairman Mao, raised characters wish him long life. Raised characters on the back of the base read: "Memento of Chairman Mao receiving worker representatives of our factory and graciously presenting a mango. Revolutionary Committee of Beijing Chemical Factory No. 2, 1968.8.15."

It presumably was the Central Cultural Revolution Small Group who decided that Mao Zedong should receive delegations of workers from representative factories at the Zhongnanhai leadership compound. This he did on 15 August 1968. Each factory had a different way of celebrating the honor. Many had badges made. Beijing Chemical Factory No. 2 had these small rubber images fabricated.

On this occasion Zhang Kui, Workers' Representative of Beijing No. 1 Machine Tool Plant, was invited to ascend the stage and shake hands with Mao Zedong. He avoided washing his hands that night so that, upon his return to his factory on 16 August, his coworkers could share the excitement of touching a hand that had touched The Hand. see also Essay ② p.36 In the photograph published in *People's Daily* of 17 August 1968, Zhang Kui, wearing light-colored pants, is in the front row on the right.

Mao receives delegations of workers,
People's Daily, 17 August 1968

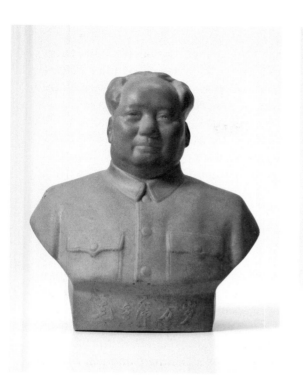

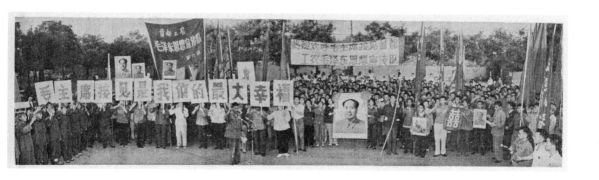

125

6 Rectangular mango vitrine
 from Beijing No.1
 Machine Tool Plant
 August 1968,
 glass, fabric, wood
 21.7 × 26.0 × 12.6 cm
 Wax mango
 11.1 cm

Beijing No.1 Machine Tool Plant was one of the factories receiving a fresh mango, but they decided to send their mango to a sister plant in Shanghai to honor them for inventing China's first numerically controlled machine tool. By 16 August facsimile wax mangoes enshrined in glass display cases had been made for each of the Plant's approximately 1,200 workers, and were bestowed on them in a great ceremony. The stick-on characters on the display case recount the circumstances of Mao's gift of 5 August 1968: "Chairman Mao said: 'We do not want to eat them; have comrade Wang Dongxing take them to Qinghua University for the comrades in the eight Worker-Peasant Propaganda Teams.' Beijing No.1 Machine Tool Plant Revolutionary Committee. 68.8. 5th day."

5 August was a significant date. It was the second anniversary of Mao Zedong's inflammatory "Bombard the headquarters" poster, which had sanctioned student rebellions against the Party and its organizations. Now, after two years of bizarrely random chaos and bloodshed, with hundreds of thousands dead, Mao's message had changed to "Unify and study under the guidance of Worker-Peasant Mao Zedong Thought Propaganda Teams."

One account noted that on the Qinghua campus the skirmishes between the most aggressive Red Guards and the Worker-Peasant Propaganda Teams continued until noon on 30 July. Over the May–July struggle there were eighteen fatalities, an estimated 1,100 wounded, and thirty left permanently disabled. [7]

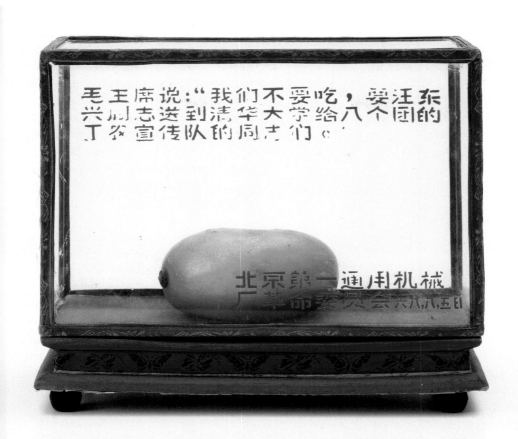

7 Rectangular mango vitrine
 from Beijing No. 1
 Machine Tool Plant
 August 1968,
 glass, fabric, wood
 21.7 × 26.0 × 12.6 cm
 Wax mango
 11.1 cm

When the gift of mangoes was announced in the state-run newspaper *People's Daily* on 7 August 1968, the headline read: "Greatest Concern! Greatest Confidence! Greatest Support! Greatest Inspiration! Our Great Leader's Heart is Always One with the Masses. Chairman Mao took the precious gift given by foreign friends and gave it to the Capital Worker-Peasant Mao Zedong Thought Propaganda Teams."

A poem was published three days later:

> …Seeing that golden mango
> Was as if seeing the Great Leader
> Chairman Mao!
> Standing before that golden mango
> Was just like standing beside Chairman Mao;
> Again and again touching that golden mango:
> the golden mango was so warm!
> Again and again smelling the mango:
> that golden mango was so fragrant!…

The poet's admiration for the leader carries over to revolutionary action: "Ah, Chairman Mao! We will ever follow you in making revolution: the seas may run dry, rocks may crumble, but our hearts will not change…"[8]

For the cadres who quickly planned and executed the propaganda campaign, expressing Mao's concern for the workers was more important than the origin of the mangoes. That they were a gift from Pakistan was glossed over to make them "tribute" from a distant land and emblems of Mao's beneficence.

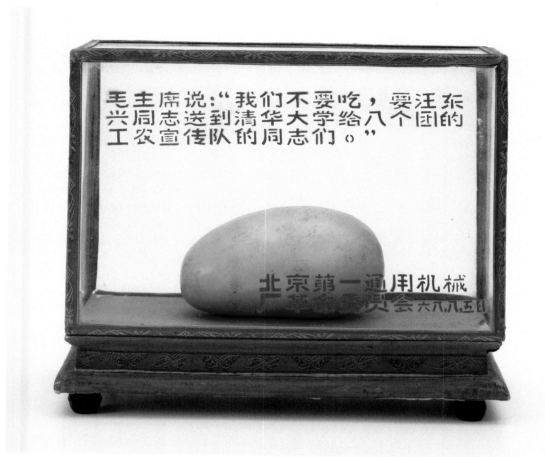

8 Quilt cover with design
 of the three major
 methods of preserving
 and presenting mangoes
 Probably August/
 September 1968,
 printed cotton
 208 × 158 cm
 (double loom width)

This printed-cotton quilt cover illustrates the three major methods of preserving and presenting mangoes: in formaldehyde, on a tray, and in a vitrine. The pair of mangoes on the covered tray suggests the idea of Mao being "heart to heart with the workers, peasants, and soldiers." The sea of flags and the lively flowers, including the sunflowers that resemble peonies, complement the discreet pink worker's hammer tied with pink ribbons.

In August and September 1968, as the real or facsimile mangoes were sent around China and exhibited in different provinces, their photographs appeared in local newspapers. This quilt cover probably dates from that time.

The activities of the printing factories were not limited to producing fabrics; they also issued colorful posters. Poster paintings in the *Beijing Daily* of 12 and 18 August show farmers and workers proudly carrying boxes heaped high with mangoes, surrounded by their comrades clashing cymbals, pounding drums, and carrying signs inscribed with double happiness, declarations of loyalty to the Chairman, and wishes for his long life. A portrait of Mao Zedong floats above the crowd. Next to the 18 August image is the name of the contributing organization: the Revolutionary Staff of Beijing Printing and Dyeing Factory. The caption reads: "The heavens are great, the earth is great, but they can't compare with the greatness of what the Party has done for the people. Dear as our parents are to us, Chairman Mao is dearer still."

Poster of farmers and
workers with bowl of mangoes,
Beijing Daily, 12 August 1968

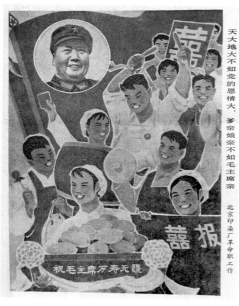

天大地大不如党的恩情大，爹亲娘亲不如毛主席亲

北京印染厂革命职工作

祝毛主席万寿无疆

囍报

II October 1968: Parades, National and Regional

Parades were important tools of political symbolism in Communist China. The most important spectacle was the National Day parade on 1 October, followed by celebrations on Labor Day (1 May) and the founding days of the Party (1 July) and the army (1 August).

The 1968 National Day parade proceeded along Chang'an Avenue, with Party leaders viewing from the rostrum of the Gate of Heavenly Peace. Handpicked guests took seats in the viewing stands on either side of the gate, and more than a hundred thousand chosen citizens packed the square in assigned places. Four hundred thousand marched in a parade that lasted ninety minutes.

Once an opportunity for the People's Republic to display its military strength and armaments, the National Day parade had since 1960 become largely civilian. For the Party, the parades were crucial instruments for communicating policy choices and changes in leadership, in a manner well understood by the audience. After two years of chaos and violence, the parade of 1968 mainly dealt with questions of power and legitimacy. By reinforcing the slogan "The working class must exercise leadership in everything," it symbolically ended the Red Guard phase of the Cultural Revolution and marked a return to Party leadership. The main symbol for this new policy was the mango.

Some provincial capitals and major cities would organize their own parades closely modeled on the detailed guidelines of the Beijing parade.

9 Pictorial magazines with
 photographs of the
 1968 National Day parade

A National Day card display
 From *People's Liberation Army
 Daily,* 2 October 1968
 Black-and-white photograph

In the parade the message of the mango
was communicated through colorful
floats, slogans, and mass card flashing. In
the square opposite Tiananmen, the
Gate of Heavenly Peace, tens of thou-
sands of participants held aloft colored
cards to configure the ten-character
slogan "The working class must exercise
leadership in everything."

B National Day parade
 From *China Reconstructs,*
 December 1968, p. 3
 Black-and-white photograph

Monumental sculptures of Mao accom-
panied by people carrying wishes for
eternal life are followed by large baskets
of artificial mangoes surrounded by
marching groups carrying streamers and
sunflowers.

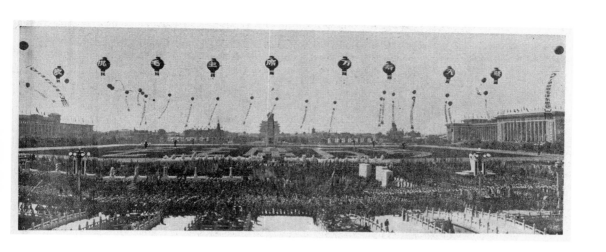

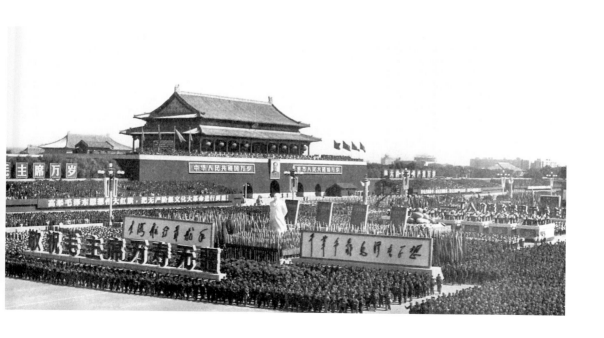

C National Day parade
basket of mangoes
From *China Revista Illustrada,*
November 1968, pp. 2–3
Color photograph

Sunflowers dominate the floral displays because, like loyal revolutionaries, all day long they turn toward the sun (that is, the leader). Sunflowers surrounding the basket of mangoes imply that the mango stood for Mao himself.

D National Day parade
mango float
From *Renmin huabao,*
December 1968, front cover
Color photograph

Leading this unit is a float that supports a sturdy flag with the legend "Workers' Mao Zedong Thought Propaganda Team." The flag is flanked by the slogans "The working class must exercise leadership in everything." Following is a large marching unit of workers with a mango float at each corner.

lleno de energía y vigor, el Presidente Mao saludó a las multitudes, agitando repetidamente la mano. Lao meses, agitando sus rojos ejemplares del preciado libro revolucionario, lo aclamaron una y otra vez expresando su profunda amistanza proletaria de ili-mitado cariño y lealtad hacia el gran líder el Presidente Mao.

Junto con el Presidente Mao y el Vicepresidente Lin Piao, en la tribuna presidencial de Tien An Men se encontraban los camaradas Chou En-lai, Chen Po-ta, Kang Sheng, Chiang Ching, Chang Chun-chiao, Yao Wen-yuan, Hsieh Fu-chih, Huang Yung-sheng, Wu Fa-hsien, Ye Chün, Wang Tung-ying y Wen Yu-cheng.

También estaban en la tribuna presidencial los camaradas responsables de los comités revolucionarios y representantes obreras de 29 provincias, municipios y regiones autónomas que llegaron a Pekín para asistir a las celebraciones del Día Nacional.

Luchadores revolucionarios proletarios de distintos países y otros amigos extranjeros fueron también invitados a las celebraciones en la tribuna presidencial de Tien An Men. Al inaugurarse el mitin, la banda tocó el himno nacional y se dispararon salvas.

El Vicepresidente Lin Piao pronunció un importante discurso. Empezó el grandioso desfile de masas. Con vigorosos paso, los integrantes del desfile marcharon hacia la plaza Tien An Men, precedidos por la bandera y el emblema nacionales de la gran patria.

Un surco alegórico, portando un enorme mapa de China, atravesó la plaza. Ese mapa rojo cubriría 6 grandes caracteres chinos dorados que significaban: "Los comités revolucionarios son excelentes". Bajo la guía de la línea revolucionaria proletaria del Presidente Mao, todas las provincias, municipios y regiones autónomas de China, con excepción de la provincia de Taiwán, han establecido ahora sus comités revolucionarios. Las masas del desfile, en trajes de diversas nacionalidades, cantaban, bailaban y vitoreaban: "¡Viva la victoria total de la gran revolución cultural proletaria!" "¡Viva la victoria de la línea revolucionaria proletaria del Presidente Mao!" "¡Viva el cuartel general proletario encabezado por el Presidente Mao y con el Vicepresidente Lin Piao como subjefe!" "¡Viva el marxismo-leninismo-pensamiento de Mao Tse-tung!"

Cuando las filas de la clase obrera de Pekín atravesaban la plaza,

人民畫報 1968 12

10 Quilt cover with design of
 National Day parade
 mango float amid fireworks
 October / November 1968,
 printed cotton
 187 × 78 cm
 (single loom width)

Under pressure to produce four or five designs a day, textile designers looked to recently published photographs for officially approved and politically correct images. Some designs, like this one, were adapted from magazine photographs of the 1968 Beijing National Day parade.

The backdrop of the design is formed by the distinctive outline of the History Museum on the east side of Tiananmen Square, whereas details of street lamps, sunflowers, and trees are generalized. The mango float of the parade stands out by its particular green color. Pairs of traditional red silk lanterns swing in the breeze. Amid searchlights, festive fireworks explode into colorful popcorn balls.

Fireworks on National Day in Beijing, *China im Bild*, November 1968, back cover

139

11 Quilt cover with design of
baskets of mangoes,
student backpacks, and
convoy of trucks
October/December 1968,
printed cotton
201 × 78 cm
(single loom width)

Baskets of mangoes resembling those deployed in the 1968 Beijing National Day parade are adorned with tassels as well as hammer and sickle, Communist symbols for worker and peasant. Pink peonies and balloons signify prosperity and joy, while the *huabiao* pillar hovering over a sea of red flags places the scene next to Tiananmen Gate.

The image of the gear that students took with them when they were sent down to the countryside—backpacks with bedrolls and satchels containing the latest directives from Mao Zedong —remind us that the Red Guards were going to the countryside to learn from farmers.

To get the message of the new leadership of the workers out to other parts of China, propaganda teams were sent with real and facsimile mangoes to Shandong, Fujian, and the western provinces. On the textile a convoy of trucks printed in fine yellow lines drives to what might be an exhibition hall, perhaps a reference to the mangoes being put on exhibition in regional cities and towns.

12 Parade with enshrined
 mangoes in Harbin,
 October 1968
 Li Zhensheng,
 signed copy from 2011,
 black-and-white photograph
 40.0 × 57.0 cm

When the Heilongjiang revolutionary committee delegation to Beijing's National Day celebration returned to Harbin in mid-October 1968, the National Day parade was reenacted on a small scale. From the train station, two wax mangoes cushioned on silk in separate glass vitrines were carried in a procession preceded by a statue of Mao Zedong. Following the mangoes four workers bore two iconic portraits of Mao. Banners, flags, blossoming branches, horns, and drums added noise and color. The elements recall annual rituals of pre-Liberation China, during which a deity and holy relics were removed from a shrine for procession through a village. Soviet influences may also have been at play in the cultic veneration of the leader.

The photojournalist Li Zhensheng worked for eighteen years in Harbin covering events for his local newspaper, the *Heilongjiang Daily*. He not only took more pictures than necessary, he also saved them in envelopes on which he wrote details of the time, place, and names. The book *Red-color News Soldier: A Chinese Photographer's Odyssey through the Cultural Revolution* selectively documents those years. [9]

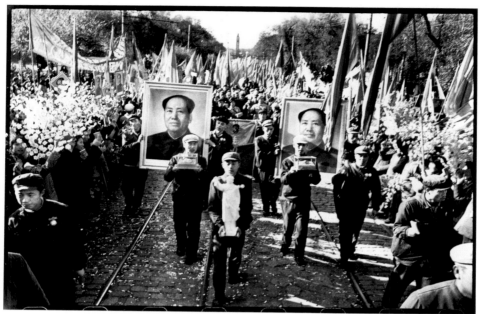

13 Small photographs
A of mangoes
B September 1968,
 black-and-white
 photograph
 8.2 × 10.1 cm and
 6.0 × 8.3 cm

While real mangoes and wax facsimiles were on parade in cities around China, some regions lacked the resources to make even wax copies. They had to rely on black-and-white photographs, perhaps something like these.

A primary school teacher in Weng'an, Guizhou Province, Huang Yuzhong, gave a vivid account of the contentious political atmosphere of the late summer of 1968 when two factions felt entitled to receive the mango sent by Mao.[10] Representatives of the faction recently ousted from power wanted to escort the mango from the next bigger city back to Weng'an, but were refused. As they were returning, they encountered the opposition faction that was currently in power. They saw what the out-of-favor faction had tried to do and were furious. A potentially deadly battle was avoided by the presence of an over two-meter-high portrait of Mao Zedong carried at the fore of the opposition faction. No one dared commit a violent crime in front of Mao.

To receive the mangoes, the faction in power organized a huge rally in the sports stadium. Both factions assembled several thousand supporters with national and battle flags as well as primitive weapons such as hoe handles and sticks. What arrived, however, was not a pile of mangoes, not even a single mango, but only a black-and-white photograph of a mango. Even so, before the rally could begin, a member of the out-of-power faction tried to take possession of the black-and-white photograph. Mayhem ensued and the rally was cancelled.

To defuse the crisis, copies were made of the photograph. The next day forty-eight framed photographs—blurry and scratchy—were distributed to each of the communes complete with Mao's blessing of benevolence and approval.

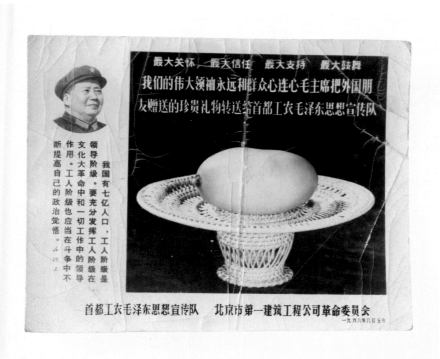

最大关怀 最大信任 最大支持 最大鼓舞

我们的伟大领袖永远和群众心连心毛主席把外国朋友赠送的珍贵礼物转送给首都工农毛泽东思想宣传队

我国有七亿人口，工人阶级是领导阶级。要充分发挥工人阶级在文化大革命中和一切工作中的领导作用。工人阶级也应当在斗争中不断提高自己的政治觉悟。

首都工农毛泽东思想宣传队　北京市第一建筑工程公司革命委员会

一九六八年八月五日

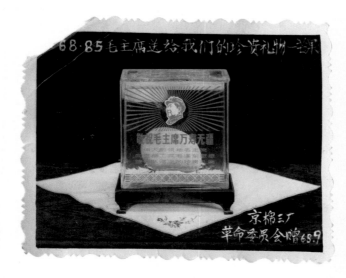

68.85 毛主席送给我们的珍贵礼物——芒果

京棉三厂革命委员会赠 68.9

145

III The People's Liberation Army

Once lavishly praised in newspapers, the People's Liberation Army is seldom visible in extant artifacts. Nevertheless, the army was of crucial importance during the Cultural Revolution. It both orchestrated the cult of Mao and provided a stable power base for the Maoist faction of the Party, ready to step in when things got out of control.

When Lin Biao became Minister of Defense and Great Deputy Commander of the PLA in 1959, he began to transform the army into a "Great School of Mao Zedong Thought," focusing on the political education of its soldiers. Just four years later the army was held up as a model for the whole nation in the campaign to "Learn from the PLA." In May 1964 the army's Political Department published a short version of Mao's pronouncements. *Quotations of Chairman Mao,* known as the Little Red Book, was printed in more than one billion copies and would become a vital accessory during the Cultural Revolution. It had to be displayed and quoted when beginning the work day, when purchasing items, and when making a public statement or publishing an essay.

At the beginning of the Cultural Revolution students and workers were called to carry out revolution from below and seize power. But as factional fighting erupted, the movement became increasingly chaotic. In early 1967 the army was ordered to move in. In February and March, while disbanding and sometimes attacking radical student and worker organizations in the provinces, the army arrested, killed, or wounded thousands of activists. On 30 March 1967 Mao propagated the idea of "three-in-one" combinations—representatives of the PLA, "revolutionary cadres," and "revolutionary masses"—to form revolutionary committees as new institutions of leadership. By mid-1968 such committees had been established in every province. Although Mao spoke of "Great Alliances," these committees were dominated by the PLA. More than one-third of its members and 70 percent of its chairmen were military officers.

Although the army had been instructed to restore order in the country in September 1967, factional fighting continued until the summer of 1968. The last battles were fought where the movement had begun, in Beijing's universities. On 27 July a Worker-Peasant Mao Zedong Thought Propaganda Team of about thirty thousand people was sent into Qinghua University to bring the campus under control. The PLA was not mentioned as part of the team, yet many of the team members were actually soldiers. To acknowledge that the army was needed to occupy factories and university campuses would have implied that the country's state of emergency was indeed dire. Rather than calling attention to the PLA, Mao promoted the working class as "Leaders in Everything."

14 Rectangular vitrine
 for facsimile mango
 December 1968,
 glass, fabric, wood
 21.7 × 26.0 × 13.6 cm

This vitrine is one of the rare objects directly mentioning the People's Liberation Army's collaboration with the Capital Worker-Peasant Mao Zedong Thought Propaganda Teams in occupying factories in late 1968.

On the front Mao is shown wearing an army cap, his head surrounded by a halo of light. The interior of the front pane of glass has printed, "Respectfully wishing Chairman Mao eternal life," and then, in smaller characters, "The precious gift presented by Great Leader Chairman Mao to the Capital Worker-Peasant Mao Zedong Thought Propaganda Teams – mango. 5 August 1968." These lines are similar to the standard inscription on thousand of vitrines produced from Autumn 1968 onwards.

The inscriptions on the right and left ends of the vitrine are printed on the inside of the glass: "Chairman Mao supports the working class" and "For Chairman Mao the working class has fighting spirit," respectively. It is the handwritten lines on the outside of the back panel of glass that make this vitrine so important. They read: "Mao Zedong Thought Propaganda Teams of the People's Liberation Army stationed in factories, presented by No. 4 Workshop's Proletarian [Cultural] Revolution Faction. 1968.12.26."

26 December 1968 is not a random date. It was Mao's 75th birthday. From 1966 onwards Mao's birthday was celebrated by his followers to prove their unquestioning loyalty.

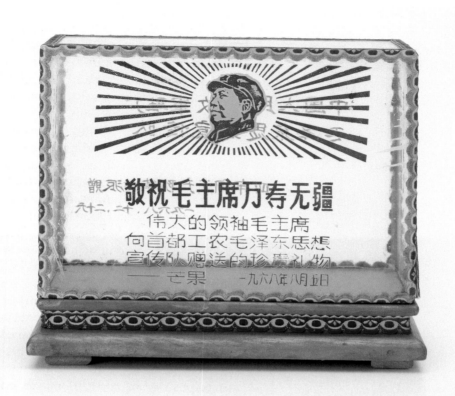

敬祝毛主席万寿无疆
伟大的领袖毛主席
向首都工农毛泽东思想
宣传队赠送的珍贵礼物
——芒果 一九六八年八月五日

中国人民解放军驻厂
毛泽东思想宣传队

四车间无产阶级革命派赠
一九六八·十二·二六

毛主席给工人
阶级撑腰·

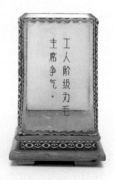

工人阶级为毛
主席争气·

15 Mug with lid and design of
 seven mangoes
 1968, industrial enamel
 H. 13.6 cm, Ø 10.7 cm

In People's Liberation Army propaganda the number seven was significant. During 1968 and the first half of 1969 the PLA actively promoted the "Three Loyalties and Four Boundlesses" *(san zhongyu si wuxian)*. Citizens were adjured to be loyal to Mao, to his thought, and to his proletarian revolutionary line, and to surrender to him boundless love, boundless faith, boundless adoration, and boundless loyalty. The seven mangoes surely refer to that movement.

This brilliantly colored mug shows a plate of seven mangoes floating under a very red sun. Supplied to Capital Worker-PLA Mao Zedong Thought Propaganda Teams in August 1968, the design's orange rays of sunlight radiate toward the back of the mug, where a directive by Mao Zedong is printed: "Our country has a population of 700 million; the working class is the leadership class." The prominent "1968.8" that is printed below commemorates the date of both the gift and the policy shift from students to workers (backed by the PLA) as leaders of the Cultural Revolution.

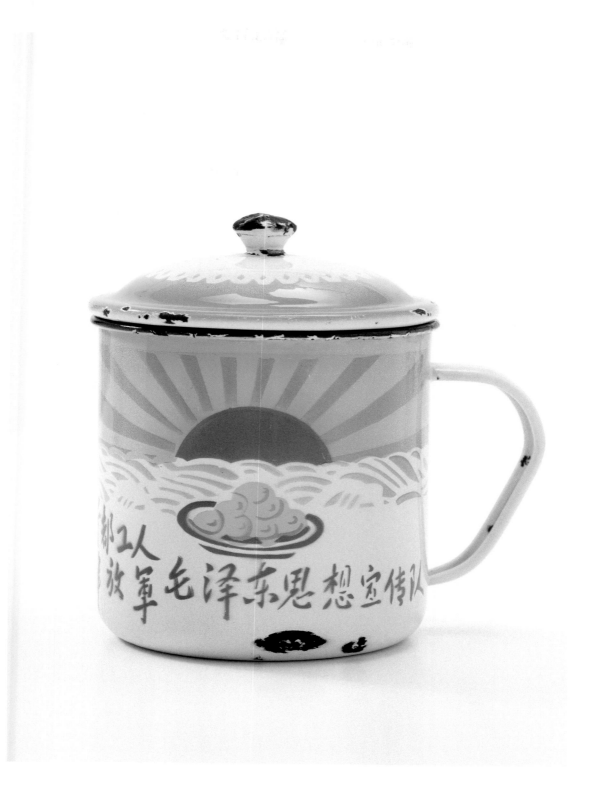

16 Quilt cover with
 design of heroic
 peasants and soldiers
 1968–1969,
 printed cotton
 133 × 77 cm
 (single loom width)

Groups of peasants and soldiers holding up the Little Red Book of Mao's sayings that is emitting sunrays appear among peony flowers on this quilt cover. In another group, proclaiming the unity of soldiers and peasants, the soldier is carrying a great bundle of grain. One heroic soldier is standing guard, solemnly watching the sun rising over the sea. The quilt bears the slogan "Respect the PLA, learn from the PLA."

Only by implication does the legend make known that students were no longer leaders of the Cultural Revolution— by the millions they were being sent, or were volunteering to go, from their schools in the cities to the countryside. Nor is the true identity of their successors explicitly stated. Nominally the workers were now in charge of the Cultural Revolution, but it was the People's Liberation Army that was running the show.

17 Badge
 December 1968,
 aluminum, red enamel
 Ø 5.0 cm

18 Badge
 February 1969,
 aluminum, red enamel,
 Ø 5.0 cm

Badges carrying the image of Mao Zedong were an integral part of the cult of Mao and one of the standard insignia of the Cultural Revolution. Prior to 1966 badges were mainly issued as awards for meritorious service or in commemoration of important events. Produced in small numbers, they were distributed to select groups of people. But with the beginning of the Cultural Revolution mass production started. Estimations of the number of badges produced between 1966 and 1971 vary between 2.5 and 5 billion. This would mean that each Chinese owned between four and six badges.

On this badge small characters, half covered by red enamel, proclaim that Mao Zedong is kinder than the sea is deep. The single mango on the plate stands out clearly. The back of the badge declares loyalty and records the first anniversary of the establishment of Beijie ge weihui on 26 December 1968, which might be the Revolutionary Committee of Beijie. 26 December is also Mao's birthday.

This badge was issued in February 1969 by PLA Unit 8122. In taking the leading role in promoting the cult of Chairman Mao, the PLA was producing badges on a great scale. Army units in virtually every province, city, and county established a "Respectfully Manufacture Mao Zedong Badge Office," which handled design, production, and distribution of raw materials. [11]

Although it is said that the military units made many of the better-crafted and exquisite badges, the nine mangoes at the bottom of this design look a lot like tomatoes. But the inscription on the back confirms their botanical identity: "With each mango dedicating a red heart."

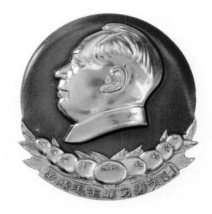

155

IV Objects Issued by Work Units

Although the cult of Mao was promoted by the state and orchestrated by the PLA, in 1968 it was elevated to supreme height by the fanatic support of many of the populace. When the workers were declared the new leaders of the Cultural Revolution, many work units celebrated by issuing their own products featuring the mango.

Even if a factory or unit did not belong to those controlled by the Central Committee that had sent their workers in to quell the unrest at Qinghua University and who were rewarded with a fresh mango, they could still produce artificial mangoes and distribute them to their workers. Most of the vitrines enshrining the mangoes carried a standard inscription commemorating the event with the addition of the word "facsimile."

To show their enthusiasm for the Cultural Revolution and their loyalty to Mao, work units designed everyday goods carrying slogans, symbols, and their unit's name to be distributed to the workers. Badges featuring an image of Mao Zedong with slogans and symbols were produced in great numbers. Units or organizations could design and produce their own badges, or they could obtain them from one of the specialized badge factories. Those factories—the largest of them employing over four hundred designers and technicians—refused payment for their work. All together it is estimated that up to fifty thousand different designs existed. In late 1968 and early 1969 the mango figured prominently on some of the badges.[12] Manufacturing badges was officially encouraged but not controlled by the state until 12 June 1969 when the Central Committee of the CCP prohibited further production of Mao badges without prior approval.[13]

19 Round mango vitrine with standard inscription and row of seven sunflowers
1968–1969,
glass, red enamel
H. 19.0 cm, Ø 16.8 cm

The fresh mangoes that Mao had bestowed on the Worker-Peasant Mao Zedong Thought Propaganda Teams at Qinghua University were distributed among those factories that had sent workers onto the campus on 27 July. Soon after, several work units produced their own facsimile mangoes, enshrined in glass vitrines, and distributed them among the factory workers. Most of these vitrines bear the standard inscription "Respectfully wishing Chairman Mao eternal life. To commemorate the precious gift presented by Great Leader Chairman Mao to the Capital Worker-Peasant Mao Zedong Thought Propaganda Teams—mango. 5 August 1968. (Facsimile)."

Nothing distinguishes this vitrine from countless others except for the identification on the back: "Revolutionary Committee of Beijing No. 1 Rolled Steel Factory."

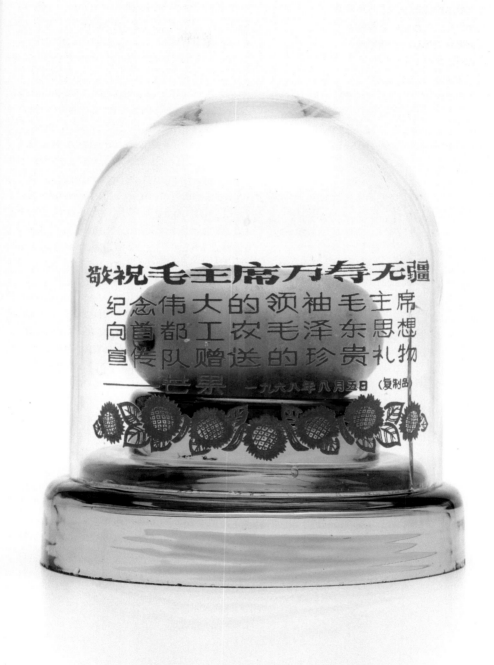

敬祝毛主席万寿无疆
纪念伟大的领袖毛主席
向首都工农毛泽东思想
宣传队赠送的珍贵礼物
——芒果 一九六八年八月五日 (复制品)

20 Badge
 1968–1969,
 aluminum, red enamel
 Ø 4.5 cm

21 Badge
 1968–1969,
 aluminum, red enamel
 Ø 5.0 cm

The vast majority of the badges are round, red in color, and show Mao's head facing left, in accord with the political message. Mao's right profile quickly became taboo.

Here Mao's portrait hovers above the slogan "With each mango, profound kindness," and seven floating mangoes alongside a stalk of wheat. This is a rare instance of mangoes shown without a plate, bowl, or basket. The enamelling is imprecise, overrunning the edges of the mangoes and the wheat. Prominent on the reverse is the character "Loyalty." The issuing organization was the Revolutionary Committee of State-Owned New China Chemical Engineering Plant.

Mao is shown above three flags which can be taken to represent the "Three Loyalties" that the PLA was promoting (see III – 15). The flags may also refer to the Three Red Banners, which indicate three movements of the late 1950s to build up a socialist state: the General Line of Socialist Construction, the Great Leap Forward, aimed to transform China instantly into a modern industrial nation by mass steel production, and the People's Commune movement, organizing agriculture into huge collectives to raise productivity. Although these policies had caused economic chaos, resulting in a famine with an estimated eighteen to forty-two million dead, Mao Zedong never admitted that they were disastrous. In his view they had failed only because people had implemented them incorrectly.

The inscription above the basket on the obverse reads: "Capital Workers' Mao Zedong Thought Propaganda Team." On the reverse we see a declaration of loyalty and wishes for Chairman Mao's longevity, along with "Department of Chemical Industries," which had issued the badge.

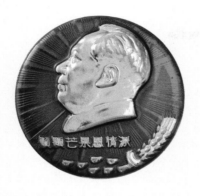

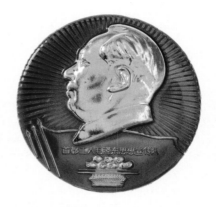

22 Badge
January 1968,
aluminum, red enamel
⌀ 5.0 cm

23 Badge
1968–1969,
aluminum, red enamel
⌀ 5.4 cm

Adorning the obverse is Mao in the usual left profile above a basket of mangoes and the caption "Capital Workers' Mao Zedong Thought Propaganda Team." On the reverse, "Loyalty" is inscribed with a flourish in the indentation formed by the back of Mao's head, and the "Revolutionary Committee of the Metal Tool Workers General Factory" claims issuance of the badge in January 1969.

Below Mao's profile looking left is a plate of three mangoes. Inscribed on the ribbon at the bottom is the slogan of the summer of 1968: "The working class must exercise leadership in everything." No work unit is identified as issuer; the reverse only reads: "Respectfully made by the Committee of the Great Revolution."

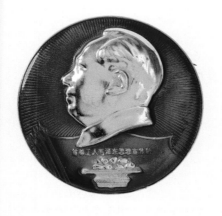 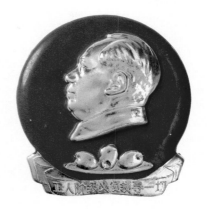

24　Badge
March 1969,
aluminum, red enamel
⌀ 6.0 cm

25　Badge
1968–1969,
aluminum, red enamel
⌀ 6.2 cm

Below and to the right of Mao's profile sit seven mangoes in a beribboned basket. The inscription on the ribbon is consistent with the period's movement: "Forever loyal to Chairman Mao." The reverse states the occasion: "Commemorating No. 8 Machine Factory Activists' attendance at the First Congress to Actively Study and Apply Mao Zedong Thought." In an effort to unite warring factions with common guidelines, "Mao Zedong Thought Study Classes" were established in all units after October 1967.

Contemporary artist Wang Huaiqing noted that only Red Guards and revolutionaries were allowed to paint Mao,[14] which helps to account for a number of mediocre portraits of the Chairman. The slogan on the obverse of this badge says, "Forever loyal to Chairman Mao." Hand-etched into the metal on the reverse is "Beijing No. 2 Machine Tool Factory, Plant 3401."

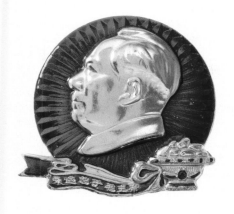
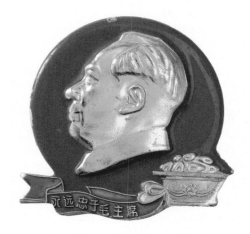

26 Badge
 1968–1969,
 aluminum, red enamel
 Ø 6.0 cm

Beneath Mao in profile and above the seven mangoes on a plate is the slogan "With each mango, profound kindness." On the reverse the top line reads: "Memento of Chairman Mao presenting a precious gift to the Worker-Peasant Propaganda Teams." The second line names the presenting work unit: "Vehicle Maintenance Bureau of the Henan Public Security Department."

27 Badge
 1968–1969,
 aluminum, red enamel
 Ø 4.9 cm

Above a plate holding seven mangoes is the left-facing profile of Mao, and between these two standard motifs the slogan "With each mango, profound kindness."

On the reverse, we see a wish for Chairman Mao's longevity, and three characters in the indentation formed by Mao's head in intaglio on the obverse. These three characters denote Halinji, referring to the National Bureau of Forestry in Harbin, Heilongjiang Province. Founded in 1958, the research institute studies mechanical equipment and forestry techniques.

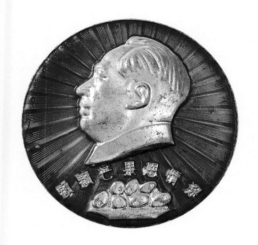 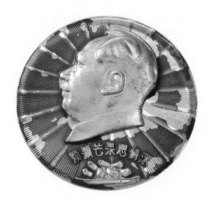

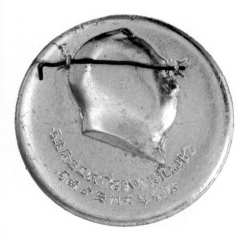 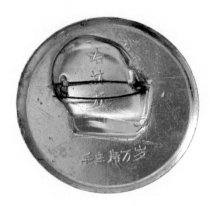

28 Large roundel with
portrait of Mao and plate
with seven mangoes
1968, steel plate, partly
tin plated and lacquered
Ø approx. 60 cm

This monumental replica of a badge
was made by a machine repair factory.
As was common, Mao is shown in
profile looking to the left. Below his pro-
file head a plate of seven mangoes
appears. Head and mango were manu-
factured separately and riveted onto
the roundel. On the reverse a slogan
is crudely written with a paintbrush:
"With each mango, profound kindness.
Machine Repair [Factory] respectfully
made."

Scale is one way to demonstrate impor-
tance. Only Mao could appear monu-
mental, whether in newspaper hyperbole,
in painting, or in sculpture. Mao's wife,
Jiang Qing, did caution against gigan-
tic sculptures of him, but only "because
when they're that big it is difficult to
achieve a good resemblance."[15]

Workers of Beijing No. 1 Machine Tool Plant
presenting big roundels produced by their
factory, *People's Liberation Army Daily,*
6 October 1968

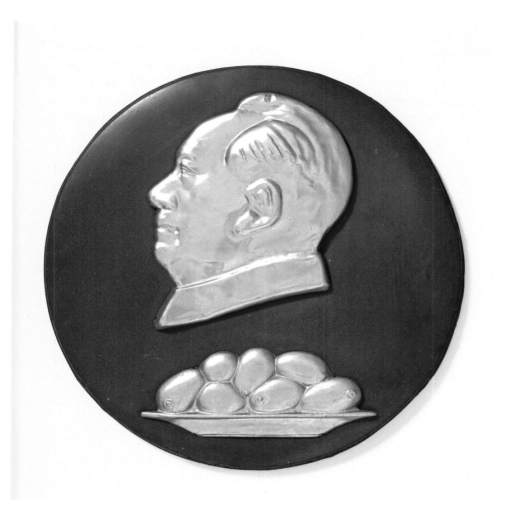

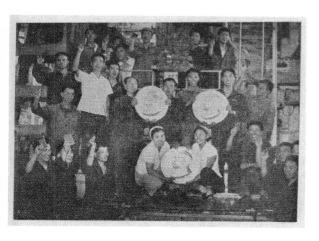

169

29 Mug with design of
 mangoes on a plate
 January 1969,
 industrial enamel
 H. 9.0 cm, Ø 9.5 cm

A two-tone undulating red ribbon complements the design of six or more mangoes on a green plate. The large characters above wish Chairman Mao limitless longevity. Eight small characters at the lower right abbreviate the name of the issuing organization: "Meeting of Working Class Representatives of the Revolutionary Committee of Bei[jing] Clock [Factory]."

The legend likely refers to the Beijing Clock Factory that was established in 1953 to consolidate several established makers of timepieces. The designs of their colorful alarm clocks took themes from daily life, including chickens pecking and students waving Mao's Little Red Book in syncopation with the seconds. With the beginning of the so-called ping-pong diplomacy in 1972, when first official contacts between China and the United States were taking place on the occasion of national table tennis matches, the clocks showed moving ping-pong paddles.

A seal on the bottom of the mug reads: "The Masses' Beijing Daily Use Enamel Factory." It is dated January 1969.

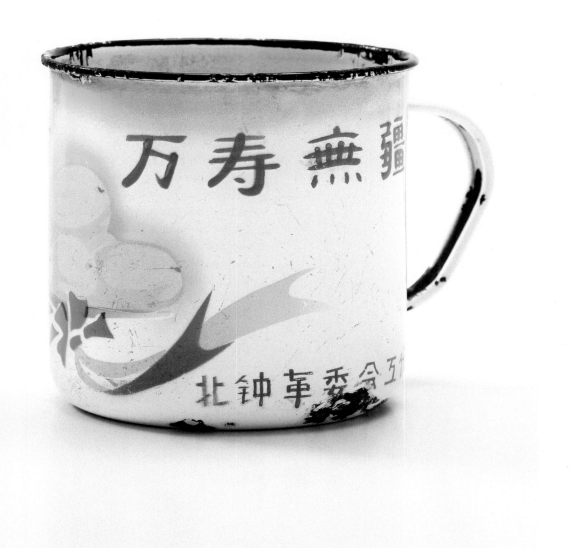

30 Rectangular vitrine for
facsimile mango,
produced by the steel
workers
1968–1969, glass, steel
17.5 × 19.5 × 13.5 cm
Facsimile plastic mango
13 cm

Steel workers must have welded this su-per-sturdy green metal frame for the glass panels that display their facsimile mango. On all four sides the base flares out from the rectilinear glass panels.

Inside the front pane is affixed a decal on which gold characters against a sea of red flags quote Mao: "The working class must exercise leadership in everything. Mao Zedong." The characters affixed to the outside of the back pane are fugitive, but still readable: "With each mango, profound kindness," followed by "Steel workers display loyal hearts."

Steel production was given great importance as a means and a symbol of modernization. After Liberation, China's industrialization strategy paralleled that of the Soviets in the 1930s, putting preference on large-scale manufacturing and heavy industry, notably metallurgy. Having received huge infusions of technology from the Soviet Union in the mid-1950s, steel production was dramatically reduced at the end of the decade by the Great Leap Forward, based on the woefully misguided notion that steel could be produced in backyard furnaces. But by the mid-1960s, steel production had rebounded and in 1965 was more than double that of 1957.[16]

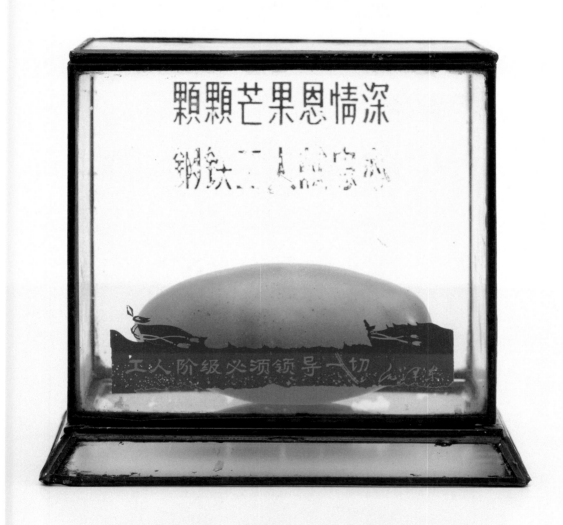

V Marketing Mangoes: Consumer Goods to Foster Loyalty

Mao was convinced that only a radical change of ideology would lead to a change in society. Therefore breaking with all tradition was a necessity. Old symbols had to be replaced by new ones, or given a totally new meaning. The symbols of luck ubiquitous on everyday goods were now substituted by political slogans. At the same time people wished to demonstrate support for the Party line by amassing politically correct objects. Henceforth, political propaganda penetrated all aspects of life, and mangoes became a cherished design motif.

Household enamelware for everyday use often featured mangoes and mango designs. Some of the pieces were suitable for celebrating revolutionary spirit and a wedding simultaneously.

Political propaganda even invaded the bedroom. Cotton fabric for quilt covers, traditionally carrying designs referring to matrimonial happiness and an abundance of children, now served to communicate political messages. Large cotton printing plants had to come up with several different designs on a daily basis. The designers were anxious to keep up with contemporary developments and to comply with the current Party policy.

In generations past every family would venerate its ancestors and some gods at their family altar. Now the statues of the gods and the ancestor tablets were replaced by devotional objects praising Mao Zedong: a bust of Mao, the Little Red Book, and even a mango in its glass vitrine would be displayed on this altar. Some placed the mango on the radio or on top of the clock, to be constantly reminded of Mao's generosity. If you did not receive a facsimile mango at your work unit, you could purchase one in a department store or at the Agricultural Exhibition Hall.

The cheapest way to display one's political correctness was a badge. More than seventy different badge designs featuring mangoes were made between August 1968 and mid-1969.

31 Tray with design of
mangoes in a bowl
Spring 1969,
industrial enamel
Ø 45 cm

A design of a red bowl holding six or
more yellow mangoes graces this large
tray. One mango lies on the table beside
the bowl. A vase of cheerful posies
and the characters for "mango" complete
the composition. The distressed sur-
face of this jumbo-size tray demonstrates
that it was much used.

Made in the spring of 1969, the tray carries
on the theme of abundance that was
illustrated during August 1968 following
Mao Zedong's gift. Its being produced
in Baotou in Inner Mongolia shows that
the mango was popular even in the
outer provinces of China.

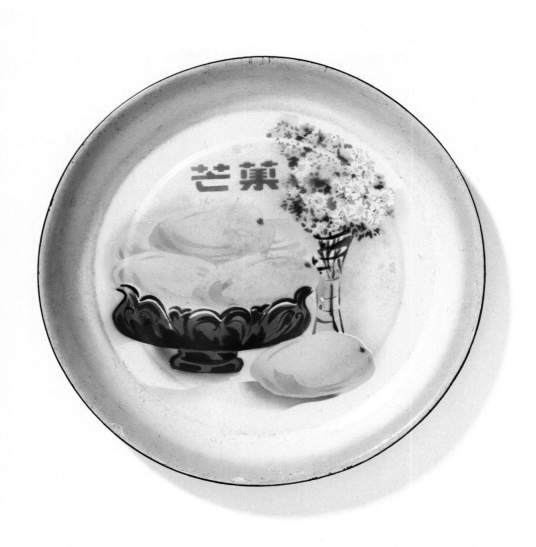

32 Tray with design of
 mangoes on a blue plate
 May 1969,
 industrial enamel
 Ø 32.0 cm

In this design a blue plate above a pink bow holds a pyramid of lemon-yellow mangoes. Below the design is the inscription "With each mango, profound kindness."

One of the slogans circulating at that time encouraged viewing Mao as a father figure: "The heavens are great, the earth is great, but they can't compare with the greatness of what the Party has done for the people. Dear as our parents are to us, Chairman Mao is dearer still." It elevated the Communist Party, and especially Mao Zedong, above the family, while blatantly undercutting filial affection and parental authority.

This tray was designed at the end of January 1969 see V-33, and judging by the factory seal on the bottom, it was popular enough still to be in production in May 1969.

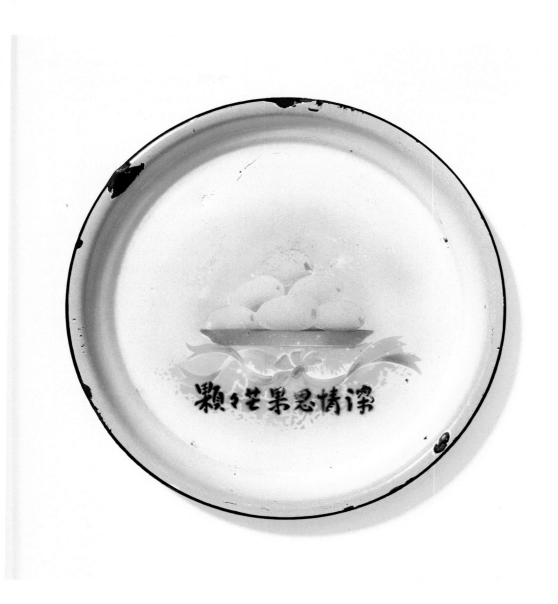

颗々芒果恩情深

33 Design for a tray
January 1969,
watercolor on paper
40.0 × 37.2 cm

This watercolor is a design for an enamel tray, an example of which is in the Museum Rietberg collection v–32. The mound of mangoes on a blue plate is accompanied by the standard inscription "With each mango, profound kindness."

At lower left a stamp with notations overwritten and adjacent demonstrates the process of approvals. Liang Jilan (Jilan, "Seasonal Orchid," is presumably a woman's name) designed the 32-centimeter tea tray on 28 January 1969. Sun Yutang approved the design on the same day, but scribbled an instruction to get rid of the grid and to make the pink peachier.

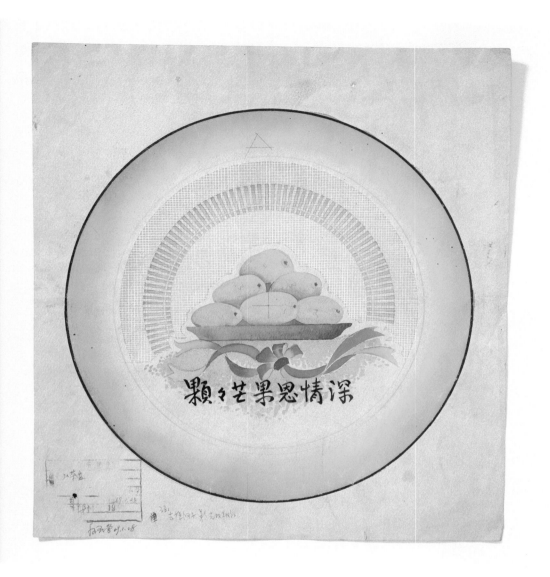

颗々芒果恩情深

34 Tray with design of cog,
 Mao's Collected Works, red
 flags, and the slogan "The
 working class must exercise
 leadership in everything"
 September 1969,
 industrial enamel
 Ø 32.0 cm

The enthusiasm with which some workers embraced Mao's recognition and his directive to take charge—particularly of education—must have surprised the Cultural Revolution leadership.

China has a tradition of celebrating the wisdom of the butcher and the fisherman, seemingly simple folk who have insights that the highly educated lack. Still, to ask the working class to educate college professors and students of the major universities was daunting for most of the smart but ill-educated workers. As one commented, "Was that ridiculous or what?!"

On the back of the tray a Shanghai factory seal is dated September 1969: "The Masses State-Owned Shanghai No. 1 Enamel Factory 69–9."

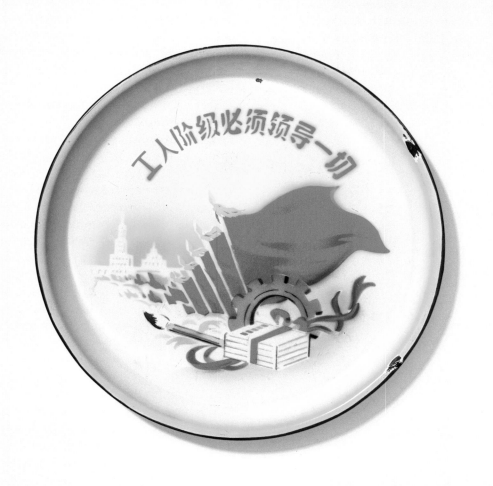

35 Washbasin with design of
 a mango branch
 Ca. 1968, industrial enamel
 H. 10.2 cm, Ø 34.5 cm

Grown in India and South Asia for millennia, mangoes are proclaimed as the national fruit of India, Pakistan, and the Philippines. Mangoes were also grown in China, albeit in the south, primarily in Guangzhou and on the Leizhou Peninsula. Unknown in northern China in the summer of 1968, the mangoes became utterly magical once they had the Chairman's imprimatur.

Because of the mangoes' initial wildly enthusiastic reception in China, the Pakistani government sent a gift of one hundred varieties of mangoes and one hundred different mango seedlings, which arrived in Beijing on 31 August 1968. Pakistani officials soon discovered, however, that the excitement was not about the mangoes per se, but rather about the emotional intensity generated by a gift from Chairman Mao.

The design in this washbasin, with the rarely depicted mango foliage, may have been inspired by the seedlings that arrived from Pakistan. For the uninitiated, two red characters, *mangguo,* label it.

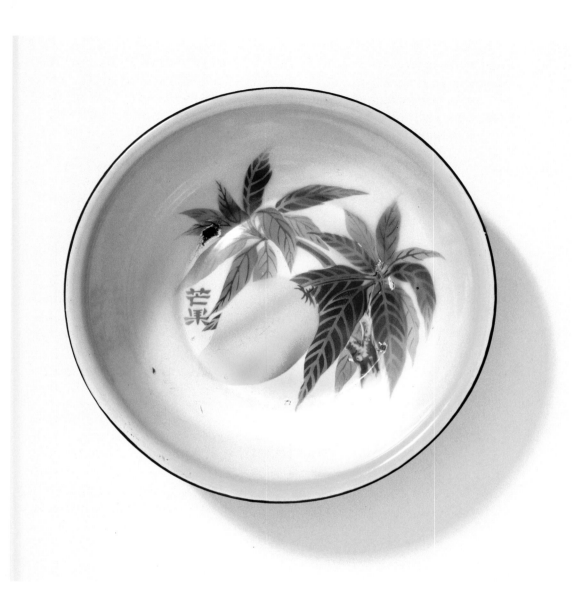

36 Tray with design of
mango and the character
for "Double Happiness"
December 1969,
industrial enamel
Ø 31.2 cm

This design was one of the most popular among the mango artifacts. One huge mango rests on a blue plate against a red ground. The background is stenciled with the slogans "With each mango, profound kindness" and "Double Happiness." Red hearts border the circle.

Double happiness was primarily associated with weddings and the birth of sons. In 1949, however, it became a joyful emblem of the success of the peoples of China and the Revolution. Those shopping for a wedding present would be pleased to combine the politically correct design with the practicality of the tray. Marriages, of course, and therefore weddings, had to be approved by one's work unit, which functioned *in loco parentis*.

Finding an appropriate and affordable wedding present was a challenge. This kind of tray would likely have been beyond the means of the average worker. Six to ten coworkers might have pooled their resources to buy such a gift.

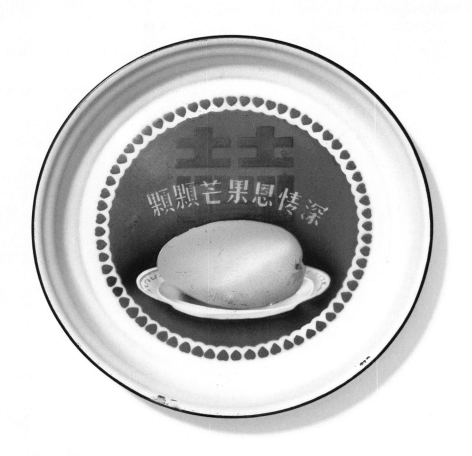

37 Badge
 1968–1969,
 aluminum, red enamel
 Ø 4.4 cm

38 Badge
 1968–1969,
 aluminum, red enamel
 Ø 2.7 cm

Mao badges reached their height of popularity and the zenith of production in 1968 and 1969. Each work unit and many other organizations as well as the official badge factories competed to produce larger and more dramatic demonstrations of loyalty. Since 1967 badges had become collectors' items. When new designs appeared in the shops officially selling badges, people would queue for hours to get hold of one, before they were sold out. In the cities, badges were exchanged and traded on well-known "black markets." To wear an especially rare or big badge would considerably enhance the status of its owner.

This badge carries the slogan "With each mango, profound kindness" on its obverse and "Long live Chairman Mao" on the reverse.

Generic badges like this were for sale at factory and street shops for fractions of a penny. Their price was normally far below production costs. Here Mao is shown, as always, in left profile, with a single mango on a plate below. On the reverse is cast "Long live Chairman Mao. Jiangsu 19. Receiving the precious gift—mango."

189

39 Badge
 1968–1969,
 aluminium, red enamel
 Ø 5.2 cm

40 Badge
 1968–1969,
 aluminum, red enamel
 Ø 5.4 cm

This and the following two badges are among many artifacts that feature seven mangoes. Given the perennial enthusiasm for numerology, it is not impossible that the number refers to the PLA movement that was being promoted during 1968 to June 1969: the Three Loyalties and Four Boundlesses, which encompassed, respectively, loyalty to Mao, to his thought, and to his proletarian revolutionary line, and boundless love, boundless faith, boundless adoration, and boundless loyalty.

The inscription says: "Forever loyal to Chairman Mao"; the reverse is inscribed "Loyalty" and "Respectfully wishing Chairman Mao eternal life."

Below the inescapable profile on the obverse, a plate of seven mangoes accompanies the message "With each mango, profound kindness." On the reverse, an inscription wishes Chairman Mao long life.

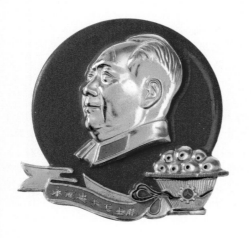
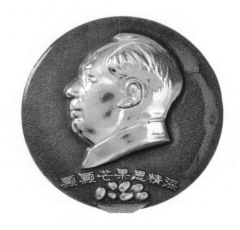
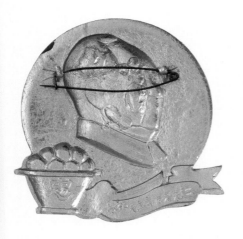

41 Badge
 1968–1969, aluminum
 ⌀ 5.4 cm

42 Golden yellow badge
 1968–1969, plastic
 ⌀ 4.0 cm

A cast aluminum badge looked gray before lacquering. This unfinished badge shows a cog, emblem of the workers, decorating a basket tied with a long ribbon. The inscription reads: "Forever loyal to Chairman Mao." The back is not inscribed.

On the obverse of this badge made of plastic, seven mangoes appear next to a stalk of grain, referring to the peasants. This combination of elements is also seen on IV–20. Here the slogan is "With each mango, profound kindness." On the reverse is the *jin* character of Tianjin and the numeral 8, presumably indicating a series.

Plastic was one of more than twenty materials out of which badges were made and it became even more important after June 1969 when a circular by the Central Committee prohibited manufacturing aluminum badges without approval by the Party center. The "Mao badge fever" subsequently cooled. After the fall of Lin Biao in 1971 it became inappropriate to wear them and people slowly began to dispose of their collected badges. A directive of 1980 decreed that badges should be officially handed in for recycling. By 1988, an estimated 90 percent of Mao badges had been destroyed.

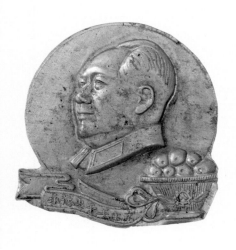
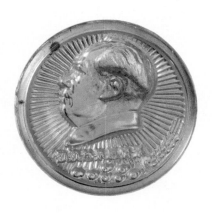

193

43 Badge
 Probably modern,
 1990 or later,
 aluminum, red enamel
 ⌀ 4.0 cm

Several features of this badge suggest that it is not original to the Cultural Revolution. A plate holding one mango hovers beneath Mao's profile and above a cast slogan rendered almost illegible by thick red enamel and overlapping spokes of light: "Chairman Mao will forever be heart to heart with workers, farmers, and soldiers." What should be a prominent feature of the badge is obscured. On the reverse is a wish for long life for Chairman Mao and, in minuscule characters, "Made by Beijing Red Flag." A little splash of red enamel on the back might be due to inexperience or to newness.

In the late 1980s badges started to appear on flea markets in China and soon became commodities of value. By 1993 trade in Mao badges had become so lucrative that elaborate fakes had appeared.

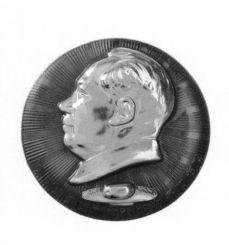

195

44 Two posters of Mao Zedong
in front of a parade
1969, color printing on paper
Each 72.0 × 106.3 cm

Standing before a sea of red flags with hands clasped behind his back, Mao Zedong looks heroic and pleased. His Zhongshan jacket is the civilian version, without military bars on the collar. The artist Chen Qiang of Xinhua Publishers painted a 1968 version without mangoes in which the discrepancy of size between Mao and the masses was less dramatic. Madame Mao (Jiang Qing) did not approve. She asked Chen Qiang to make Mao larger, the people smaller, and to add the plate of mangoes.[17] The resulting painting was made into this poster.

In the detail on the left, workers, peasants, and soldiers march joyfully together. A powerful worker lifts a huge plate of mangoes aloft aided by a woman peasant and, somewhat obscured to the left, a soldier. The obfuscation was intentional, because the workers were to be the leaders of all, with peasants and soldiers playing supporting roles. The military is visible but off to the left. One of the huge banners at the back, however, reads: "China People's Liberation Army Mao Zedong Thought Propaganda Team."

Everyone in the parade raises their Little Red Books in unison. The bounce in their steps was no doubt timed to the booms produced by the exuberant drummer. Large red characters proclaim: "Forging ahead courageously while following the Great Leader Chairman Mao."

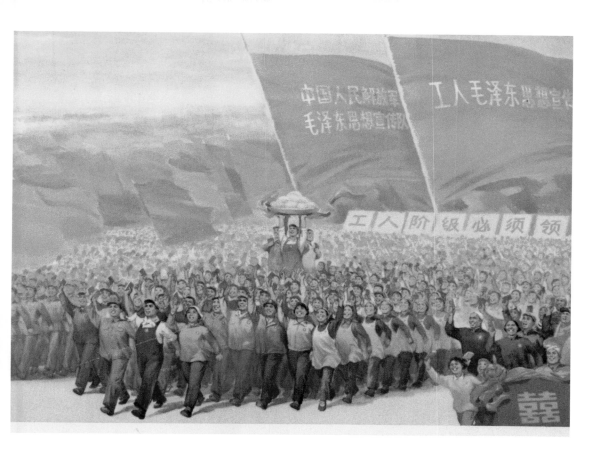

A Xinhua Publishers sketch.
Printed at People's Art
in Shanghai, March 1969,
first edition. Number 6910101 (32).

B Xinhua Publishers sketch.
Printed at People's Art
in Shanghai, June 1969,
fifth edition. Number 69118 (28).

紧跟伟大领袖毛主席奋勇前进！

紧跟伟大领袖毛主席奋勇前进！

45 Rectangular mango
 vitrine with likeness of Mao
 and standard inscription
 1968–1969, glass, red enamel
 20.3 × 14.0 × 9.0 cm
 Papier-mâché mango
 13.0 cm

You were not in one of Mao's six personally directed factories nor in the units controlled by the 8341 Corps (the security detachment of the Central Committee) that sent workers onto the university campuses in Beijing (Qinghua and Peking Universities), so you did not get a facsimile mango. You were not among the activists who were issued mangoes after volunteering to move to the far west and south of China to advance Mao Zedong Thought. Your house is without a mango. What to do?

In Beijing you could buy one at your local department store. It bears the standard inscription of the mango vitrines distributed widely among the factory workers compare IV–19, V–46, except for not naming a work unit: "Respectfully wishing Chairman Mao eternal life. To commemorate the precious gift presented by Great Leader Chairman Mao to the Capital Worker-Peasant Mao Zedong Thought Propaganda Teams – mango. 5 August 1968. (Facsimile)."

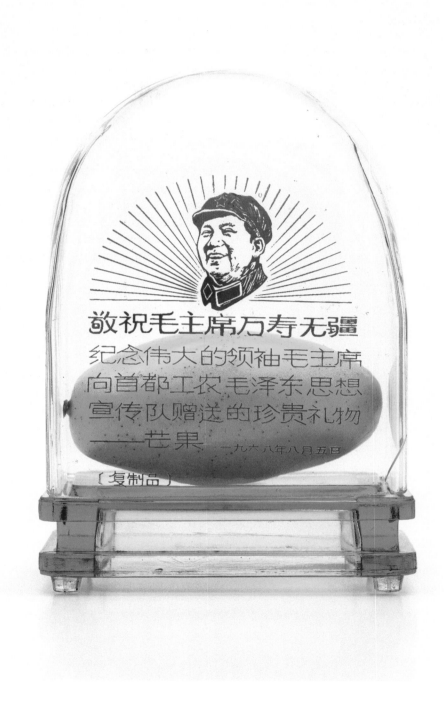

敬祝毛主席万寿无疆

纪念伟大的领袖毛主席
向首都工农毛泽东思想
宣传队赠送的珍贵礼物
——芒果 一九六八年八月五日

〔复制品〕

46 Mango vitrine with
 standard inscription
 1968–1969,
 Glass, red enamel, cloth
 26.0 × 22.0 cm
 Papier-mâché mango
 13.1 cm

Political symbols aim to generate compliance, support, and solidarity. In his study of the efforts of the Tang dynasty (618–906) to gain legitimacy, Howard Wechsler points to the manipulation of symbols that typically accompany political movements. Texts give the content of precepts that should be believed and followed. Objects such as flags and insignia provide a focus for emotional attachment.[18]

The mango was a potent symbol because it was given by an adored authority figure and empowered those previously of low status.

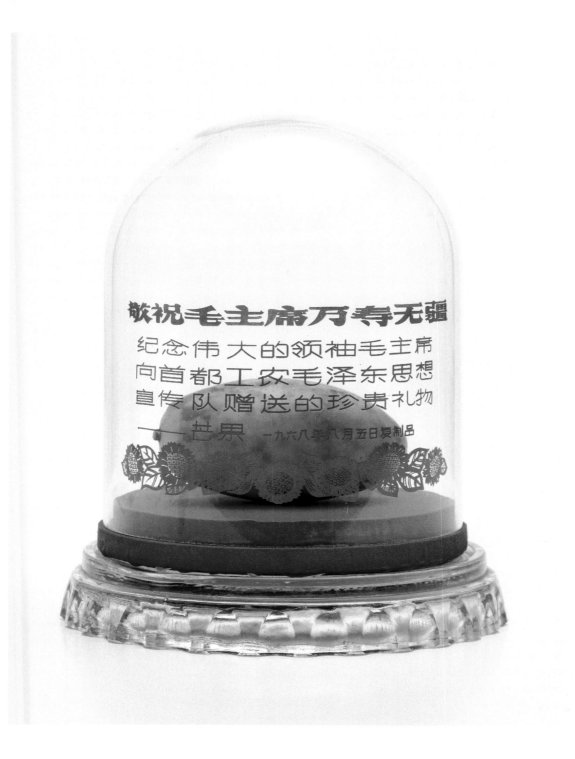

敬祝毛主席万寿无疆

纪念伟大的领袖毛主席
向首都工农毛泽东思想
宣传队赠送的珍贵礼物
——芒果 一九六八年八月五日复制品

47 Quilt cover with design
 of mangoes, sunflowers,
 and the rising sun over
 a sea of red flags
 1968–1969, printed cotton
 177 × 152 cm
 (double loom width)

Symbols that thrive have, at minimum, an internal logic. In many cultures a king was linked to the sun, lofty in the firmament, bringing the benefit of warmth, and dazzling the eyes of mere mortals with light. Similarly, blossoms that daily rotate following the sun (such as mallows and sunflowers) can be understood as loyal subjects looking to the ruler. For centuries Chinese poets had employed the "flower that faces the sun" *(kui hua, xiangri kui)*. The sunflower, a perfect simile, was thoroughly familiar to Chinese propagandists and their audience.

On this quilt cover, a tray of mangoes rests beneath red flags and a rising sun. Lush sunflowers surround the sun and the mangoes. As the design repeats, the blossom in front is oriented downward to the sun below it. These motifs are flanked by two architectural wonders—the Great Wall and the Nanjing Bridge spanning the Yangzi River. The Great Wall represented heroic struggle ending in success over hostile enemies in mountain terrain. Because the construction of the Nanjing Bridge was completed after the withdrawal of Soviet advisors, it represented both industrial progress and indomitable self-reliance. The pairing of mountains *(shan)* and a river *(shui)* echoes the traditional concepts of landscape and landscape paintings *(shanshui)*.

205

48 Quilt cover with design of
 mangoes on a cog in front
 of Nanjing Bridge
 1968–1969, printed cotton
 192 × 154 cm
 (double loom width)

If there were any doubts about whose brawn built the Yangzi River Bridge at Nanjing, this quilt cover puts them to rest: The Workers!

Three monumental mangoes are raised up on wheat stalks topped by cotton balls, which in turn emerge from a cog, a symbol of the working class. The flower is the fanciful hybrid that was so popular in these textile designs, a sunflower much resembling a peony, the latter a symbol of wealth and social position.

The ambitious two-level vehicular and rail bridge at Nanjing was a complicated engineering project. The first bridge to span the lower reaches of the Yangzi River, its construction was guided by Soviet experts until they were withdrawn after a falling-out between the PRC and the USSR in 1960. Chinese workers (directed by Chinese engineers) managed to complete the project in 1968. The bridge opened to great fanfare and outpouring of pride on National Day, 1 October. Had it not been for the mango, the Nanjing Bridge might have been the focus of the National Day parade.

49 Quilt cover with design
 of students with backpacks
 1968–1969,
 printed cotton, 194 × 77 cm
 (single loom width)

With bedrolls on their backs, students splash through mountain streams and assault precipitous hillsides. One of the group pauses to inscribe a cliff face. A second group makes a campfire in the countryside. These two scenes illustrate the slogan "Up to the mountains, down to the countryside" *(shang shan xia xiang)*, which summarizes the fate of millions of students in 1968.

After Mao's gift, mangoes came to symbolize the working class taking charge of the Cultural Revolution. That student Red Guards had been discredited and ordered to step down was not mentioned, nor was the presence of the People's Liberation Army.

Additional symbolic meanings assigned to the mango were appropriated from the "longevity peach." Since antiquity peaches had been associated with the Queen Mother of the West, in whose garden grew magical peach trees that fruited only once a millennium. Eating one of those sublime peaches ensured long life. The mango—like the peach—symbolized a wish for a prolonged and healthy life.

50 Quilt cover with design of
 mangoes on a cog
 1968–1969, printed cotton
 204.5 × 150 cm
 (double loom width)

As if radioactive, six mangoes emit an eerie glow as they rest on a cog representing the working class. Framing them is a branch of plum blossoms, a likely reference to Mao, who enjoyed writing poems about flowering plum trees. Mao no doubt admired the heartiness of the plum tree, which for more than a millennium was regarded as a symbol of rejuvenation because it blossoms when it appears to be dead. If the pink plum blossoms are a symbol of Mao, then the combination of motifs communicates that Mao—who was regarded as politically dead after the disastrous Great Leap Forward—has revived to lead the Cultural Revolution and support the workers.

51 Magenta quilt cover with
 design of a basket of
 mangoes, trains, farms,
 and factories
 1968–1969, silk damask
 182 × 141 cm

During the Cultural Revolution, unlike printed cottons on which patterns repeat, silk and synthetic quilt covers had one overall design. The figured weave produces a reversible fabric. It was therefore more challenging to create a pleasing design in monochrome damask, whether silk or synthetic fibers, but the mechanized weaving technique was based on silk damask for which Chinese manufactures had millennia of experience.

This design has all the elements necessary to celebrate the worker-peasant alliance. A basket of mangoes bears a clear label for those who did not recognize them. The three mangoes sit in a basket decorated with tassels and topped by a jolly ribbon. In a mirror image, two steam-belching trains converge toward the center of the design. The trains are set against agricultural fields where tractors are working. In the distance, the productivity of factories is indicated by the smoke pouring from the chimneys. In the lower center of the design, the line of the train tracks is continued by the spokes of light from the torch of the revolution that burns above a sea of flags.

The characters at bottom center identify the factory: "Product of the State-Owned No. 1 Zibo Silk Weaving Mill." Historically the city of Zibo, Shandong Province, provided silk for the imperial court and for trade across Central Asia.

52 Quilt cover with design
 of basket of mangoes,
 sunflowers,
 cog, and row of trucks
 1968–1969,
 printed cotton
 186 × 77 cm
 (single loom width)

The blue cog, a symbol of the working class, stands on edge before a basket holding three mangoes. The sunflowers, pink and lushly petalled, resemble peonies and thus hint at high status. Small trucks probably depict the ones that carried the mangoes through the hinterlands of China.

Among the absurdist literature of the post-Cultural Revolution are accounts of mangoes trucked through towns, villages, and county seats. A Chinese poet recalled the day that her nursery school was taken to see the Mango Truck. Lined up along a small-town road in Sichuan, the children grew restless and hungry as the hours passed, but leaving would have shown lack of revolutionary spirit. Twilight came and still no magical vehicle. Finally, a commotion and the Mango Truck drove past in a cloud of dust. The children never saw the precious mango nor could they imagine it, but they knew it was tremendously important.

215

53 Quilt cover with design
of textile production
1968–1969, printed
cotton
174 × 75 cm
(single loom width)

Fortunately for the history of visual culture, some among the factories that participated in the pacification of the Qinghua campus in July 1968 printed cotton textiles. Foremost among them were Beijing Bed Sheet Factory and Beijing Textile Factory.

This cotton quilt cover depicts four vignettes of textile production amid floral clusters. At the right are piles of yarn and weaving machinery. At the left, yard goods are being woven. In the center, cottons are being printed next to a chart showing soaring output. Lower down and centered is a stamp of authority, which symbolized the workers taking charge, juxtaposed with the three overlapping rings of science.

Accounts in the August 1968 *People's Daily* name other work units that participated in the occupation of the campus: the Jushan Agricultural Commune, factories for vacuum tubes and transformers, No. 2 Machine Tool Plant, New China Printing Plant, and Beijing Knitting Mill see 1–4.

54 Quilt cover with
 design of hammer and
 stamp tied by a ribbon
 1968–1969,
 printed cotton
 192 × 149 cm
 (double loom width)

Even without a mango, the composition on this quilt cover communicates the important message that the working class has the authority to lead. The hammer of the laborer and the stamp of authority are bound tightly together, and the ribbon that ties them configures the symbol for science. A halo of light canopies all three symbols. Beyond the nimbus, sunflowers turn toward the light.

Directly below the hammer is an evergreen called "Green for Ten Thousand Years" *(Wannian qing)*. It reminds us that workers are to be permanently in charge. In the background is a farm and in the far distance factories are at work.

55 Quilt cover with design of numinous mangoes in a basket
Possibly mid-1970s, printed cotton
204 × 158 cm
(double loom width)

This design pairs numinous, radiance-emitting mangoes with a peony, traditional symbol of wealth, prosperity, and society's leading class. Formerly associated with the imperial family, the peony became an emblem of the workers during the Cultural Revolution. Summer hydrangeas and autumn chrysanthemums lend time markers to the design.

The design of this printed cotton is different from the other quilt-cover designs. There are no trucks coming and going, no references to the 1968 parade in Tiananmen Square, no Nanjing Bridge that was dedicated on 1 October 1968, and no electrification. Could it date as late as the mid-1970s? In the fall of 1974 there was an event that might have occasioned its design and manufacture. In September 1974 Imelda Marcos brought mangoes from the Philippines. On the eve of National Day Jiang Qing sent one of the Philippine mangoes to workers at Beihai and Coal Hill Parks. Dutifully the park workers held a ceremony, made speeches, and returned thanks.[19] Although the whole affair missed the electric spark of the 1968 gift— Jiang Qing indisputably lacked even a jot of her husband's charisma—the quilt cover includes a color palate and a saucy ribbon that seem distinctly feminine.

56 Small vanity mirror with
design of mangoes, cog, and
the Little Red Book
1968–1969, glass, metal
22.4 × 15.0 cm

This rectangular vanity mirror displays its user's loyalty to Mao in the lower right corner, where yellow mangoes on a dish are supported by a cog laced with a red ribbon and by Mao's Little Red Book of quotations. The inscription reads: "Long life to Chairman Mao." Evergreens form the background.

On the reverse is a color print of the spirited heroine from *The Red Lantern,* one of the model theatrical works promoted by Mao's wife, Jiang Qing. A former movie actress, Madame Mao was put in charge of cultural affairs for the military in 1966. She immediately exercised her strong opinions about what was appropriate cultural fare for the masses. Entertainment for its own sake and traditional Peking opera were out; revolutionary themes were in. The Eight Model Theatrical Works featured unjustly maligned peasants, oppressed women, and heroic workers who, despite daunting hardships, rose to take revolutionary action. Jiang Qing also promoted the 1976 feature film *Song of the Mango* Essay ⑤, p. 78.

57 Circular wall mirror with
 design of bowl of mangoes
 in front of a sea of red flags
 1968–1969, glass, metal
 ∅ 34.5 cm

58 Circular wall mirror with
 design of mango plate and
 sunflowers
 1968–1969, glass, metal
 ∅ 39.5 cm

Red characters outlined in yellow announce "The working class must exercise leadership in everything." Below is a basin of six yellow mangoes, more than a dozen red flags in sets of three, three sunflowers flanked by evergreens, and a long red ribbon. On the reverse is reproduced a color photograph of Mao's home in Shaoshan, Hunan Province.

Mirrors were considered a good choice for wedding presents. One doctor recounts that when she and her husband, also a doctor, got married, so many patients gave them mirrors that their living-room walls were completely covered.

In Beijing in 2012, when you ask people over fifty what the mango signified, they talk about its magical aura bespeaking Mao's love of the people and especially the working class, even, improbably, his affection for the students (whom he wrested from their studies and sent down to labor in the countryside by the millions).

Seven sunflowers frame seven mangoes on a plate. As on so many Mao portrait badges, the number seven probably refers to the PLA's Three Loyalties and Four Boundlesses see III–15, V–39. In the middle of the row of sunflowers is a large character for "Loyalty" and above them the slogan "With each mango, profound kindness."

In his installation "Golden Apples," the contemporary artist Xu Bing related to this and similar slogans of "compassion" and "socialist consideration," notions deeply embedded in the collective memory of the Cultural Revolution generation. The artwork was created for the exhibition *Provident Harvest: Contemporary Art* in Beijing's Agricultural Exhibition Hall in October 2002, which was partly sponsored by Qixia municipality in Shandong Province, an area famous for apple cultivation. Most of the three tons of apples that were trucked into Beijing Xu Bing had distributed to workers employed or laid off from factories around the capital, accompanied by the message "Golden apples confer warm feelings."[20]

On the reverse of the mirror is a color photograph of Mao's home in Shaoshan, Hunan Province, with visitors waiting in line to enter. A metal band, now rusty, encircles the mirror.

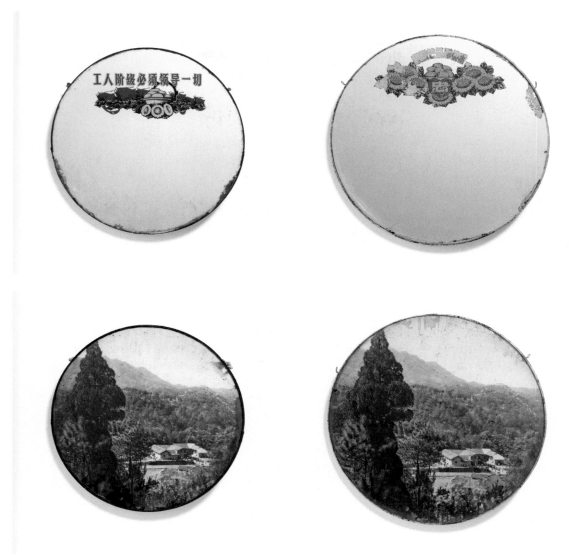

59 "How to sketch a mango"
 Liaoning Province Primary
 School Teaching Materials: Art
 1970, paperback book,
 print on paper
 12.8 × 18.8 cm

Children were presumably guided by their teachers regarding the symbolism of the mango, which is nowhere mentioned in the book; only the authorized method of painting it is described.

The text may be translated,

> "Simple steps to a realistic watercolor:
> 1. On painting paper, use pencil to lightly draw the contours (like figure 1). The object should not be too large or too small; it should be correctly positioned.
> 2. Begin by spreading pale color; leave the highlight untouched.
> 3. Carefully observe the lights and shadows of the form; from light to dark colors, go over it many times. When you have progressed to figure 3, you can paint in the background, and then finish painting the main object."

Here too the mango is given a base to rest on and a sumptuous red background.

配合时，由于各自量的不同，
……那那个颜色的混合色，如紫红
……色少，调配而得。
……色彩是把描绘物体在光的作用
……中的效果，它有几方面的作用，
……运用——主次互相衬托，可以
……写生中的红宝书、蜡笔色的红
…………画不如涂上红色鲜明。
……暖——颜色给人的感觉，大
……是暖的，蓝紫是冷的，但不是
……对比中才能看出来，如在红
……红冷一些，可是紫红比紫蓝
……画有较充分的表现力，如：
……红色、黄色和少量的黄绿等
……飘舞的热烈场景，表现反面
……，黑暗场景，多用蓝紫和蓝
……

……提——物体立体空间关系，
……空气的影响下有亮一些的，
……都附合一定的冷度，即色
……

……，受光面就是呈现暖色的感觉，
……下冷一些，反之也一样。
……立体的描绘，同一个颜色
……偏暖，远的色淡、偏冷（冷
……过份不好）。
……的和过去的也是这个道
……风景大地那么明显罢了。

图一

图二

图三

芒果—水彩写生

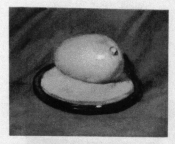

水彩写生简单步骤：

1. 在图画纸上，用铅笔轻轻画出轮廓（如图一），物体在画面上不能太大也不能太小，位置要适当。

2. 从淡颜色开始涂起，把最亮处留出。

3. 仔细观察依据明暗立体，由浅色到深色多次去画，在进行到图三时可画上背景，然后再把主要物体画完。

60 Pencil box with design
 of mango on plate
 1968–1970, metal
 21.0 × 5.0 × 1.2 cm

Printed on the left side of the pencil box cover is a color photograph of a single mango on a plate. On the right is an inscription in gold on red ground: "The precious gift presented by Great Leader Chairman Mao to the Capital Worker-Peasant Mao Zedong Thought Propaganda Teams—mango."

Who used this? Was it just a child's pencil box, or did adults look at it and feel that the Great Leader had their well-being at heart? Or both?

61 Paper wrapper for
 mango candy
 1969, printed paper
 Ca. 7.5 × 6 cm
 Lend by A. Solomon
 and J. Habich

Said to be juicy and sweet, the mango's flavor was the subject of much speculation in China. In his semi-autobiographical collection of short stories, Jin Zhao wrote about a criticism session that was precipitated by a worker eating a precious mango given by Chairman Mao.[21] The worker was accused of having serious Rightist tendencies and was sent from the campus back to the factory with his monthly stipend of eleven RMB cancelled.

This wrapper was printed for a Mango Chew Candy *(Mangguo naibaitang)* made in the city of Tianjin. The small print on the edges reveals that it was the Red Guard Food Packaging Plant. Presumably 69–009 indicates the year 1969 followed by the month or the series.

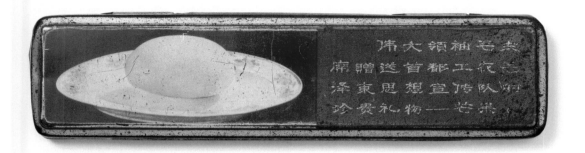

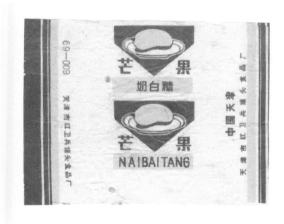

62 Large mango vitrine
 with sunflowers and
 standard inscription
 1968–1970,
 glass, red enamel
 26.6 × 20.0 cm

This large mango vitrine must have cost quite a sum and was surely a cherished item on the Mao altar of its owner. But after the death of Mao and the trial of the Gang of Four in the winter of 1980/1981, the wind had changed. Jiang Qing and her cohorts were blamed for all the atrocities of the Cultural Revolution. The official assessment of Mao, however, adopted in June 1981 after many drafts, was moderate. Mao was said to have committed serious errors but to have had positive intentions. To a population sensitized to Party directives, now was the time to dispose of Mao memorabilia.

In Tianshui, Gansu Province, two young girls were surprised to see revered wax mangoes in garbage heaps. After school they nudged the mangoes out of the garbage and gently kicked them home. They didn't report the rescue mission to their mother, who, they suspected, would consider it too much like stealing. Instead, they hid them under the front steps of the house. The next winter, when Tianshui had power outages and all the shops were out of candles, they confessed to the hidden cache of wax mangoes. Their father rigged wicks, and the mangoes gradually disappeared as they illuminated the kitchen on winter evenings.

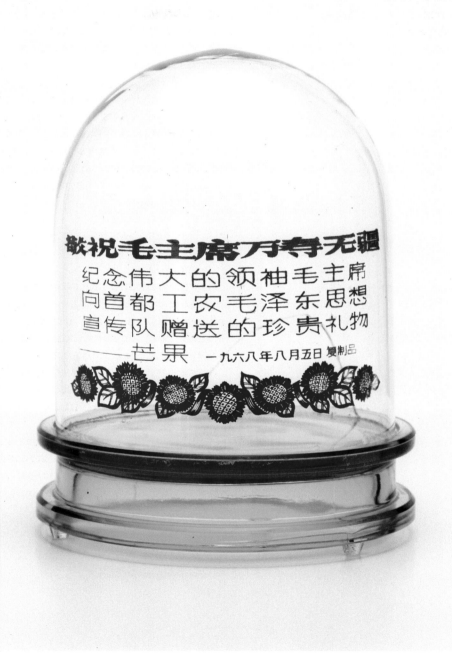

63 Three Mango brand
 cigarette pack wrappers
 1968 – 1983,
 paper, each wrapper
 16.0 × 9.3 cm

Taking advantage of the perception that mangoes were precious and good for your health and lifespan, the state tobacco authority started marketing Mango brand cigarettes in 1968. In 1969 Mango cigarettes outsold all other brands.

Mango brand cigarettes were wrapped in a bright green packet with a picture of one mango on a plate. These three wrappers carry different dates: one has the original date, 1968.8.5, which was part of the trademark until 1972. One wrapper is dated 1983, and one is undated.

According to Jason Sun (Sun Zhixin), curator in the Asian Art Department at the Metropolitan Museum of Art, New York, Mango remained an enduringly attractive brand. As late as 2003 he entertained museum couriers from Henan Province who were smoking Mango brand cigarettes.

64 Two unopened packs
 of Mango brand cigarettes
 Around 1980
 7.0 × 5.8 × 2.0 cm

In China offering a cigarette in leisure moments or during negotiations was a gesture of friendship. Sharing cigarettes was a bonding experience.

During the Cultural Revolution Mango brand cigarettes were the most popular among the working class. But two other brands had superior status: China *(Zhonghua)* were smoked by high-level cadres, and Great Front Gate *(Da Qianmen)* were smoked by people above the status of workers but below cadres. Recently Golden Mango *(Jin Mangguo)* cigarettes made a bid for upscale clientele with a shiny and chic dark-blue box of menthol filter cigarettes, perhaps the last vestige of the mango phenomenon.

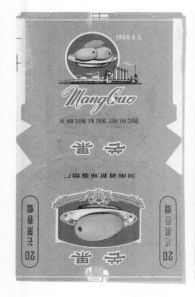

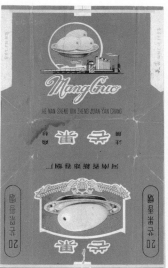

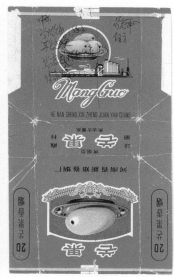

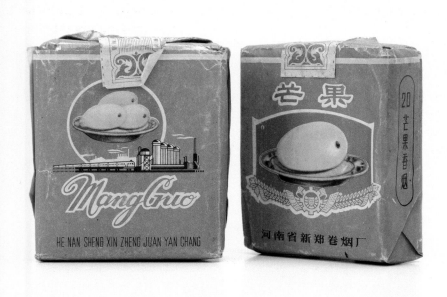

233

Endnotes
Catalog

1 –– Lin Biao's praise for Mao's thought. Cited in Maurice Meisner, *Mao's China and After: A History of the People's Republic*, 3rd ed. (New York: The Free Press, 1999), p. 280.

2 –– *People's Liberation Army Daily* began to publish daily quotations of Mao in the beginning of 1964, *People's Daily* in June 1968. Barbara Barnouin and Yu Changgen, *Ten Years of Turbulence: The Chinese Cultural Revolution* (London and New York: Kegan Paul International, 1993), p. 33.

3 –– Frederick C. Teiwes, "The establishment and consolidation of the new regime, 1949–57," in Roderick MacFarquhar (ed.), *The Politics of China, 1949–1989* (Cambridge: Cambridge University Press, 1993), p. 74. Maurice Meisner, Mao's China and After, p. 280.

4 –– Hinton, *Hundred Day War,* pp. 226–227. Yao Wenyuan's editorial on Mao's instruction to workers to take charge of education was published in *People's Daily* only on 26 August 1968.

5 –– Helmut Opletal, *Die Kultur der Kulturrevolution* [The culture of the Cultural Revolution] (Vienna: Museum für Völkerkunde Wien, 2011), p. 136.

6 –– Li Zhisui, *The Private Life of Chairman Mao,* trans. Tai Hung-chao (New York: Random House, 1994), p. 503.

7 –– Tang Shaojie, *Yiye zhi qiu— Qinghua daxue 1968 nian bairi dawudou* [An episode of the Cultural Revolution: The 1968 Hundred-Day War at Tsinghua University] (Hong Kong: The Chinese University of Hong Kong, 2003), pp. 29–30, 64.

8 –– Excerpts from "Jinse mangguo" [Golden Mango], *Renmin ribao,* 10 August 1968.

9 –– Li Zhensheng, *Red-color News Soldier: A Chinese Photographer's Odyssey through the Cultural Revolution* (London: Phaidon Press Limited, 2003).

10 –– Huang Yuzhong, "Mao Zhuxi de mangguo dao Weng'an" [Chairman Mao's mango arrives in Weng'an], *Yanhuan Chunqiu* 2010, no. 2, pp. 23–24.

11 –– Bill Bishop, *Badges of Chairman Mao Zedong,* digitally published 1996. http://museums. cnd.org/cr/old/maobadge/ (last accessed 21 July 2012).

12 –– After Bishop, *Badges of Chairman Mao Zedong.*

13 –– Helen Wang, *Chairman Mao Badges: Symbols and Slogans of the Cultural Revolution* (London: British Museum Press, 2008), p. 21.

14 –– Melissa Chiu, "The Art of Mao's Revolution," in Melissa Chiu and Zheng Shengtian (eds.), *Art and China's Revolution* (New York: Asia Society in association with Yale University Press, 2009), p. 10.

15 –– Michael Schoenhals (ed.), *China's Cultural Revolution, 1966–1969: Not a Dinner Party* (Armonk, NY: M. E. Sharpe, 1996), p. 200.

16 –– Roderick MacFarquhar and John K. Fairbank (eds.), *The Cambridge History of China, Vol. 14, The People's Republic, Part I: The Emergence of Revolutionary China, 1949–1965* (Cambridge: Cambridge University Press, 1987), p. 392.

17 –– Yang Peiming, Propaganda Poster Museum, Shanghai, oral communication, 20 July 2012.

18—— Howard J. Wechsler, *Offerings of Jade and Silk: Ritual and Symbol in the Legitimation of the T'ang Dynasty* (New Haven, CT: Yale University Press, 1985), p. 7.

19—— "Guanyu Jiang Qing tongzhi zengsong Beihai gongyuan mangguo de baogao" [Report on Comrade Jiang Qing sending a mango to Beihai Park], dated 4 October 1974. Beijing Municipal Archives, document no. 98-2-337.

20—— http://www.xubing.com/ index.php/site/projects/ year/2002/a_consideration_of_ golden_apples (last accessed 20 June 2012).

21—— Jin Zhao, *Mangguo de ziwei* [The flavor of mangoes] (Taipei: Lianjing chuban gongsi, 1980).

Inscriptions

1 Poster of mango on
 porcelain plate

In cartouche:

我們伟大領袖毛主席永远和群众心連心

在紀念毛主席 «炮打司令部» 大字报和 «中国共产党中央委员会关于无产阶级文化大革命的决定» 发表两周年的大喜日子里，偉大領袖毛主席亲自把外国朋友赠送的珍貴礼物––芒果，轉送給首都工农毛澤东思想宣轉队。 毛主席說： "我們不要吃，要汪东兴同志送到清华大学給八个团的工农宣轉队的同志們"。

Our Great leader Chairman Mao forever joins his heart with the hearts of the people.
To commemorate the happy day of the second anniversary of Chairman Mao's big-character poster "Bombard the headquarters" and the publishing of "Decision of the Chinese Communist Party's Central Committee on the Great Proletarian Cultural Revolution," Great Leader Chairman Mao presented the precious gift that he had personally received from foreign friends—mangoes—to the Capital Worker-Peasant Mao Zedong Thought Propaganda Teams. Chairman Mao said: "We do not want to eat them; have comrade Wang Dongxing take them to Qinghua University for the comrades in the eight Worker-Peasant Propaganda Teams."

Bottom:

伟大領袖毛主席亲自赠送給首都工农毛澤东思想宣傳队的珍贵礼物 – 芒果

The precious gift personally presented by Great Leader Chairman Mao to Capital Worker-Peasant Mao Zedong Thought Propaganda Teams—mango.

2 Small poster of mango on
 porcelain plate

In cartouche:

我国有七亿人口，工人阶级是领领导阶级，要充分發揮工人阶级在文化大革命中和一切工作中的領导作用。工人阶级也应当在斗爭不断提高自己的政治觉语。

Our country has a population of 700 million, and the working class is the leadership class. Bring into full play the leading role of the working class in the Great Cultural Revolution and in all fields of work. The working class also must continuously raise its political consciousness through struggle.

Bottom:

伟大領袖毛主席亲自赠送給首都工人毛泽东思想宣传队的珍贵礼物--芒果

The precious gift personally presented by Great Leader Chairman Mao to Capital Workers' Mao Zedong Thought Propaganda Teams—mango.

3 Members of the Worker-Peasant Propaganda Teams at Qinghua University cheering the gift of mangoes

Inscription on ribbon:

敬祝毛主席万寿无疆

Respectfully wishing Chairman Mao eternal life.

5 Bust of Mao Zedong in
 Zhongshan suit

Obv.:

毛主席万岁

Long live Chairman Mao.

Rev.:

毛主席接见我厂工人代表及赠送芒果纪念

北京化工二厂革命委员会一九六八，八，十五

Memento of Chairman Mao receiving worker representatives of our factory and graciously presenting a mango. Revolutionary Committee of Beijing Chemical Factory No. 2, 1968.8.15.

6　Rectangular mango vitrine from Beijing No. 1 Machine Tool Plant

毛主席说:
"我们不要吃，要汪东兴同志送到清华大学给八个团的工农宣传队的同志们"。
北京第一通用机械厂革命委员会
六八，八，五日。

Chairman Mao said:
"We do not want to eat them; have comrade Wang Dongxing take them to Qinghua University for the comrades in the eight Worker-Peasant Propaganda Teams." Beijing No. 1 Machine Tool Plant Revolutionary Committee. 68.8.5th day.

7　Rectangular mango vitrine from Beijing No. 1 Machine Tool Plant

毛主席说: "我们不要吃，要汪东兴同志送到清华大学给八个团的工农宣传队的同志们"。
北京第一通用机械厂革命委员会
六八，八，五日。

Chairman Mao said: "We do not want to eat them; have comrade Wang Dongxing take them to Qinghua University for the com-rades in the eight Worker-Peasant Propaganda Teams." Beijing No. 1 Machine Tool Plant Revolutionary Committee. 68.8.5th day.

9　Pictorial magazines with photographs of the 1968 National Day parade

A　National Day card display
工人阶级必须领导一切
The working class must exercise leadership in everything.

D　National Day parade mango float
毛泽东思想工人宣传
Workers' Mao Zedong Thought Propaganda Team.
工人阶级必须领导一切
The working class must exercise leadership in everything.

13　Small photographs of mangoes

A　Small photograph of mango on a wicker plate
最大关怀　最大信任　最大支持　最大鼓舞
我们的伟大领袖永远和群众心连心
毛主席把外国朋友赠送的珍贵礼物转送给首都工农毛泽东思想宣传队
首都工农毛泽东思想宣传队
北京市第一建筑工程公司革命委员会，
一九六八年八月五日

Greatest Concern! Greatest Confidence! Greatest Support! Greatest Inspiration!
Our Great Leader's Heart is Always One with the Masses. Chairman Mao took the precious gift given by foreign friends and gave it to the Capital Worker-Peasant Mao Zedong Thought Propaganda Teams.
Capital Worker-Peasant Mao Zedong Thought Propaganda Team. Revolutionary Committee of Beijing City No. 1 Building Engineering Cooperation, 5.8.1968.

B　Small photograph of mango in rectangular vitrine with Mao's portrait and standard inscription
68。8。5 毛主席送给我们的珍贵礼物–芒果
京棉三厂　革命委员会赠68。9
5.8.1968 The precious gift Chairman Mao gave to us—mango. Presented by the Revolutionary Committee of Beijing No. 3 Cotton-textile Factory, 9. 1968.

14　Rectangular vitrine for fac-simile mango

Front:
敬祝毛主席万寿无疆
Respectfully wishing Chairman Mao eternal life.
伟大的领袖毛主席向首都工农毛泽东思想宣传队赠送的珍贵礼物--芒果，
一九六八年八月五日
The precious gift presented by Great Leader Chairman Mao to the Capital Worker-Peasant Mao Zedong Thought Propaganda Teams—mango. 5 August 1968.
Right side:
毛主席给工人阶级撑腰
Chairman Mao supports the working class.
Left side:
工人阶级为毛主席争气
For Chairman Mao the working class has fighting spirit.
Back:
中国人民解放军驻厂，毛泽东思想宣传队，四车间无产阶级革命派增，
一九六八，十二，二十六。
Mao Zedong Thought Propaganda Teams of the People's Liberation Army stationed in factories. Presented by No. 4 Workshop's Proletarian [Cultural] Revolution Faction. 1968.12.26.

15　Mug with lid and design of seven mangoes
首都工人解放军毛泽东思想宣传队
Capital Worker-PLA Mao Zedong Thought Propaganda Teams.
我国有七亿人口，工人阶级是领导阶级。 毛泽东, 1968。8
Our country has a population of 700 million; the working class is the leadership class. Mao Zedong, 1968.8.

16 Quilt cover with design of heroic peasants and soldiers
向解放军致敬，向解放军学习
Respect the People's Liberation Army, learn from the People's Liberation Army.

17 Badge
Obv:
毛主席恩情比海深
Chairman Mao's kindness is deeper than the sea.
Rev:
忠. 毛主席万岁
Loyalty. Long live Chairman Mao.
北结革委会成立一周年 68.12.26
The first anniversary of the establishment of the Beijie Revolutionary Committee, 68.12.26.

18 Badge
Obv:
敬祝毛主席万寿无疆
Respectfully wishing Chairman Mao eternal life.
Rev:
颗颗芒果献红心1969.2.
中国人民解放军8122部队
With each mango dedicating a red heart. 1969.2. Unit 8122 of the Chinese People's Liberation Army.

19 Round mango vitrine with standard inscription and row of seven sunflowers
Front:
敬祝毛主席万寿无疆
纪念伟大的领袖毛主席向首都工农
毛泽东思想宣传队赠送的珍贵礼物――
芒果 一九六八年八月五日 (复制品)
Respectfully wishing Chairman Mao eternal life. To commemorate the precious gift presented by Great Leader Chairman Mao to the Capital Worker-Peasant Mao Zedong Thought Propaganda Teams—mango. 5 August 1968. (Facsimile).
Back:
北京第一轧钢厂革命委员会
Revolutionary Committee of Beijing No. 1 Rolled Steel Factory.

20 Badge
Obv.:
颗颗芒果恩情深
With each mango, profound kindness.
Rev.:
忠, 国营新华工厂革命委员会
Loyalty, Revolutionary Committee of State-Owned New China Chemical Engineering Plant.

21 Badge
Obv.:
首都工人毛泽东思想宣传队
Capital Workers' Mao Zedong Thought Propaganda Team.
Rev.:
祝毛主席万寿无疆, 化学工业部
Wishing Chairman Mao eternal life, Department of Chemical Industries.

22 Badge
Obv.:
首都工人毛泽东思想宣传队
Capital Workers' Mao Zedong Thought Propaganda Team.
Rev.:
忠, 五金工具厂革命委员会, 1969。1
Loyalty, Revolutionary Committee of the Metal Tool Workers General Factory, 1968.1.

23 Badge
Obv.:
工人阶级必须领导一切
The working class must exercise leadership in everything.
Rev.:
大革委会敬制
Respectfully made by the Committee of the Great Revolution.

24 Badge
Obv.:
永远忠于毛主席
Forever loyal to Chairman Mao.
Rev.:
八机厂首届活学活用毛泽东思想积极分子代表大会纪念, 1969。3
Commemorating No. 8 Machine Factory Activists' attendance at the First Congress to Actively Study and Apply Mao Zedong Thought, 1969.3.

25 Badge
Obv.:
永远忠于毛主席
Forever loyal to Chairman Mao.
Rev.:
北京二机床 3401 工厂.
Beijing No. 2 Machine Tool Factory, Plant 3401.

26 Badge
Obv.:
颗颗芒果恩情深
With each mango, profound kind-
ness.
Rev.:
毛主席送工农宣传队珍贵礼品纪念，
河南公安机关车管会
Memento of Chairman Mao pre-
senting a precious gift to the
Worker-Peasant Propaganda
Teams. Vehicle Maintenance
Bureau of the Henan Public
Security Department.

27 Badge
Obv.:
颗颗芒果恩情深
With each mango, profound
kindness.
Rev.:
毛主席万岁，哈林机.
Long live Chairman Mao, Halinji.

28 Large roundel with portrait of
 Mao and plate with seven
 mangoes
Rev.:
颗颗芒果恩情深，机修敬制
With each mango, profound kind-
ness. Machine Repair [Factory]
respectfully made.

29 Mug with design of mangoes
 on a plate
祝毛主席万寿無疆，
北钟革委会工代会
Wishing Chairman Mao eternal
life. Meeting of Working Class
Representatives of the Revolu-
tionary Committee of Bei[jing]
Clock [Factory].
Bottom seal:
大众北京日用搪瓷厂
The Masses' Beijing Daily Use
Enamel Factory.

30 Rectangular vitrine for
 facsimile mango, produced
 by the steel workers
Top:
颗颗芒果恩情深，钢铁工人献忠心
With each mango, profound kind-
ness, Steel Workers display loyal
hearts.
Bottom:
工人阶级必须领导一切，毛泽东
The working class must exercise
leadership in everything.
Mao Zedong.

31 Tray with design of mangoes
 in a bowl
Obv.:
芒果
Mango.
Rev.:
草原牌，包头搪瓷厂大众
1968.5.4. (5); several characters in
old Mongolian script.
Grassland brand, Baotou Enamel
Factory 1968.5.4 (5); Mongolian
sheep breeding brand (in old Mon-
golian script).

32 Tray with design of mangoes
 on a blue plate
Obv.:
颗颗芒果恩情深
With each mango, profound
kindness.
Factory seal:
大众。北京市日用搪瓷，69。5。8
Dazhong. Beijing Factory for Daily
Use Enamels, 69.5.8.

33 Design for a tray
Obv.:
颗颗芒果恩情深
With each mango, profound
kindness.
Seal of authority:
32 茶盘，69。1。28 梁季兰
(designer Liang Jilan)
Annotation:
孙玉堂69。1。28, 注:
去掉纲子，影光改桃
Commentary by Sun Yutang:
get rid of the grid, make the
background radiance a more
peachy color.

34 Tray with design of cog, Mao's
 Collected Works, red flags,
 and slogan
Obv.:
工人阶级必须领导一切
The working class must exercise
leadership in everything.
Factory seal:
大众国营上海搪瓷一厂 69—9.
The Masses State-Owned Shanghai
No. 1 Enamel Factory, 69.9.

35 Washbasin with design of a
 mango branch
No inscription, no factory seal.

36 Tray with design of mango
 and the character for "Double
 Happiness"
Obv.:
颗颗芒果恩情深
With each mango, profound
kindness.
Factory seal:
天津市搪瓷厂，30公分，68。12。26
Tianjin City Enamel Factory, 30
cm., 68.12.26.

37 Badge
Obv.:
颗颗芒果恩情深
With each mango, profound kindness.
Rev.:
毛主席万岁
Long live Chairman Mao.

38 Badge
Obv.:
颗颗芒果恩情深
With each mango, profound kindness.
Rev.:
毛主席万岁, 江苏19,
迎接珍贵礼物芒果
Long live Chairman Mao. Jiangsu 19. Receiving the precious gift—mango.

39 Badge
Obv.:
永远忠于毛主席
Forever loyal to Chairman Mao.
Rev.:
忠, 敬祝毛主席万寿无疆
Loyalty. Respectfully wishing Chairman Mao eternal life.

40 Badge
Obv.:
颗颗芒果恩情深
With each mango, profound kindness.
Rev.:
毛主席万岁
Long live Chairman Mao.

41 Badge
Obv.:
永远忠于毛主席
Forever loyal to Chairman Mao.

42 Golden yellow badge
Obv.:
颗颗芒果恩情深
With each mango, profound kindness.
Rev.:
津8.
Jin 8.

43 Badge
Obv.:
毛主席永远和工农心连心
Chairman Mao will be forever heart to heart with our workers, peasants, and soldiers.
Rev.:
毛主席万岁, 北京红旗制
Long live Chairman Mao. Made by Beijing Red Flag.

44 Two posters of Mao Zedong in front of a parade
A Poster of Chairman Mao
紧跟伟大领袖毛主席奋勇前进!
Forging ahead courageously while following the Great Leader Chairman Mao.
Lower right corner:
上海人民美术出版社集体创作 上海人民美术出版社出版·1969年3月第1次印刷 (2) 书号:6910101 (32)
Collectively created by Shanghai People's Art Publisher. Printed at People's Art in Shanghai, March 1969, first edition. Number 6910101 (32).
B Poster of Chairman Mao
紧跟伟大领袖毛主席奋勇前进!
Forging ahead courageously while following the Great Leader Chairman Mao.
Lower right corner:
新华社稿 上海人民美术出版社出版·1969年6月第5次印刷 (1) 书号:69118 (28)
Xinhua Publishers sketch. Printed at People's Art in Shanghai, June 1969, fifth edition. Number 69118 (28).

45 Rectangular mango vitrine with likeness of Mao and standard inscription
敬祝毛主席万寿无疆
纪念伟大的领袖毛主席向首都工农毛泽东思想宣传队赠送的珍贵礼物–芒果 一九六八年八月五日 [复制品]
Respectfully wishing Chairman Mao eternal life.
To commemorate the precious gift presented by Great Leader Chairman Mao to the Capital Worker-Peasant Mao Zedong Thought Propaganda Teams—mango. 5 August 1968. (Facsimile).

46 Mango vitrine with standard inscription
敬祝毛主席万寿无疆
纪念伟大的领袖毛主席向首都工农毛泽东思想宣传队赠送的珍贵礼物–芒果 一九六八年八月五日 复制品
Respectfully wishing Chairman Mao eternal life.
To commemorate the precious gift presented by Great Leader Chairman Mao to the Capital Worker-Peasant Mao Zedong Thought Propaganda Teams—mango. 5 August 1968. (Facsimile).

51 Magenta quilt cover with design of a basket of mangoes, trains, farms, and factories
国营淄博缫织一厂出品
Product of the State-Owned No. 1 Zibo Silk Weaving Mill.

56 Small vanity mirror with design of mangoes, cog, and the Little Red Book
毛主席万岁
Long life to Chairman Mao.

57 Circular wall mirror with design of bowl of mangoes in front of a sea of red flags
工人阶级必须领导一切
The working class must exercise leadership in everything.

58 Circular wall mirror with design
 of mango plate and sunflowers
忠 ， 颗颗芒果恩情深
Loyalty. With each mango, pro-
found kindness.

60 Pencil box with design of
 mango on a plate
伟大领袖毛主席赠送首都工农毛泽东
思想宣传队的珍贵礼物 - 芒果
The precious gift presented by
Great Leader Chairman Mao to
the Capital Worker-Peasant Mao
Zedong Thought Propaganda
Teams—mango.

61 Paper wrapper for mango
 candy
芒果, 奶白糖
Mango Chew Candy.
中国天津, 天津市红卫兵罐头食品厂,
69—009
Tianjin, China. Tianjin City, Red
Guard Food Packaging Plant,
69–009.

62 Large mango vitrine with
 sunflowers and standard
 inscription
敬祝毛主席万寿无疆
纪念伟大的领袖毛主席向首都工农毛
泽东思想宣传队赠送的珍贵礼物 – 芒
果 一九六八年八月五日 复制品
Respectfully wishing Chairman
Mao eternal life.
To commemorate the precious gift
presented by the Great Leader
Chairman Mao to the Capital
Worker-Peasant Mao Zedong
Thought Propaganda Teams—
mango. 5 August 1968. Facsimile.

63 Mango brand cigarette packs
 and wrappers
芒果。 河南省新郑卷烟厂。
注册商标。
20芒果香烟。规格16.1×9.5,
長高 印刷厂 印1983
Mango. Henan Province, Xinzheng
Rolled Cigarette Factory. Regis-
tered trade mark.
20 Mango cigarettes, normal size
16.1 x 9.5, Changgao printing
factory, printed 1983.

⑤ Essay
 (Adam Yuet Chau)
 Chinese texts in "Political
 Awakening through the
 Magical Fruit:
 The Film *Song of the Mango*"
 (see pp. 78–95)
Song of the Mango
(see footnote 7, p. 83)
颗颗芒果恩情长,
闪着金色的阳光。
毛主席呀红太阳,
您的光辉照四方。
这是巨大的鼓舞,
这是无尽的力量。
我们纵情欢呼,
热情歌唱,
热情歌唱毛主席,
衷心祝福您老人家万寿无疆！

The song at the end of the film
(see footnote 11, p. 94)
红旗摆满天,
飞舞向太阳。
工宣队员斗志昂扬,
誓把那资产阶级彻底埋葬。
万里飘香,
毛主席送芒果情深意长。
个个芒果,
对我们寄托着无限期望。
高举起铁锤,
把旧世界的丧钟敲响。
我们的光荣
将揭开历史新篇章。

Character List

Bai Juyi (772–846)	白居易
balinghou	八零后
Boyi (ancient recluse)	伯夷
cai (vegetable)	菜
cai (talent)	才
Cao Cao (155–220)	曹操
Cao Pi (187–226)	曹丕
Cao Zhi (192–232)	曹植
Chang Yan	常彦
chedi zalan jiu Qinghua	彻底砸烂旧清华
Chen Boda	陈伯达
Chen Guidi (geb. 1942)	陳桂棣
Chen Qiang	陈强
choulaojiu	臭老九
chuji ren linghun	触及人灵魂
da fan'ge	大翻个
Da Qianmen	大前門
dangquanpai	当权派
Daxing	大幸
Deng Xiaoping	邓小平
Diyi ke	第一课
dou, pi, gai	斗，批，改
Du Fu (712–770)	杜甫
Fan Lixin	范立欣
Fan Pu	范璞
Fenglei zaofan bingtuan	风雷造反兵团
gao, da, quan	高，大，全
gongren jieji bixu lingdao yiqie	工人阶级必须领导一切
gua shi	瓜时
Gu Yu	谷雨
Han Aijing	韩爱晶
hong, guang, liang	红，光，亮
hongwei bing	红卫兵
Hongweisi	红卫司
Huang Tingjian (1045–1105)	黄庭坚
Huang Zhanpeng	黄展鹏
Jiang Qing	江青
jianhua qingzhu	简化庆祝
Jinggangshan	井冈山
Jin Mangguo	金芒果
jiulinghou	九零后
Kang Sheng	康生
Kuai Dafu	蒯大富
kui hua	葵花
kunnan shiqi	困难时期
Liandong	联动
lianhuan	联欢
Lin Biao	林彪
Linxi	临溪
Liu Shaoqi	刘少奇
Liu Zongnian (773–819)	柳宗元
li zhi	荔枝
lingli bu ru chi	伶俐不如痴

lingzhi	灵芝
Luo Daqing (died after 1248)	罗大经
Luo Ping (1733–1799)	罗聘
Luo Zhongli	罗中立
Mangguo zhi ge	芒果之歌
Minghuang (Tang Xuanzong, r. 713–755)	明皇
Nie Jialiang	聂家良
Nie Yuanzi	聂元梓
nongmin	农民
pidou	批斗
qingbai (light green)	青白
qingbai (pure and incorruptible)	清白
san zhongyu si wuxian	三忠于四无限
shang shan xia xiang	上山下鄉
shanshui	山水
Shen Ruhuai	沈如槐
shou guo / shou tao	寿果 / 寿桃
Shuqi (ancient recluse)	叔齐
Sima Qian (145–86 B.C.)	司马迁
sipai	四派
Song Qingling	宋庆龄
su	粟
Sun Yat-sen	孙中山
Su Shi (1037–1101)	苏轼
Tan Houlan	潭厚兰
Tang Dequan	唐得泉
Tang Wie	唐伟
tuanpai	团派
Wang Dabin	王大兵
Wang Dongxing	汪东心
Wang Guangmei	王光美
Wang Jianwei	汪建伟
Wang Qingshan	王青山
Wang Xiaoping	王小平
Wannian qing	万年青
Weng Fanggang (1733–1818)	翁访纲
woju / wosun	莴苣 / 莴笋
Wu Chuntao	吴春桃
Xia Caiyun	夏彩云
xiang ri kui	向日葵
xianzai shi xiaojiang fan cuowu de shihou le	现在是小将犯错误的时候了
Xie Fuzhi	谢富治
xie sheng	写生
xie yi	写意
Xu Chongsi	徐崇嗣
Xuqu	序曲
Xuegongnong zaofan bingtuan	学工农造反兵团

yangbanxi	样板戏
Yang Guifei (died 756)	杨贵妃
Yang Peiming	杨培明
Yang Yangming	杨扬名
Yao Wenyuan	姚文元
Ye Qun	叶群
yixiaocuo	一小撮
Yuanding zhi ge	园丁之歌
Yu Ping	俞平
Zhang Chunqiao	张春桥
Zhang Kui	张奎
Zhang Puren	张普人
zhanlue bushu	战略部署
Zhaoxia	朝霞
Zhonghua	中华
Zhongyang wenhua geming xiaozu	中央文化革命小组
Zhou Enlai	周恩来
Zhou Lina	周麗娜
Zhou Quanying	周泉缨
zongdui	纵队

Selected Bibliography

Barnouin, Barbara, and
Yu Changgen
*Ten Years of Turbulence: The
Chinese Cultural Revolution.*
London and New York: Kegan
Paul International, 1993.

Bishop, Bill
Badges of Chairman Mao Zedong.
Digitally published 1996.
http://museums.cnd.org/cr/old/
maobadge/ (last accessed
21 July 2012).

Hung, Chang-tai
*Mao's New World: Political Culture
in the Early People's Republic.*
Ithaca, NY, and London: Cornell
University Press, 2011.

Clark, Paul
*The Chinese Cultural Revolution:
A History.* Cambridge: Cambridge
University Press, 2008.

Chau, Adam Yuet
"Mao's Travelling Mangoes: Food
as Relic in Revolutionary China."
Past and Present, Supp. 5
(Relics and Remains), 2010,
pp. 256–275.

Chen Guidi and
Wu Chuntao
Zhongguo nongmin diaocha
[Survey of the Chinese peasant].
Beijing: Renmin wenxue chuban-
she, 2004; abridged English trans-
lation: Zhu Hong. *Will the Boat
Sink the Water.* Cambridge:
PublicAffairs, 2007.

Chiu, Melissa, and
Zheng Shengtian (ed.)
Art and China's Revolution. New
York: Asia Society in association
with Yale University Press, 2009.

Chow, Rey
Primitive Passions: Visuality, Sexuality, Ethnography, and Contemporary Chinese Cinema. New York: Columbia University Press, 1995.

Dutton, Michael
"Mango Mao: Infections of the Sacred." *Public Culture,* vol. 16 (2004), pp. 161–187.

Harney, Alexandra
The China Price: The True Cost of Chinese Competitive Advantage. New York: Penguin Books, 2008.

Hinton, William
Hundred Day War: The Cultural Revolution at Tsinghua University. New York and London: Monthly Review Press, 1973.

Leese, Daniel
Mao Cult: Rhetoric and Ritual in China's Cultural Revolution. Cambridge: Cambridge University Press, 2011.

Li Zhensheng
Red-color News Soldier: A Chinese Photographer's Odyssey through the Cultural Revolution. Ed. by Robert Pledge. London: Phaidon Press Limited, 2003.

Li Zhisui
The Private Life of Chairman Mao. Trans. by Tai Hung-chao. New York: Random House, 1994.

Liu Shu
Behind-the-Scenes Stories in Chinese Cinema. Beijing: Xinhua Publishers, 2005.

MacFarquhar, Roderick (ed.)
The Politics of China, 1949–1989. Cambridge: Cambridge University Press, 1993.

MacFarquhar, Roderick and John K. Fairbank (eds.)
The Cambridge History of China, Vol. 14, The People's Republic, Part 1: The Emergence of Revolutionary China, 1949–1965. Cambridge: Cambridge University Press, 1987.

MacFarquhar, Roderick and John K. Fairbank (eds.)
The Cambridge History of China, Vol. 15, The People's Republic, Part 2: Revolutions within the Chinese Revolution, 1966–1982. Cambridge: Cambridge University Press, 1991.

MacFarquhar, Roderick, and Michael Schoenhals
Mao's Last Revolution. Cambridge, MA: The Belknap Press of Harvard University Press, 2006.

May, Jennifer
Sources of Authority: Quotational Practice in Chinese Communist Propaganda. Ph.D. diss., Heidelberg University, 2008.

Meisner, Maurice
Mao's China and After: A History of the People's Republic. 3rd edition, New York: The Free Press, 1999.

Murck, Afreda
"Golden Mangoes: The Life Cycle of a Cultural Revolution Symbol." *Archives of Asian Art,* vol. 57 (2007), pp. 1–22.

Opletal, Helmut
Die Kultur der Kulturrevolution [The culture of the Cultural Revolution]. Vienna: Museum für Völkerkunde Wien, 2011.

Schoenhals, Michael (ed.)
China's Cultural Revolution, 1966–1969: Not a Dinner Party. Armonk, NY: M. E. Sharpe, 1996.

Song Yongyi (ed.)
Chinese Cultural Revolution Database. Hong Kong: Chinese University Press, 2006 (CD-ROM).

Wang, Helen
Chairman Mao Badges: Symbols and Slogans of the Cultural Revolution. London: British Museum Press, 2008.

Wang Yao
"A Chronicle of 'Cultural Revolution Literature'," in: *Contemporary Writers' Criticism,* April 2000.

Yan Jiaqi and Gao Gao
Turbulent Decade: A History of the Cultural Revolution. Trans. and ed. by D. W. Y. Kwok. Honolulu: University of Hawai'i Press, 1996.

Yang Kelin (ed.)
Wenhua da geming bowuguan [Museum of the Cultural Revolution]. Hong Kong: Oriental Publishing House and Cosmos Books, Ltd., 1995.

Zheng, Xiaowei
"Passion, Reflection, and Survival: Political Choices of Red Guards at Qinghua University, June 1966–July 1968," in: Esherick, Joseph W., Paul G. Pickowicz, and Andrew G. Walder (eds.), *China's Cultural Revolution As History.* Stanford, CA: Stanford University Press, 2006.

Authors

Adam Yuet CHAU grew up in Beijing and Hong Kong, and received a Ph.D. in anthropology from Stanford University. His first book, *Miraculous Response: Doing Popular Religion in Contemporary China*, was on the revival of popular religion in rural China during the reform era. He has also edited *Religion in Contemporary China: Revitalization and Innovation*. He teaches at the University of Cambridge.

Alonzo EMERY is Assistant Professor at Renmin University of China Law School, Beijing. A graduate of Harvard Law School, he also runs the disability law clinic established by Renmin University in close collaboration with the "Harvard Law School Project on Disability." He writes about the contemporary art market for *Orientations* magazine and other publications.

Daniel LEESE authored the first book on the personality cult of Mao Zedong: *Mao Cult: Rhetoric and Ritual in China's Cultural Revolution*. He received his Ph.D. from Jacobs University Bremen and teaches at the Orientalisches Seminar, Universität Freiburg, Germany.

Alfreda MURCK encountered the story of the mango in the collectibles markets of Beijing. More often writing about traditional Chinese art, she studies visual culture through symbols and literary metaphors. Her book *Poetry and Painting in Song China: The Subtle Art of Dissent* has been published in Chinese.

WANG Xiaoping was the loudspeaker announcer for Beijing No. 1 Machine Tool Plant because of her strong voice and good pronunciation, until her family background disqualified her. Now retired, she lives in Beijing, writes on contemporary China, and volunteers for a Non-Government Organization that supports education in Sichuan Province.

Xiaowei ZHENG studied political science of the late Qing and Republican era and has published on the Red Guards' conflicts at Qinghua University. Her doctoral dissertation at the University of California, San Diego was *The Making of Modern Chinese Politics: Political Culture, Protest Repertoires, and Nationalism in the Sichuan Railway Protection Movement in China*. She teaches at the University of California, Santa Barbara.

Credits

Despite best efforts, we have not been able to identify the holders of copyright and printing rights for all the illustrations. Copyright holders not mentioned in the credits are asked to substantiate their claims, and recompense will be made.

Museum Rietberg Zürich,
Gift of Alfreda Murck,
Photo: Rainer Wolfsberger
−− All catalog objects
After *Beijing ribao [Beijing Daily]*
−− Introduction, figs. 1, 6
−− Fig. I−8
After *China im Bild,* Beijing:
Foreign Language Press
−− Introduction, figs. 2, 3, 4, 5, 8
−− Essay ① figs. 1, 4, 8, 9, 11
−− Essay ③ figs. 2, 4, 5, 11
−− Essay ⑥ fig. 2
−− Fig. II−10
After *China Reconstructs,* Beijing:
The China Welfare Institute
−− Essay ① figs. 2, 3, 7, 10
−− Essay ③ figs. 7, 9, 10
After *Jiefangjun ribao [The People's Liberation Army Daily]*
−− Essay ③ fig. 8
−− Fig. I−2, fig. IV−28
After Yang Kelin (ed.), *Wenhua da geming bowuguan* [Museum of the Cultural Revolution], Hong Kong: Oriental Publishing House and Cosmos Books, Ltd., 1995
−− Essay ① figs. 5, 6, 12
After *Renmin ribao [People's Daily],* Beijing: Renmin ribaoshe
−− Essay ③ figs. 1, 3
−− Fig. I−4, fig. I−5

After *Sichuan Ribao [Sichuan Daily]*
−− Introduction, figs. 7, 9
Bloomberg, by Getty Images
−− Essay ⑥ fig. 5
chenmodemaque.blog.163.com
−− Introduction, fig. 10
Collection Dong Zhongchao
−− Essay ⑥ fig. 1
Film stills from *Song of the Mango,* Guangzhou: Beauty Media Inc.
−− Essay ⑤ figs. 1−24
Wang Jianwei
−− Essay ⑥ fig. 6
Alfreda Murck
−− Essay ② fig. 1
−− Essay ④ fig. 3
National Art Museum of China, Beijing
−− Essay ⑥ fig. 3
The Art Institute of Chicago
−− Essay ④ fig. 1
The Freer Gallery of Art
−− Essay ④ fig. 2
Völkerkundemuseum Wien
−− Essay ⑥ fig. 4
−− Fig. I−3
zhaoqingwei.blsh.com
−− Essay ① fig. 13

This book accompanies the
exhibition *Mao's Golden Mangoes
and the Cultural Revolution*
Museum Rietberg Zürich
15 February to 16 June 2013

Editor
Alfreda Murck

Co-editor
Alexandra von Przychowski

Translation from the Chinese
(Essay ②)
Li Yang and Zhuang Ying

Copy editor
Naomi Richards

Design
Elektrosmog, Zürich
Marco Walser and Selina Bütler
Assisted by
Christian Pérez

Proofreading
Anne McGannon

Production
Lithographs, printing, and binding
DZA Druckerei zu Altenburg
GmbH, Thuringia

Front cover
Rectangular mango vitrine with
likeness of Mao and standard in-
scription, 1968 – 1969, Fig. V – 45.
Back cover
Two old workers admiring the
mango, *China im Bild*, December
1968, p. 13.

Copyright © for the texts
the authors
Copyright © 2013
Museum Rietberg Zürich and
Verlag Scheidegger & Spiess AG,
Zürich

ISBN 978-3-85881-732-7

German edition
ISBN 978-3-85881-367-1

Verlag Scheidegger & Spiess AG
Niederdorfstrasse 54
CH – 8001 Zürich
Switzerland

www.scheidegger-spiess.ch